OREGON
SEARCH & RESCUE

ANSWERING THE CALL

GLENN VOELZ

Published by The History Press
Charleston, SC
www.historypress.com

Copyright © 2023 by Glenn Voelz
All rights reserved

Front cover, top: Crew of the life-saving station at Point Adams near Astoria. Point Adams was Oregon's first fully professional station, beginning active service in December 1889. *Bandon Historical Society Museum*; *bottom*: Portland Mountain Rescue, the Crag Rats and an Oregon Army National Guard helicopter respond to an injured climber in the Old Chute area of Mount Hood, July 2022. *Clackamas County Sheriff's Office*.
Back, cover: A Deschutes County Sheriff's Office Search and Rescue team evacuates an injured hiker near Broken Top in the Three Sisters Wilderness, September 2021. *Deschutes County Sheriff's Office*; *inset*: Oregon State Sheriffs' Association (OSSA) logo. *Used with permission*.

First published 2023

Manufactured in the United States

ISBN 9781467155250

Library of Congress Control Number: 2023938442

Notice: The information in this book is true and complete to the best of our knowledge. It is offered without guarantee on the part of the author or The History Press. The author and The History Press disclaim all liability in connection with the use of this book.

All rights reserved. No part of this book may be reproduced or transmitted in any form whatsoever without prior written permission from the publisher except in the case of brief quotations embodied in critical articles and reviews.

CONTENTS

Preface 5
Acknowledgements 7
Introduction 9

1. Pre-1920s: Mountain Men, Good Samaritans and Life-Savers 13
2. The 1920s and 1930s: The Golden Age of Volunteer Search and Rescue 40
3. The 1940s and 1950s: World War II and the Birth of National SAR 72
4. The 1960s and 1970s: Outdoor Recreation and Growing Demand for SAR Services 98
5. 1980s to the Present: SAR Professionalization and Government Involvement 119

Notes 153
Bibliography 167
Index 187
About the Author 191

Preface

A NOTE ON TERMINOLOGY

The acts of searching for missing persons and rescuing those in distress are as old as humanity, but the terminology describing these activities has evolved over time. Before World War I, the terms were generally used separately, referring to the specific acts of searching or rescuing. After the war, the British Royal Air Force (RAF) began using the term *air-sea rescue* to describe the operations of its Marine Craft Section, responsible for recovering lost crews of Royal Navy and Air Force seaplanes.[1]

The term *air-sea rescue* became more widely used during World War II. When the conflict began, the Royal Air Force was largely unprepared for the difficult task of recovering downed aviators during the Battle of Britain. In response, it created the Air-Sea Rescue Service in early 1941, later known as the Search and Rescue Force. The group's motto was, "The sea shall not have them."[2]

When the United States entered the war in late 1941, it borrowed much of what the British had already established, including its terminology. The American military used the British term *air-sea rescue* for much of the war, reflecting its operational focus on rescuing aviators and sailors lost at sea. In February 1944, the Joint Chiefs of Staff established the Air-Sea Rescue Agency under the Coast Guard to coordinate the military's rescue operations.

After the war, the term *air-sea rescue* gradually fell into disuse as civilian entities began adopting the phrase "search and rescue." That usage was formally enshrined in May 1945 when the Provisional International Civil Aviation Organization met to establish common standards for international

aviation. It selected *search and rescue* to describe the act of "finding and returning to safety the survivors from an emergency incident."[3] The Pentagon followed suit in 1946 when it officially changed the name of the Air-Sea Rescue Agency to the Search and Rescue Agency.

By the mid-1950s, the term *search and rescue* and the associated acronym SAR were part of the common lexicon. In 1956, the U.S. government published the first edition of its National Search and Rescue Plan. That foundational document defined SAR as "the employment of available personnel and facilities in rendering aid to persons and property in distress."[4] That usage evolved only slightly through the modern era into what is currently found in the National SAR Plan, in which search is defined as "an operation using available personnel and facilities to locate persons in distress" and rescue as "operations to retrieve persons in distress, provide for their initial medical or other needs, and deliver them to a place of safety."[5]

ACKNOWLEDGEMENTS

Search and rescue operations depend on the collective actions of many individuals working together for a common purpose. Writing a history is a similar process in that it depends on leveraging the collective knowledge of many to create a single accurate narrative of facts and events. In writing this book, numerous individuals generously provided their time and assistance to help tell the story of Oregon's volunteer search and rescue tradition.

I'm grateful for the research of several authors whose work touched on various aspects of the story. They include David Pinyerd, Eino Annala, Jack Grauer, Ric Conrad, Dee Molenaar, Butch Farabee and Ross Nixon.

I would like to thank several individuals who supported this research, including Joe O'Leary, who led Oregon governor Ted Kulongoski's SAR Task Force in 2007; Scott Lucas, Oregon's search and rescue coordinator; and Jason Myers, former sheriff of Marion County and the executive director of the Oregon State Sheriffs' Association. Many others provided interviews and background information assisting with the research. A complete list of those individuals appears in the bibliography.

Numerous organizations supported this research by providing documents and archival materials. They include the Oregon Historical Society, Southern Oregon University, the Oregon State Archives, the Crater Lake Institute, the Mazama Library, the Oregon Wing of the Civil Air Patrol and the 920th Rescue Wing.

Acknowledgements

The following groups and individuals provided images appearing in the book, including the Deschutes County Historical Society, the Mazama Library, the Deschutes National Forest, the Ray Atkeson Image Archive, the Walters Art Museum, the Bowman Museum, the Salem Public Library, the Oien family, the Lincoln County Historical Society, *Boy's Life* magazine, the Bandon Historical Society Museum, the U.S. Coast Guard, the Oregon Historical Society, the Douglas County Museum, Gary Randall, Arthur Babbitz, the Hood River Museum, the Tillamook Air Museum, the Civil Air Patrol National Archives, the Associated Press and numerous Oregon search and rescue organizations.

A generous group of readers reviewed portions of the draft manuscript, providing comments and suggestions for improvement. They include Joe O'Leary, Georges Kleinbaum, Tom Stringfield, Steve Cash, Jim Blanchard, Steve Rollins, David Pinyerd, Dennis Griffiths, Jim Tuschschmidt, Ed Weiser, Robert Towne, Russell Gubele and Susan Conrad.

This project could not have happened without the help of many—however, any mistakes and errors are my own. The book is dedicated to the thousands of volunteers who have built and sustained Oregon's proud tradition of volunteer search and rescue.

INTRODUCTION

This book traces the history of Oregon volunteer search and rescue. That story begins with the earliest migrants on the Oregon Trail, who faced unimaginable hardships and hazards as they traveled west. The region's arid deserts, powerful rivers and treacherous mountains challenged even the most experienced frontiersmen. When wagon trains encountered trouble, fellow citizens often answered the call without hesitation or expectation of reward. That sense of selfless obligation established a legacy that endures to this day among Oregon's volunteer search and rescue organizations.

This history is organized chronologically and thematically. The first section begins during the settlement period and continues up to the 1920s. During that time, state and local governments had little formal role in search and rescue. The function was performed mainly by Good Samaritans and members of Oregon's early outdoor clubs, such as the Mazamas. One exception was on the Oregon coast, where the U.S. Life-Saving Service became the state's first cadre of professional rescuers.

The decades of the 1920s and 1930s represented Oregon's "golden age" of volunteer search and rescue. During this era, county sheriffs and forest rangers relied almost exclusively on the civic spirit of outing clubs, climbing groups and ski patrols, whose members answered the call when needed. These groups operated with little formal support or direction from government authorities but established a strong foundation for later professionalization of the state's search and rescue apparatus.

Preface

Organizations like the Crag Rats, the Skyliners and the Obsidians trace their origins to some of the era's most famous search and rescue missions.

The start of World War II brought most outdoor recreation to a halt. Consequently, there was limited civilian search and rescue activity during the war years. However, the conflict profoundly changed how SAR developed in the postwar era. The military's air-sea rescue service introduced new technologies and methods that civilian SAR organizations would adopt after the war. Many Oregon veterans returned from military service with experiences and knowledge that they used to begin professionalizing the state's volunteer SAR organizations.

Starting in the 1950s, as Americans gained more leisure time and disposable income, there was a surge of interest in outdoor recreation. As Oregonians took to the slopes, the forests and the rivers in search of adventure, it created an unprecedented demand for SAR services. Faced with this growing need, communities across the state began forming volunteer SAR units during the 1960s and 1970s.

As these new SAR organizations formed, it spurred discussions in the state legislature about how to fund, manage and train these new volunteer organizations. By the early 1970s, Oregon lawmakers had become more involved in overseeing and regulating the state's SAR activities. With the help of the Oregon State Sheriffs' Association, state officials began developing tools and resources to assist county sheriffs in executing their mandated SAR functions. Governmental support became increasingly important as the number of SAR missions steadily increased, requiring more technical capabilities and training for volunteers.

The history of Oregon search and rescue involves tens of thousands of missions since the mid-nineteenth century. Only a small fraction of these could be included in this book. The stories recounted here generally fall into two categories. First of these are missions that tell something important about the nature of search and rescue during a particular era and the people who performed it. The stories in the later part of the book generally relate to incidents that had a significant effect on how SAR was performed, organized and regulated in the state.

Several themes run through this story. The first is the role of the natural environment in spurring the development of Oregon's search and rescue tradition. The state's rugged coastline, wild rivers and beautiful mountains draw visitors from around the world. But these natural treasures also create hazards for those who enjoy them. For that reason, search and rescue became a matter of necessity in Oregon and matured here far ahead of other states.

Preface

A second theme concerns the state's long tradition of volunteerism. Although the government became closely involved in coordinating SAR operations in the modern era, the foundation of Oregon's SAR capacity was built on the dedication of volunteers dating to the nineteenth century and continuing to this day.

A related theme is the concept of professionalization. That word implies a process of formalized training and the establishment of standards, best practices and oversight. Professional activities are those founded on a base of expert knowledge applying a recognized standard of practice. Professional organizations operate according to clear ethical guidelines with identities, norms and values distinct to that group. Oregon's volunteer search and rescue history is defined by its steady path toward professionalization.

A final theme involves the process of institutional change. One hard lesson of search and rescue is that incremental progress often comes in the wake of setbacks. Moments of failure become catalysts for change by forcing the reexamination of accepted practices and creating evolution in organizational culture.

No one wants to fail, especially when lives are on the line, but those setbacks create space for self-reflection and inspire a willingness to accept change. As this book demonstrates, much of Oregon's search and rescue history has been driven by moments when something went wrong. These setbacks pushed individuals and organizations to find better ways of doing things, being ready to answer the call when needed.

1

PRE-1920s

Mountain Men, Good Samaritans and Life-Savers

Oregon's volunteer search and rescue tradition began with the first wagon trains leaving Missouri on the Oregon Trail. The journey of over two thousand miles was daunting for even the most experienced frontiersmen. Early pioneers encountered an unforgiving landscape of arid deserts, high mountain passes and wild rivers. Hundreds died of disease, accidents, starvation and natural hazards along the route.

During Oregon's settlement period, there was no formal system for search and rescue. When settlers fell victim to misfortune, they had to rely on their own courage and resourcefulness. If help did arrive, it was often days or weeks away and depended on the goodwill of neighbors who took it upon themselves to aid those in trouble.

One of Oregon's first rescuers was Moses "Black" Harris, a fur trapper and scout who began guiding into Oregon Country in the 1830s. Little is known about his early life. Harris was of mixed-race ancestry and possibly the son of an enslaved mother.[6] He was famous for his powerful physique and ability to navigate through the mountains during winter. One account from the period described him as "fearless as an eagle, strong as the elk."[7] He was well-acquainted with various tribal groups and allegedly fluent in the Shoshone dialect.[8]

In 1836, Harris accompanied the Whitman-Spalding party during their journey to Fort Vancouver. He was a gifted storyteller who allegedly charmed Oregon pioneer Narcissa Whitman over tea during an encampment along the Platte River.[9] In the mid-1940s, Harris settled in Yamhill County and would subsequently lead two of the Oregon Trail's most famous rescues.

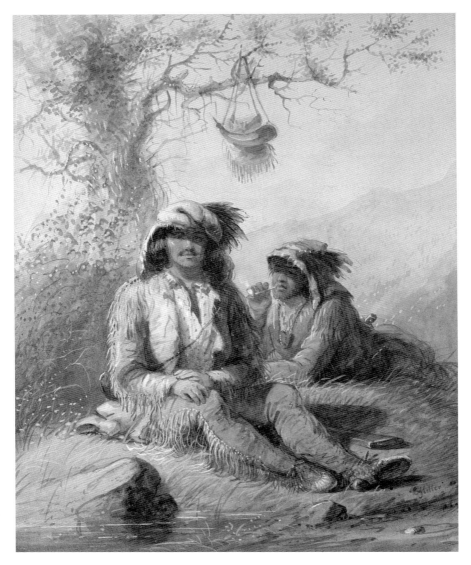

The only known likeness of Moses "Black" Harris. Watercolor by Alfred Jacob Miller titled *Trappers*, 1859. *The Walters Art Museum of Baltimore.*

In 1845, a party of over one thousand settlers with two hundred wagons hired Stephen Meek to lead them on a shortcut to the Willamette Valley. Meek's route took them through the high deserts of eastern Oregon, along the Malheur River and into the Harney Basin. However, Meek wasn't familiar with the area, and the path was poorly marked. When the party

approached the Wagontire Mountains, east of Christmas Valley, they were already low on food and water, and several members had died of typhus.[10]

As the situation became desperate, the party split into two groups. One group, led by Samuel Parker, set out through the desert, hoping to find the Crooked River. Wagon master Solomon Tetherow led a smaller group, including Meek, to the banks of the Deschutes River near Cline Falls.[11] The two parties eventually reunited and made their way to the area around the present-day Sherars Bridge, north of Maupin. However, they couldn't find a way across the deep gorge on either side of the Deschutes River.

With the wagon train unable to advance, Meek went to The Dalles, hoping to organize a relief party. He arrived exhausted and desperate but found no one willing to help. Finally, Meek happened upon Moses Harris, passing through the area. The men knew each other from previous meetings, and when no one else volunteered to help, Harris agreed to lead the rescue.

Harris quickly organized a small party, including several Native Americans from the Warm Springs band who lived along the Columbia's tributaries. They gathered food, water, ropes and fording materials before setting out on their mission.[12] Meek declined to join the rescue, unable to face the members of his abandoned party. When the rescuers arrived at the Deschutes, they found the pioneers on the verge of calamity, with "provisions nearly exhausted and the company weakened by exertion and despairing of ever reaching the settlements."[13]

After providing them with food, the rescue party began constructing a river crossing system using pulleys and wagon beds to ferry the settlers to safety, a method described by one observer as "novel in the extreme."[14] It took nearly two weeks to move all one thousand people across the river.[15] By the end of the ordeal, at least forty had died, but Harris and the other rescuers likely saved many more lives. A member of the rescued party described Harris as "a brave old mountaineer, one of the noblest."[16]

After that rescue, Harris was determined to find a better path from Fort Hall to the Willamette Valley.[17] He joined the Applegate brothers to scout a southern route through the Calapooya and Umpqua Mountains, linking up with the California Trail along the Humboldt River in Nevada. Perhaps more than anyone, the Applegate clan understood the dangers of the trail, having lost two sons during their family's migration to Oregon when their boat overturned in the rapids on the Columbia River near The Dalles in 1843.

In the late summer of 1846, Jessie Applegate recruited a party of some two hundred settlers for the first journey along the proposed route. The unproven shortcut presented numerous challenges, and the party was

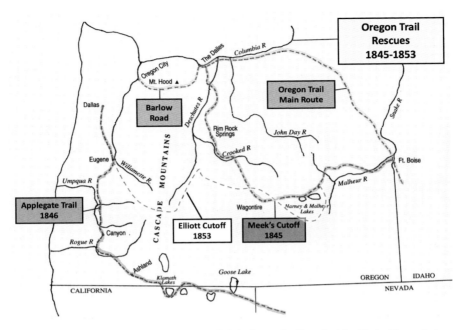

The Oregon Trail and its various cut-offs. Original map by Ross Smith. *Used with permission of Ross A. Smith and modified by the author.*

exhausted and running low on food by the time they crossed the Klamath River.[18] In the Calapooya Mountains, the settlers encountered torrential rains, part of the same historic weather system that trapped the Donner Party in California's Sierra Nevada that November. Many of the migrants were forced to abandon their wagons and walk, experiencing "suffering beyond anything you have ever known," according to one survivor.[19]

When news of the stranded wagon train reached the Willamette Valley in early December, citizen volunteers formed several rescue parties. Moses Harris led one relief party composed of several men with twenty-five horses and provisions.[20] Thomas Holt, a recent immigrant and resident of Polk County, organized another rescue party at his own expense. When Holt encountered the lead elements of the wagon train south of Eugene, they were "suffering almost beyond description" and unable to continue without assistance.[21]

The rescue effort lasted nearly two months, until all the stragglers made it to the Willamette Valley. Only twenty wagons of the original one hundred made it to the end, and at least a dozen settlers died from typhoid fever and exposure. Despite Harris's role in the rescue, he and the Applegates faced

harsh criticism for promoting an unproven route. Nevertheless, Lindsay Applegate praised Harris for his actions during the rescue, declaring him a "brave and useful man."[22]

Harris left Oregon the following year. The reason for his departure is unknown, but as a person of mixed race, he must have been acutely aware of the territory's Black exclusion law enacted the year before he led the famous rescue along the Deschutes River. Harris died of cholera in Missouri two years after leaving Oregon City.

The tragedy of Meek's Cutoff was nearly repeated in 1853, this time along the Free Immigrant Road, also known as the Elliott Cutoff. The route had been partially scouted in 1852 but wasn't well marked. It followed a similar course as Meek's Cutoff into the Harney Valley, then took a different path south of Malheur Lake. Promotors billed it as a shorter, less expensive option than the Barlow Road south of Mount Hood.

Elliot recruited a party of around one thousand settlers with over 250 wagons.[23] They left Vale in late August but became bogged down in the Harney Basin and were low on food and water. A small group was sent ahead in mid-September to get help but lost their way when they mistook the Three Sisters for their intended route south of Diamond Peak. The advance party arrived in Springfield forty days later, barely alive and too late to help the rest of their group.

Meanwhile, the main party reached the Deschutes River near Bend in early October, then traveled upstream looking for the path over the Cascades. When they couldn't find the route, the settlers were forced to cut their way through dense forests past Crescent Lake and down the middle fork of the Willamette River.[24] By then, many had abandoned their wagons and struggled ahead on foot as their provisions ran out.[25]

In mid-October, on the verge of starvation and with temperatures falling, a small group went ahead, hoping to find help. They were discovered near Butte Disappointment, overlooking present-day Lowell and the Dexter Reservoir. When word of the struggling wagon train reached the valley, residents of Lane, Linn and Benton Counties quickly organized a massive rescue effort involving hundreds of pack animals, cattle, dozens of wagons and tons of food and supplies—a rescue effort described in one account as "unequaled in the history of the West."[26]

The rescue parties reached the lead wagons around Big Pine Opening upstream from the present-day town of Oakridge. Even with the rescuers' help, it was an arduous journey, lasting several weeks before everyone was brought to safety. The party arrived in the lower Willamette Valley,

starving and destitute, but somehow, only nine had died during the ordeal. The rescuers refused payment for their services, reportedly telling the new arrivals to "put away your purses. We have been there. We know how it is ourselves."[27]

With the establishment of Oregon Territory in 1848, the federal government assumed a more significant role in protecting migrants along the trail. However, in the early 1850s, federal soldiers could scarcely care for themselves, much less anyone else. The first regiment to arrive in Oregon lost nearly seventy soldiers to accidents, disease and desertion during the trek from Fort Leavenworth to The Dalles.[28] Some men were barefoot and barely able to walk when they arrived. Six soldiers drowned while moving supplies through the rapids on the Columbia River.

After the Civil War, Congress authorized the construction of new wagon roads over the Cascades.[29] In addition to making for safer travel, the roads facilitated the movement of troops and commerce. But even improved roads didn't guarantee safe passage over the mountains—demonstrated by the famous search for missing postmaster John Templeton Craig during the winter of 1877.

Craig had come to Oregon Territory from Ohio in 1852 and settled in the lower McKenzie Valley. In 1862, Captain Felix Scott hired him to lead a work crew cutting a new route from Eugene over the Cascades that would eventually become the path of the McKenzie Highway.[30] In 1877, Craig took over the contract for delivering mail along that route.

In December of that year, Craig left Belknap Springs on snowshoes carrying a heavy pack of mail heading for Camp Polk, about three miles northeast of the present-day town of Sisters. Craig had traveled the route many times but may have been ill as he began his climb up from the McKenzie River.[31] At the same time, a powerful winter storm hit the mountains. Authorities grew concerned when he didn't arrive by early January.[32]

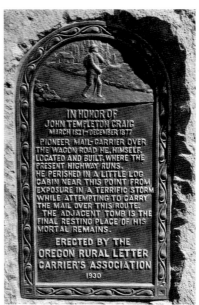

The memorial marker honoring John Templeton Craig near the cabin on McKenzie Pass where he sought shelter and died during a storm in December 1877. *U.S. Forest Service*

A search party set out several weeks later but was forced back after the rescuers experienced snow blindness.[33] A second party of two experienced mountain men went out a few days later, struggling through ten feet of snow. They eventually made it to a cabin west of McKenzie Pass that Craig used as a stopover along his route. Inside the cabin, they found Craig's body curled around a pile of ashes and ruined matches. There was a single snowshoe, leading them to surmise that the other one must have been lost or broken along the way.

The thwarted rescuers guessed that Craig had pushed through the storm to make the cabin, arriving cold and exhausted before lying down to sleep. Sometime during the night, his fire went out and couldn't be restarted with wet matches. After the fact, a newspaper account suggested that the benefits of maintaining the mail route during winter months were "entirely inadequate to the dangers incurred."[34] Today, a historical marker along the McKenzie Highway sits near the site where Craig took shelter and died in the cabin.

The U.S. Life-Saving Service on the Oregon Coast

At the time of Craig's death, inland search and rescue was a haphazard affair, entirely dependent on the initiative of Good Samaritans and mountain men. However, it was a different situation on Oregon's coast as the U.S. Life-Saving Service opened its first station at Cape Arago, near Coos Bay, in 1878.

Oregon's coast was a dangerous environment for nineteenth-century travelers. Cold water, strong currents, frequent storms and hazardous sand bars created an unforgiving challenge for maritime navigation. As shipping expanded, so did the number of accidents, particularly along the stretch of coast between Tillamook Bay and the Columbia River Bar, known as the "graveyard of the Pacific."[35] For that reason, a professionalized search and rescue capability developed on the coast long before anywhere else in the state.

The U.S. Life-Saving Service began on the East Coast as a series of shore-based stations with volunteer crews. The federal government began funding these stations in 1848 with the passage of the Newell Act.[36] Oregon's program began thirty years later as coastal shipping expanded along the Pacific Northwest.

OREGON SEARCH AND RESCUE

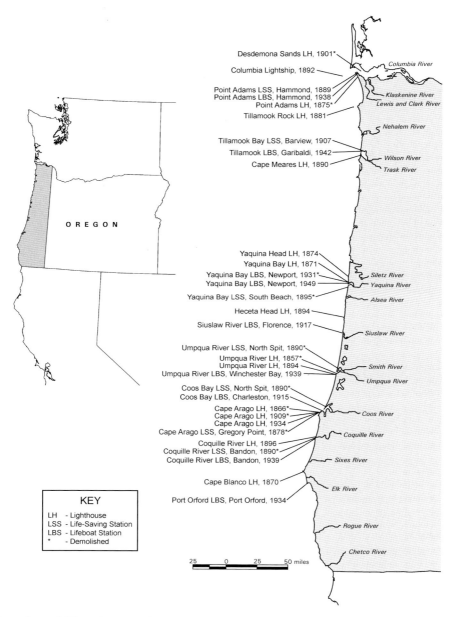

Locations of life-saving and lifeboat stations along the Oregon coast. *Map courtesy of David Pinyerd.*

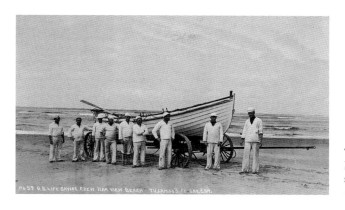

The Tillamook Bay Life-Saving crew with surfboat, circa 1910. *U.S. Coast Guard*.

Initially, the station at Cape Arago had only a keeper in charge with no paid crew. The keeper gathered volunteers from the local community to assist when a rescue was required. This ad hoc situation changed by the early 1890s when Oregon's legislature pressured the federal government to fill the stations with paid, professional lifesavers.

Oregon's first fully operational station was established at Point Adams near Astoria in 1889 with a crew of eight. Other stations were gradually created near known hazards and where crews could quickly access the water. They included stations on the Coquille River at Bandon in 1890 and the Umpqua River near Winchester Bay in 1890. By 1891, the Argo station had moved to a better location on the North Spit of Coos Bay and was staffed with a full-time professional crew. Two other stations were established at Yaquina Bay in 1896 and Tillamook Bay in 1908.[37]

Crew members, known as "surfmen," were generally under the age of forty-five and had a high level of physical fitness. Their responsibilities included lookout and patrol duties.[38] Keepers generally lived at the stations with their families while the crews found accommodations nearby. Surfmen were often hired locally and served for many years in one location, ensuring they were familiar with the unique hazards of the area.

The work schedule was a demanding regime of training and maintenance, with one day of rest per week on a rotating basis. Critical skills included boat launching, rowing through rough surf, capsizing drills, ship-to-shore rescue and medical training.[39] The work was inherently dangerous—and the pay was low—but the crews had pride in their work and strong esprit de corps. The surfmen were visible members of their coastal communities and often assisted with other public safety tasks when called upon, such as fighting fires and conducting rescues on land.[40] The service's unofficial motto was, "You have to go out, but you don't have to come back."

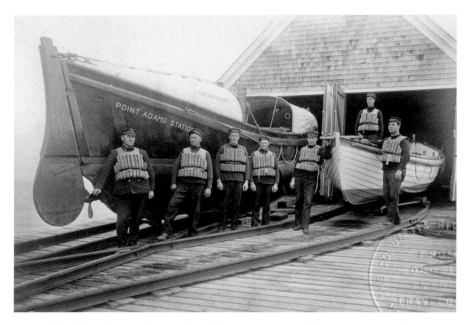

Crew of the life-saving station at Point Adams near Astoria. Point Adams was Oregon's first fully professional station, beginning active service in December 1889. *Bandon Historical Society Museum.*

During the years of Oregon's Life-Saving Service, several surfmen lost their lives in the line of duty. One incident occurred on the Coquille River bar in 1892, where three surfmen died during a training accident.[41] Another incident happened during a rescue of the steamer *Argo* in November 1909 as it entered Tillamook Bay in stormy weather. A life-saving crew from the nearby Garibaldi station was transferring passengers from the ship when one of the rescue boats capsized in rough surf. Three passengers and a crewmember drowned before the other surfmen could reach them.[42]

Early Oregon life-saving stations were equipped with two kinds of rescue boats: a surfboat and a lifeboat. Surfboats were around twenty-five feet long and weighed as much as one thousand pounds.[43] The boats had a six-person crew who moved them to the water using a pull-cart or horses before launching them into the surf.[44] The surfboats were agile but exhausting to row.

Oregon stations also had larger "Dobbins" lifeboats, rowed by a crew of eight. These boats could hold around thirty people and were self-righting and self-bailing.[45] Around 1910, the service began distributing thirty-six-foot motorized lifeboats that significantly extended the range for rescues and

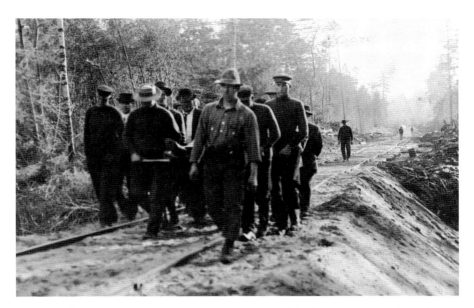

Surfmen of the Coquille River station evacuating casualties from a deadly train accident on the Seely-Anderson Logging Road near Bandon, November 1912. *Bandon Historical Society Museum.*

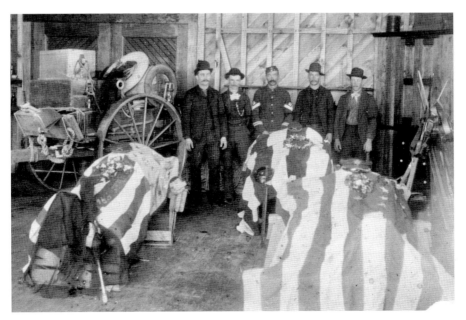

Three surfmen are honored by their crewmates following a deadly training accident on the Coquille River bar near Bandon, April 1892. *U.S. Coast Guard.*

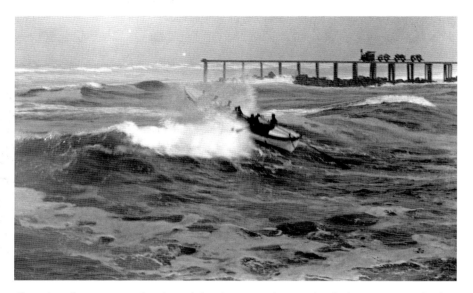

Above: A surfboat crew rowing through breakers near the notoriously dangerous mouth of the Coquille River. Construction of the north jetty is ongoing in the background. *Bandon Historical Society Museum.*

Opposite, top: A sketch of the life car rescue apparatus, circa 1893. *U.S. Coast Guard.*

Opposite, bottom: A breeches buoy in use during a rescue, 1919. *George Grantham Bain collection, Library of Congress.*

saved the crews from the exhausting work of rowing out to wrecks. By 1915, all Oregon's stations had at least one motorized vessel.

In cases where a ship was stranded closer to shore, the crew might opt to use a Lyle gun, named after its designer, U.S. Army ordnance officer Lieutenant David Lyle.[46] The gun could propel a seventeen-pound projectile with a messenger line over six hundred yards. A stranded crew used the messenger line to draw over a heavier rope, enabling the surfmen to set up a pulley system.

Once the pulley system was established, the shore-based rescuers could ferry stranded victims to safety using a breeches buoy. That device was a life preserver resembling a pair of oversize pants attached to a zip line. A trained crew of surfmen could set up the pulley system and breeches buoy in less than five minutes.[47] Stranded passengers and sailors climbed into the buoy to be shuttled from the wrecked vessel one person at a time.

Another shore-based rescue device was the life car, an enclosed pod enabling subjects to climb inside and close a watertight hatch behind

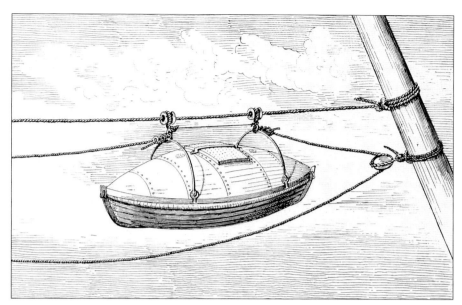

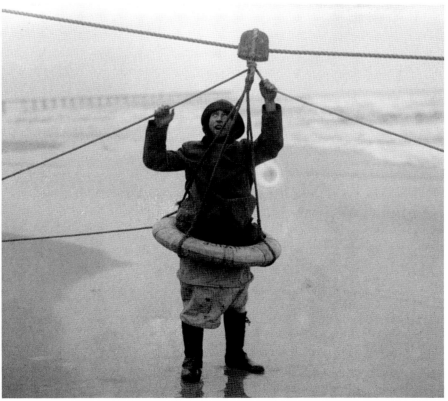

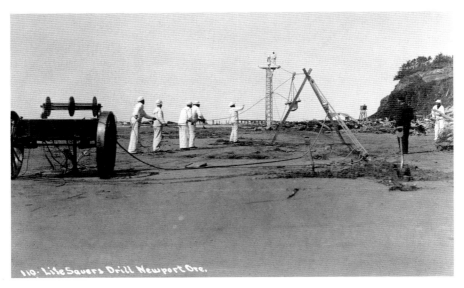

Surfmen of the Yaquina Bay station practicing on the beach with a Lyle gun and breeches buoy. *Lincoln County Historical Society.*

them. The life car could hold four to five passengers and be pulled through the water to shore using the pulley system. Although the life car could move several victims at once, it was much heavier and more complicated to deploy.

During the years that the Life-Saving Service operated along Oregon's coast, surfmen responded to hundreds of wrecks and rescues. Two of these gained widespread attention: the wrecks of the *Czarina* and the *Rosecrans*.

In January 1910, the steamer *Czarina* left Coos Bay with a crew of twenty-three and one passenger, carrying a large load of cement and timber bound for San Francisco.[48] The crew encountered strong winds and high seas as they left the harbor. The ship passed over the bar and was near the jetties when it began having trouble.[49] After drifting in high surf, the *Czarina* grounded on South Spit.

Violent waves damaged the ship's lifeboats, setting them adrift in the storm. Unable to maneuver, the crew dropped anchor several hundred yards from shore and climbed into the rigging to escape the waves. Two nearby boats attempted to reach the crew but couldn't maneuver close enough.

Clarence Boice, the keeper of the lifeboat station at Coos Bay, had watched the *Czarina* leave the harbor. At the first sign of trouble, Boice alerted his surfmen. However, he decided that the sea was too rough for the lifeboats

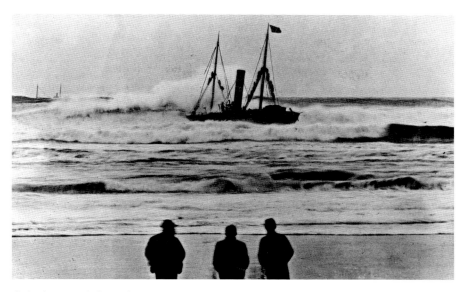

Onlookers watch from shore as crewmembers of the *Czarina* cling to the rigging above the ship. Only one of the crewmembers survived. *Photo by Arthur Prentiss; courtesy of David Pinyerd.*

and ordered his crew to deploy the beach rescue equipment instead.[50] The life-saving crew brought the Lyle gun to the water's edge and tried to fire it into a heavy wind, but it failed to reach the ship after several attempts.

Meanwhile, onlookers watched in horror as members of the *Czarina*'s crew began dropping from the rigging into the water. Boice's crew tried unsuccessfully to relaunch the surfboats through the rough surf but eventually gave up. In the early afternoon, a second crew from the Coquille River station, twenty miles to the south, joined the Coos Bay team.

The crews worked through the night patrolling the beach, looking for survivors. But only one of the *Czarina*'s crew made it to shore, kept afloat by grasping onto a piece of drifting timber. Several others lasted through the night by lashing themselves to the rigging. By morning, the weather had worsened, and no further attempt was made to reach the ship. At midday, no survivors were visible from shore.

In the aftermath of the tragedy, the community criticized Boice for not doing more to reach the ship and save the twenty-three men aboard. The Life-Saving Service investigated the incident and determined "that no human power could have succeeded in rescuing the men of the *Czarina*."[51] Nevertheless, it determined that Boice should have attempted further efforts with Lyle gun and boats, and his failure indicated "a certain degree of

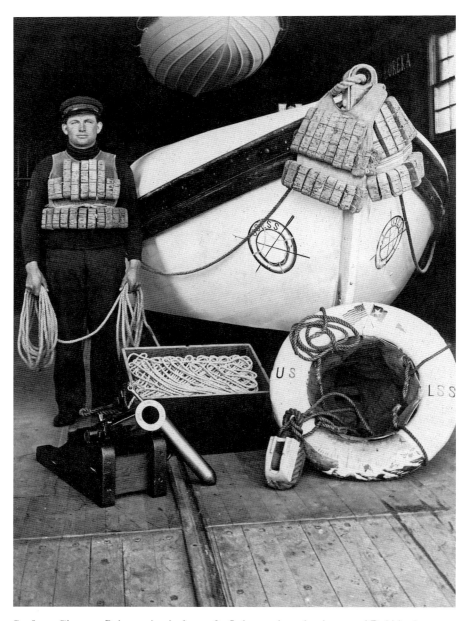

Surfman Clarence Boice posing in front of a Lyle gun, breeches buoy and Dobbins boat. Boice was accused of dereliction during the attempted rescue of the *Czarina*'s crew in 1910 and was forced to resign as keeper of the Coos Bay station. *Bandon Historical Society Museum.*

incompetency." Boice resigned but was eventually rehired as a surfman at the Coquille River station, where he had served before becoming the keeper at Coos Bay.

A second notable incident involved the *Rosecrans* on the Columbia River Bar, a spot that claimed some two thousand boats and over seven hundred lives during the last two centuries. In January 1913, the *Rosecrans* was sailing from California to Portland with a cargo of oil when it encountered heavy swells and poor visibility.[52] According to witnesses, the captain ran the ship aground on Peacock Spit on the Washington side of the river. When the captain realized the danger, he dropped anchor, but by that time the boat was already heavily damaged and taking on water.

A wireless operator in Astoria received the distress message from the ship. Several tugboats responded to the call but couldn't approach the *Rosecrans* in heavy seas. Calls also went out to the life-saving stations at Point Adams and Cape Disappointment; however, the storm disrupted the telephone lines and delayed transmission of the message.

Daybreak revealed that the ship had broken in two parts on the spit, leaving only the pilothouse and masts visible above the waves.[53] Some crewmembers climbed into the rigging as the waves battered the wreck. Unfortunately, the ship was located miles from shore, leaving no possibility of using the Lyle gun.

The surfmen of the Cape Disappointment station set out in their thirty-six-foot motor surfboat, appropriately dubbed the *Tenacious*, but returned to shore after three hours of fighting heavy surf, unable to reach the wreck. Next, the crew from Point Adams station set out in their surfboat, the *Dreadnought*, but couldn't locate the *Rosecrans* through the high seas.

Crews from both stations made multiple attempts during the day to fight their way to the stranded sailors. During the effort, the *Tenacious* became severely damaged and capsized. The crew of the *Dreadnought* went to their rescue. After pulling the disabled *Tenacious* to a nearby tug, the *Dreadnought* crew returned to the *Rosecrans*. But by then, the remaining sailors had dropped from the rigging into the water.

The surfmen aboard the *Dreadnought* pulled two survivors from the water but couldn't return to shore. They reached the lightship *Columbia* and transferred to the larger vessel. However, the *Columbia* couldn't pull the *Dreadnought* to safety through the storm. The surfboat was set adrift, never to be seen again.

The next day, a single survivor from the *Rosecrans* washed ashore, miles from the wreck. Rescuers on shore took him to the life-saving station at

Klipsan Beach in Washington. In total, thirty-four sailors of the *Rosecrans* were lost, making it the second-most deadly maritime disaster on the Columbia River bar in the twentieth century.

An investigation ultimately found fault with the captain of the *Rosecrans* for misjudging his course and running the ship aground on Peacock Spit. The two life-saving crews had failed to rescue most of the sailors and lost two surfboats in the effort, but the investigation found that they had done everything possible to save the crew. The surfmen of the two stations were awarded a total of sixteen gold life-saving medals, the most ever awarded by the service for a single rescue.[54]

In 1915, the U.S. Life-Saving Service merged with the Revenue Cutter Service, creating the modern United States Coast Guard. The new service assumed responsibility for maritime search and rescue operations along Oregon's coast. The old life-saving stations continued to operate much as before. But now, the surfmen fell within the military chain of command, receiving similar pay and benefits as other service members.

The bureaucratic transition to the Coast Guard brought about station closures and consolidations on the East Coast. However, Oregon saw continued expansion of its maritime safety infrastructure, including new stations on the Suislaw River in 1917 and at Port Orford in 1934. By World War II, the Coast Guard had thirteen stations along the Oregon coast, many of which were legacy sites from the era of the U.S. Life-Saving Service.

Early Search and Rescue on Oregon's Public Lands

In the late nineteenth century, Oregon's public lands were largely undeveloped. Access was difficult, and there were few recreational opportunities. When President Theodore Roosevelt created the Forest Service in 1905, the agency was focused more on protecting forest lands from misuse than protecting citizens from hazards encountered while recreating there.[55]

That outlook would gradually change into the early twentieth century as the Forest Service began viewing recreation as a legitimate use of system lands. Oregon was among the first states where the Forest Service actively promoted outdoor recreation, aided by the rise of automobile ownership, which allowed citizens to access remote national forests. The first automobiles started appearing at Government Camp shortly after the turn of the century, bringing an increase in visitors to Mount Hood.[56] By the early 1920s, the area was one of the most visited national forests in the United States.[57]

Despite the influx of visitors, search and rescue was still not among the Forest Service's designated responsibilities.[58] The function fell into the broad category of unstated duties expected of all forest rangers, who often acted as "the only policeman, fish and game warden, coroner, disaster rescuer, and doctor" in their district.[59] However, the rising popularity of outdoor recreation inevitably led to more accidents and mishaps, generating a need for search and rescue.

Before the founding of the Crag Rats in the mid-1920s, no formal search and rescue authority existed inside Oregon's National Forests. That duty fell on a handful of district rangers and local outdoorsmen who volunteered their services when a rescue was required. Fortunately, the Forest Service employed some of the era's best climbers and outdoorsmen. This included men such as forest ranger Adolph Aschoff, the first supervisor of the Cascade Range Forest Reserve, later known as the Mount Hood National Forest.

Aschoff settled near Sandy and opened a hotel frequented by early Mount Hood climbers traveling from Portland.[60] There he met the future Mazamas,

Adolph Aschoff was a charter member of the Mazamas and the first supervisor of the Cascade Range Forest Reserve, later the Mount Hood National Forest. Lige Coalman would lead a search party for Aschoff's son, who went missing in the summer of 1914. *Courtesy of Gary Randall.*

William Steel and Oliver Yocum. Aschoff took up climbing and became a founding member of the Mazamas before joining the Forest Service.

While serving as a ranger, Aschoff joined a Mazama outing in 1901, hosting Henry Fielding Reid, renowned geophysicist and the world's leading authority on glaciers. One evening, Reid became so enthralled while exploring Zigzag glacier that he wandered away and failed to return to camp by nightfall. Aschoff set out into the darkness with a lantern to track down the famous scientist and guide him safely back to camp. Reid Glacier on Mount Hood's western slope, the source of the Sandy River, was later named in honor of the rescued scientist.[61]

During those years, the Forest Service maintained a close relationship with the Mazamas and often used club members as an informal resource for search and rescue.[62] In later years, outdoor groups like the Skyliners and Obsidians would perform a similar role in the Deschutes and Willamette National Forests.[63]

Among those early informal rescuers was Oliver Yocum, a climbing guide on Mount Hood. As a young man, Yocum had been an actor, a farmer and a justice of the peace before becoming interested in photography and opening a studio in Portland.[64] In the summer of 1883, Yocum made his first climb of Mount Hood. On that climb, he carried an enormous load of photography equipment, taking the first known photographs from the summit.[65]

Yocum later moved to Government Camp, where he began working as a guide. In July 1901, he was involved in one of the era's most unusual rescues while leading a climb during the Mazamas' annual outing on Mount Hood.[66] Yocum spotted a group of climbers having difficulty near Crater Rock, a triangular lava dome near the summit. A woman in the group was unconscious and needed to be brought down as a storm closed in.

A group of Mazamas went to her aid but didn't have rescue equipment and were forced to improvise. One of the Mazamas wrapped himself in an overcoat and lay flat on the ground, turning himself into a human toboggan. The unconscious woman was lowered over a mile across a snowfield, riding atop her rescuer. She was transferred to a horse at the edge of the snowline and taken to Government Camp, where she received medical care.[67]

Elijah "Lige" Coalman was another legendary mountaineer and rescuer who worked for the Forest Service. In 1897, at the age of sixteen, Coalman made his first ascent of Mount Hood, guided by Oliver Yocum. Over several summers, Yocum trained Coalman in climbing, and they eventually went into business together as guides and running a hotel at Government Camp until Yocum retired in 1910.

Coalman was known for his tremendous physical endurance and unfailing willingness to help those in need. He made his first rescue at the age of seventeen, pulling a drowning man from the storm-swollen Sandy River. The man was unconscious and not breathing when pulled to shore. Coalman placed the man on his stomach and rolled him vigorously until he began breathing again, using the accepted method of resuscitation at the time.[68]

By his early thirties, Coalman was living at Government Camp and had become one of Oregon's most experienced mountain guides. By that time, he was also a legendary rescuer. Late one evening in December 1914, a half-frozen man stumbled into Government Camp with news that a family traveling with a baby was trapped in the snow in the direction of Rhododendron. They had come from nearby Sandy, planning to spend the winter as caretakers of a farm and sanitarium near Clackamas Lake.

Coalman set out in the middle of the night with two other men to find the stranded family. The temperature was near zero, with nine feet of snow on the ground as they left Government Camp.[69] When the rescuers found them, the parents were suffering from frostbite and exposure, having used what little they had to protect their baby. After Coalman got them back to Government Camp, the family spent the next four days recovering before he escorted them by snowshoe some sixteen miles to Clackamas Lake, towing a toboggan full of supplies and the young child.[70]

But his mission didn't end there. Coalman encountered three other caretakers waiting at the farm who needed help back to Government Camp. The party included a man severely ill with the flu and unable to walk. Coalman towed him in a toboggan for the two-day journey back to Government Camp, where the man convalesced for a week before continuing to Portland.

The following summer, while working for the Forest Service, Coalman built the summit cabin on the top of Mount Hood. He hauled up most of the supplies with the assistance of government packer Dee Wright. In 1916, Coalman became the first fire lookout, and the summit hut became the starting point for many rescue missions. That summer, a Portland climber went missing for two nights when Coalman spotted him staggering near the edge of a crevasse on the Zigzag Glacier. Coalman glissaded down from the summit in fifteen minutes, reaching the climber just in time and leading him to safety.[71]

The following year, Coalman rescued the famous Swiss-born guide Hans Fuhrer, who had been severely injured while glissading down from the Hogsback, a prominent saddle between Crater Rock and the main

Elijah "Lige" Coalman (*left*) carrying supplies up to the summit lookout on Mount Hood. *U.S. Forest Service.*

summit. Fuhrer's ice axe cut deeply into his abdomen, exposing his intestines. Coalman saw the group waving for help and raced to their aid. He dressed the abdominal wound and moved Fuhrer down the mountain using an improved rucksack toboggan. The surgeons at Portland's St. Vincent Hospital were reportedly impressed by the expertise of Coalman's impromptu field dressing.[72]

Coalman summited Mount Hood nearly six hundred times during his career. But in 1918, he became the subject of a rescue after being injured by a rockfall on Cooper Spur, a large moraine extending northeast from the summit. The day after his injury, Coalman returned to the summit cabin but couldn't move the next morning. He called the Zigzag district ranger using a phone line linked to the summit hut. The ranger organized a rescue party to carry Coalman down from the top of Mount Hood.[73]

Coalman never fully recovered from that incident but continued working intermittently for the Forest Service and even continued participating in rescues into the 1920s. When he died in 1970, the Oregon Geographic Names Board designated a small glacier in his honor, located between the White River and Zigzag Glaciers. The Coalman Glacier contains two features on the popular south side climbing route that have been the site of

numerous rescues over the years: the Hogsback, a prominent snow ridge extending from Crater Rock toward the summit ridge, and the infamous "Bergschrund" crevasse, one of the obstacles facing climbers as they near the summit.

The early mountain men working for the Forest Service around Mount Hood were a tight-knit fraternity that came to the aid of strangers and each other. In 1914, Adolph Aschoff's son became the subject of a highly publicized search when he went missing for several days from his family's home near Sandy. Coalman volunteered to lead the extensive search operation that located the young man's body a week later. Suicide was suspected.[74]

Search and Rescue in Crater Lake National Park

Unlike the early National Forests, which were created primarily for resource management, the National Park System was meant to bring Americans in contact with nature for "enjoyment, education, and inspiration."[75] Thus, providing a safe environment for visitors was an implied aspect of the agency's mission.[76] For that reason, the National Park Service assumed a more proactive role regarding search and rescue within its jurisdiction.[77]

When Crater Lake was established in 1902, it became the fifth national park in the United States and the only one in Oregon. At the time, the area was remote and difficult to access. This kept away all but the hardiest adventurers, who were generally self-reliant and accustomed to wilderness travel.

When Crater Lake opened, it operated with minimal staff from a headquarters at Bridge Creek Springs, six miles from the lake. William Arant was the park's first superintendent. At the time, he was the only staff member available for year-round search and rescue.[78] By 1906, the park was attracting around 1,700 visitors annually, and Arant was increasingly concerned about the potential hazards to guests. His annual report that year noted the "danger of accident or even loss of life" at some of the more exposed overlooks and trails around the crater's rim.[79]

In 1907, he hired Henry Momyer of Klamath Falls as the first seasonal ranger. Momyer's duties included enforcing park regulations, protecting resources, preventing and controlling forest fires and operating the park's entrance stations.[80] During those early years, Arant and Momyer attended to numerous guests needing rescue while visiting the park.

One of the more notable incidents involved a professional photographer named B.B. Bakowski of Oregon City, who set out for the lake from Fort

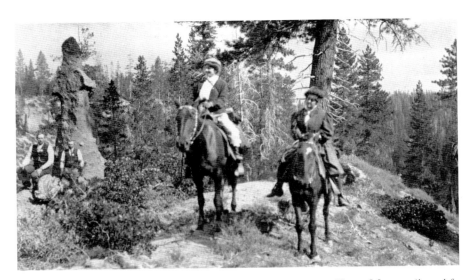

Crater Lake Park superintendent William Arant and forest ranger Henry Momyer (*lower left corner*) pose for a photo after rescuing two women who went missing near Kerr Notch, 1908. *NPS History Collection/Dewey Huffman.*

Klamath in January 1911. The young man took a month's worth of provisions, intending to camp near the lake and take photographs for postcards. When he failed to return by mid-February, several volunteer search parties set out to find him. An early search group located Bakowski's sled and a shovel near the crater rim in Munson Valley but not the rest of his gear.

An extended blizzard from late February into early March brought over twelve feet of snow and subzero temperatures, hampering search efforts. After the storm cleared, a second search party from Medford reached the lake by snowshoe. The men found Bakowski's camera equipment but no trace of the photographer, leading them to assume the worst.[81] In early March, park ranger Momyer discovered a canvas tarp stretching across the mouth of a snow tunnel. Bakowski's telescope, clothes and provisions were inside the tunnel, but there was no sign of his body.

Superintendent Arant and Ranger Momyer continued searching for Bakowski through the spring and summer of that year, but his remains were never found. It was the park's first recorded loss of a visitor. After that, Arant recommended a prohibition on winter travel inside the park from December through May without written permission.

In 1915, the Crater Lake Lodge opened, with the Rim Drive completed three years later. As the park's infrastructure improved, it began attracting visitors less familiar with the outdoors. Crater Lake still didn't have a

designated search and rescue unit, so the tiny staff was increasingly responding to emergencies in the park.[82]

By the 1920s, Park Service supervisors regularly reported on rescue incidents as part of their annual reports. At the first Chief Ranger's Conference held in Sequoia National Park in 1926, visitor safety, rescue and law enforcement were topics on the agenda.[83] That same year, Congress passed legislation formally directing the secretary of the interior "to aid and assist visitors within the national parks or national monuments in emergencies."[84] Although such activities had occurred regularly since the establishment of Yellowstone National Park in 1872, the legislation marked the first time the Park Service formally authorized and funded a search and rescue function. The law also provided for medical care and evacuation of park employees working at isolated locations.

On-site medical services first appeared at Crater Lake in the late 1920s when Dr. R.E. Green of Medford began working seasonally at the park. Dr. Fred Miller, head of the University of Oregon's health service program, also worked there under contract during the summer months.[85] Still, the park remained woefully understaffed through the 1920s. By the middle of

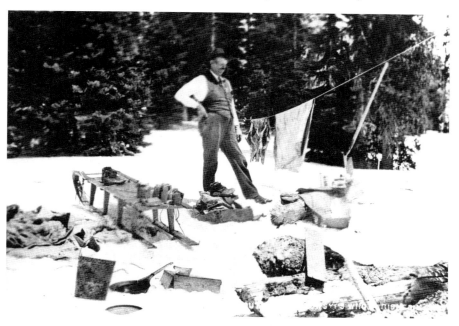

Superintendent William Arant inspects the campsite of B.B. Bakowski, who disappeared in the park during the winter of 1910. Despite extensive searches, Bakowski's body was never found. *Douglas County Museum.*

the decade, there was only one full-time ranger and eight seasonal rangers responsible for protecting an area of 249 square miles, receiving well over 100,000 visitors each year.[86] In the fall of 1930, the consequences of that understaffing became tragically apparent.

That year, an early-season storm brought over thirty inches of snow to the region, trapping several guests inside the park. Chief Ranger William Godfrey drove from Fort Klamath through the west entrance, trying to reach the stranded guests but found the road blocked by snow. Godfrey then drove to the south entrance near Annie Springs and spent the night in his car. The next morning, he called an operator at Fort Klamath and told her he was going into the park on foot, planning to rendezvous with a snowplow and retrieve the trapped guests. However, the plow was already working to open the west road, and the driver never reached Godfrey.

Later that morning, Ranger Rudy Luech learned of Godfrey's plan from the operator in Fort Klamath. When he hadn't heard from Godfrey, Luech organized a search party and set out on skis to find him. Around nine o'clock that evening, Luech found Godfry collapsed in the snow two miles from the Annie Springs entrance station. Godfrey was alive when the search party reached him but died shortly after from exposure.[87] He was forty-one years old and had been the park's chief ranger for only a year. After his death, Superintendent E.C. Solinsky named the park's Godfrey Glen Trail in his honor.

During the 1930s, the ranger force gradually expanded, but so did the number of incidents. During the mid-1930s, a series of accidental deaths led the park administration to focus more on visitor safety, protection and rescue operations.[88] The first incident involved a capsized boat near Wizard Island that took rescuers over an hour to reach, resulting in one death. Shortly after, there were two more deaths caused by visitors falling over the crater rim. There were also reports of numerous guests needing rescue after climbing down the crater wall and becoming stuck.

In response to the rising number of incidents, Park Superintendent Ernest Leavitt and Chief Ranger Carlisle Crouch created a ranger training school in 1938 to help prepare new rangers for the job's demands. Crouch also wanted a new, permanent ranger station located at the Rim Village to help deal with the rising number of fatalities and accidents around the lake, including water rescues, searches for lost persons and recovering bodies from the crater.[89]

At the time, Crouch proposed creating a new ranger position responsible for visitor services, including first aid, rescue and other emergency services.

However, the start of World War II significantly reduced park operations, and the position was never filled. After the war, the park gradually increased its training for search and rescue. By the early 1960s, SAR was among the designated duties for supervisory park rangers assigned to Crater Lake.[90]

2

THE 1920s AND 1930s

The Golden Age of Volunteer Search and Rescue

When the Mazamas formed in 1894, it was the third-oldest mountaineering society in the United States.[91] The club focused on climbing, exploration, research and advocacy. Nowhere in its charter was any mention of search and rescue. Nevertheless, its roster included some of the era's best climbers. When a rescue was needed in the mountains, it was inevitable that a Mazama was close by and willing to help.

In August 1908, during a club encampment on Mount St. Helens, a man in a separate party suffered a severely broken leg while descending the volcano's south side. Given the remote location, the Mazama party decided that the best option for evacuation involved re-summiting the mountain and descending the far slope to Spirit Lake. It took the rescue party twelve hours to reach the summit. By then, they were running low on food and water.

A different group of Mazamas joined them during the night to help move the injured hiker over the last five miles. A doctor and nurse, both Mazamas, met the rescue party at Spirit Lake, where they reduced and splinted the fracture, then prepared the patient for a forty-eight-mile wagon trip to Castle Rock.[92] The Washington state legislature later named the prominent glacier on the volcano's north side after S.E. Forsythe, the Mazama member who led the rescue effort.

Although search and rescue were not part of the club's charter, during the 1920s and 1930s, Mazama members were often at the center of the era's most dramatic missions. Over the years, the Mazama's climbing committee included numerous prominent rescuers such as Everett Darr, John Scott, Joe Leuthold and Dick Pooley.

One of the club's most famous searches began on New Year's Day 1927, involving Mazama members as both the subject and as rescuers. A Mazama member named Leslie Brownlee and his friend Al Feyerabend set out from Government Camp on New Year's Eve, hoping to be the first to summit Mount Hood in the new year. But a storm hit the mountain just after midnight. With poor visibility, the men became disoriented as they ascended the White River Glacier.[93]

As Brownlee struggled, the two friends became separated. Feyerabend eventually realized he was veering west toward Mississippi Head, a prominent band of sheer cliffs rising above Zigzag Canyon. He decided to descend toward Timberline Cabin and spotted four men on their way down the mountain to Government Camp. Feyerabend assumed that his friend Brownlee was among the group, so he continued to the Battle Axe Inn. But when Feyerabend arrived, he realized that Brownlee wasn't there.

Local authorities launched a search effort as soon as Brownlee was reported missing. Two Mazamas took charge of the operation. The overall headquarters was established at the Battle Ax Inn under the command of future Mazama president Lorenz Nelson.[94] Nelson came to the club in 1913 with an extensive

The Battle Axe Inn at Government Camp was the headquarters for many search and rescue missions around Mount Hood during the 1920s and 1930s. The inn was destroyed by fire in November 1950. *U.S. Forest Service.*

mountaineering background. He had climbed for many years in the Olympic Range and was a board member of the Seattle Mountaineers.[95] He would lead two famous search efforts that year and eventually convince the Mazamas to establish a rescue committee within the club.

Another Mazama named Ray Conway took charge of the operational headquarters at the Timberline Cabin. Conway joined the Mazamas in 1914, a year after Nelson. He was also an accomplished mountaineer and credited with making the first ascents of Rooster Rock above the Columbia River and the iconic Illumination Rock on Mount Hood's southwestern flank.[96] Conway worked as the public relations officer for the Oregon Automobile Association and often leveraged his extensive statewide connections by serving as a fundraiser during search and rescue operations.

The Brownlee operation eventually included dozens of searchers from the Mazamas, the Crag Rats and the Forest Service. Veteran Mount Hood climbing guides Lige Coalman and Mark Weygandt also joined the search. But after a week without success, Nelson and Conway called off the operation. The following summer, the two men led another search operation, hoping to find some clue of Brownlee's fate, but his remains were never found.

Later that year, the Mazamas were again at the center of another tragic incident. But this time, as subjects of the rescue. The event occurred in July during the Mazamas' annual climb on Mount Hood.[97] A group of over one hundred club members was on the Sunshine route when a climber slipped on Horseshoe Rock, the steepest section of the climb. The fall sent an entire rope team of ten climbers sliding out of control down the mountain. The novice climbers on the team couldn't self-arrest as they tumbled over six hundred feet down the mountain before dropping over the edge of a crevasse.[98]

The rest of the party immediately began organizing a rescue effort. They were assisted by a group of Crag Rats who had been training nearby on Eliot Glacier and were the first to respond. They arrived to find several climbers seriously injured. One Mazama, Dr. Stanton Stryker, had been impaled and mortally injured on his alpenstock, an iron-tipped walking staff. With help from the uninjured Mazamas, the rescuers began assembling makeshift stretchers. It took the rest of the day to evacuate Stryker's body and move the other injured climbers down to the Cloud Cap Inn, where they received medical attention and were transported to local hospitals.

The incident was the first fatal accident on an organized Mazama climb. Stryker's death shocked Mount Hood's tight-knit climbing community and drew scrutiny from the media. The incident led to an internal safety review and changes in how the Mazamas conducted their group climbs.

Answering the Call

Two months after Stryker's death, the Mazamas would be called to Central Oregon to assist in the search for two University of Oregon students lost in the Three Sisters Wilderness.

While the club gladly took on these rescue missions, there wasn't a formal program for search and rescue within the organization. That would change after two events on Mount Jefferson in 1933. The first incident occurred in August on the last day of the club's annual outing as members packed for an early departure the following morning. Earlier in the day, the Mazamas encountered a group of young men from the Civilian Conservation Corps (CCC) who had hiked in from their work camp at Breitenbush. They were inexperienced climbers without proper equipment but planned to explore the cliff bands above the Jefferson Park Glacier. The Mazamas warned them of the hazards, but the young men went off undeterred.[99]

In the middle of the night, two members of the CCC group stumbled into the Mazama camp, cold and exhausted. They explained that a boulder had crushed the leg of their companion on the north ridge between the Whitewater and Jefferson Park Glaciers. The Mazamas sprang into action and quickly organized a rescue party. Mazama member Dr. Paul Spangler put together a medical kit while the others gathered climbing gear, food, warm clothing and materials for a makeshift stretcher. The rescue team started up the mountain before sunrise.

When they reached the stranded climbers, the men were suffering from exposure. The rescue team made warm drinks of beef cubes and canned milk while Dr. Spangler splinted the injured man's leg and gave him a morphine tablet. They placed him on an improvised stretcher made from alpenstocks, ice axes and blankets, then began a slow and dangerous evacuation down the glacier, punctuated by frequent rock falls.

When they arrived at Jefferson Park, a troop of Boy Scouts camping in the area had hot food waiting for them. Around forty CCC men came up from Breitenbush to help evacuate their comrade. After a brief rest, the exhausted Mazama rescue party started their nine-mile hike to Olallie Lake, carrying their supplies and equipment from the two-week outing.

Two weeks later, the Mazamas would be called back to Mount Jefferson to help search for one of their own, Don Burkhart, who was a dual member of the Mazamas and Wy'east Climbers. Burkhart had gone missing over Labor Day while exploring a new route on Mount Jefferson's east face with two other climbers. Mazama member Perlee Payton, who had been on the Mount Jefferson rescue two weeks earlier, would volunteer to lead that historic mission.

The Crag Rats: An Oregon First

While the Mazamas may have been the first organized group in Oregon to assist with wilderness search and rescue, it was never the club's intended purpose. That distinction belonged to the Crag Rats, the first volunteer group west of the Mississippi to be organized expressly for mountain rescue.

The Crag Rats evolved from a group of hikers and climbers living around Hood River during the 1920s. Some were members of the local American Legion post and had been part of that group's first climb of Cooper Spur in 1921.[100] A few of the Legionnaires overlapped with the Hood River Guides, later known as the Hood River Ski Club.[101] During the 1920s, the Guides occasionally performed as an informal search and rescue group on Mount Hood's northern slopes.

The Hood River Guide's most famous mission occurred in 1923 when a nine-year-old boy named Blanchar Baldwin went missing on a family camping trip. A group of forty men spent the night searching the forest around Tony Creek. Fortunately, the boy was found asleep under a tree the following day in good condition.[102] The Baldwin search spurred a discussion about the need for an organized search and rescue group around Hood River. But nothing came of the idea until several years later when a young boy named Jack Strong went missing in the summer of 1926.

A few weeks before that event, a logger named Andy Anderson called a meeting about forming a search and rescue group.[103] Mason Baldwin and Jess Puddy, the father and uncle of Blanchar Baldwin, the subject of the 1923 search, attended the gathering. The meeting adjourned with a draft of bylaws and a constitution but no formal declaration. However, it did produce a tentative name: the Crag Rats. The moniker was jokingly suggested by Anderson's wife, who compared the motley crew to a bunch of rats, leaving their families on the weekends to climb among the local crags.

Two weeks later, seven-year-old Jack Strong wandered from his family's campsite near Paradise Park into the forested ridge above the Zigzag River. That prompted a massive search effort lasting for three days, involving around 250 searchers from the military, the Forest Service, the Mazamas, the Trails Club and search dogs from the local sheriff's office. Andy Anderson led a group of twenty men, including Baldwin and Puddy, from Hood River.

The multiday operation drew significant media attention. On the third day of the search, Baldwin and Puddy found the boy in good condition in the forest below Yocum Ridge. Newspaper reporters were waiting at

Government Camp when the search party returned. According to legend, one reporter asked if the men belonged to a club. They replied yes, and when asked its name, they blurted out, "The Crag Rats from Hood River."[104] The name made it into the newspapers and stuck.

The Crag Rats became one of the first volunteer search and rescue organizations in the United States. Within days of its first official meeting, the group was called out to rescue a young woman named Vanda York, who was injured in a fall on Eliot Glacier.[105] York's group had been climbing without ropes when she slid into a crevasse and became stuck. One party member went into the crevasse to reach her and found her unconscious and wedged between the ice walls. Another member of the party descended Cooper Spur to find help.

Andy Anderson and several other Crag Rats were training close by and responded to the call. They were joined by another group of Crag Rats coming up from the Cloud Cap Inn. By the time the second team arrived, York had been freed from the crevasse, and the Crag Rats helped evacuate her to the Homestead Inn on Cooper Spur Road, where she was transported to the hospital.

With their reputation firmly established, the Crag Rats would participate in two more highly publicized missions the following year. The first was the search for a lost sixteen-year-old skier named Calvin White, who left Government Camp with friends on New Year's Eve 1926. Coincidentally, that mission happened at the same time as the Mazama-led operation searching for the lost climber Leslie Brownlee.

Calvin White had been skiing with friends without proper clothing when he was separated from his group. A search began that evening, but there was no sign of White after two days. On the third day, a team of Crag Rats searching Zigzag Canyon found him cold and hungry but alive. They warmed White and gave him dry clothes and food before constructing an improvised toboggan to move him back to Government Camp. A dog team helped transport him to the Battle Axe Inn, an informal headquarters for many rescue operations during the era. Back at Government Camp, White received medical care and was reunited with his parents. He eventually lost several toes to frostbite but otherwise recovered.[106]

After finding Calvin White, several Crag Rats joined the ongoing search for Leslie Brownlee. The Crag Rats were assigned to search the area around Crater Rock, Illumination Rock and the upper Zigzag Canyon but found no trace of Brownlee.[107] During the search, four Crag Rats spent a bitterly cold night out in Paradise Park, cutting firewood in shifts to keep

Above: A team of Crag Rats begins the search for sixteen-year-old lost skier Calvin White on New Year's Day 1927. *History Museum of Hood River County.*

Opposite, top: Calvin White is reunited with his parents at the Battle Axe Inn after being rescued from Zigzag Canyon. *History Museum of Hood River County.*

Opposite, bottom: A team of Crag Rats bivouacs through a cold night in Paradise Park during the search for Leslie Brownlee, January 1927. *History Museum of Hood River County.*

warm. Unfortunately, the search was called off after a week, and Brownlee was never found.

During the 1930s, the Crag Rats continued assisting with rescues around Mount Hood and the Columbia Gorge. They focused their efforts on the mountain's north slopes but sometimes responded to missions as far away as Mount Rainier. As some of the most experienced rescuers in the Pacific Northwest, the Crag Rats were in high demand. Nevertheless, the group kept its numbers small and limited its membership to residents of Hood River County. The main requirement for membership was to have summited Mount Hood or other challenging peaks in the Cascades.

The Crag Rats attracted members from various backgrounds and professions, from loggers to doctors. Members provided their own sleeping bags, climbing gear and skis. Shortly after the club's formation, they adopted their signature black-and-white checkered wool shirts.[108] In 1931, the Crag Rats made a deal with the Forest Service to use the Tilly Jane Guard Station during the winter. The structure was built in 1924 and provided the Crag Rats with close access to Cooper Spur for rescue missions.[109]

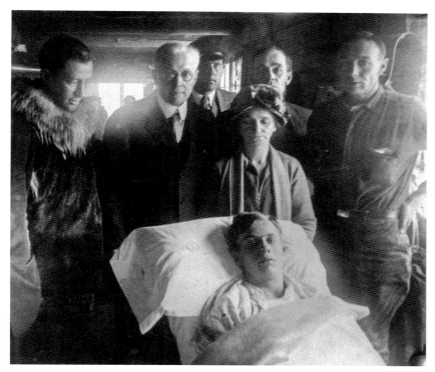

In the 1940s, the Forest Service purchased the Cloud Cap Inn on Mount Hood's northeastern flank, initially built in 1889 at an elevation of six thousand feet.[110] After the purchase, the agency allowed the structure to fall into disrepair and eventually planned to demolish it before reaching a deal with the Crag Rats. Under the agreement, the group would maintain the building in return for using it as a base for snow surveys, rescue operations and club outings. The location became an unofficial headquarters for many rescues and is still maintained by the Crag Rats today.

The Skyliners and Obsidians

The Bend Skyliners and the Obsidians of Eugene share an origin story dating to a legendary search in September 1927. Over Labor Day weekend, Guy Ferry and Henry Cramer of The Dalles set out on a climbing expedition in the Three Sisters Wilderness.[111] After allegedly scaling North Sister, the two young men met forest ranger Prince Glaze at Frog Camp and informed him of their intent to climb South Sister. But after their departure, an early-season storm brought bitter temperatures, dense fog and over a foot of snow to the mountains. When the men didn't return from their trip as planned, Glaze organized a search effort.

That search became one of Oregon's most extensive operations to date. It was led by a handful of Forest Service rangers and eventually involved over one hundred ground searchers, climbers, skiers and pilots. The mission drew teams from Eugene, Portland, Bend, Hood River and The Dalles and attracted significant media attention. For nearly two weeks, readers across Oregon followed the dramatic events in their local papers.

A search headquarters was established at Frog Camp off the McKenzie Highway. Rangers Perry South and Prince Glaze from Sisters District and Smith Taylor of McKenzie District were placed in charge of three search groups.[112] The noted Mazama climber Ray Conway helped manage operations and coordinated a fundraising effort through the Portland Ad Club.

The Bend contingent of rescuers included four of Central Oregon's best skiers and mountaineers: Nils Wulfsberg, Emil Nordeen, Nels Skjersaa and Chris Kostol. After driving to Frog Camp, the men set out on a twelve-mile cross-country journey by skis to the base of Middle Sister. They climbed both Middle and South Sisters before returning to camp without finding the young men.

Right: Forest ranger Prince Glaze near Scott Mountain. Glaze helped lead the search effort for Guy Ferry and Henry Cramer in the Three Sisters Wilderness and was later a charter member of the Obsidians. *Bowman Museum*.

Below: The founding members of the Bend Skyliners: Nels Skjersaa, Nils Wulfsberg, Emil Nordeen and Chris Kostol (*not pictured*). The men led an epic search up Middle and South Sisters looking for missing climbers Guy Ferry and Henry Cramer in September 1927. *Deschutes County Historical Society*.

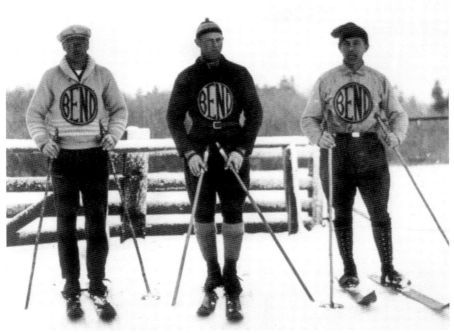

As the mission progressed, searchers endured heavy rain and snow in the mountains. Unfortunately, the operation was unsuccessful and was called off after two weeks. The bodies of Ferry and Cramer were found two years later by hikers near the Chambers Lakes, between South and Middle Sister. Although the searchers failed to find the missing climbers, the incident became the impetus for the creation of the Skyliners Ski Club.

The Bend rescuers, known as the "four musketeers of the mountains," became the founding members of the Skyliners.[113] Sadly, Nils Wulfsberg died the following year at the age of twenty-eight. Reports suggested that he suffered from a preexisting heart condition, possibly exacerbated by the demanding rescue mission. Skjersaa and Kostol went on to become the nucleus of the Skyliners' rescue squad that would serve as Central Oregon's unofficial search and rescue unit until the early 1960s.

Like the Mazamas, the Skyliners were principally an outdoor recreation club. Search and rescue were ancillary activities related to the club's role as a local ski patrol.[114] Nevertheless, the rescue squad regularly conducted training "in readiness to go into the nearby areas to aid in searches for lost

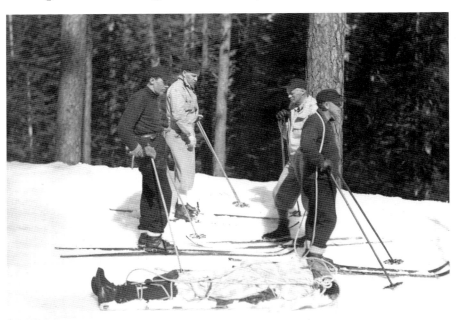

The Bend Skyliners rescue squad trains for patient transport using an early version of its rescue sled, circa 1930s. *Deschutes County Historical Society.*

persons or rescue those endangered by storm or their over-confidence in their ability to meet the perils of weather or forest or mountain."[115]

The club primarily performed winter search and rescue and didn't offer a robust, year-round capability. Nevertheless, Skyliners members participated in numerous operations during the 1930s, including a famous search for three lost Wy'east climbers on Mount Jefferson in 1933.[116]

In 1938, Skyliners member Paul Hosmer led a fundraising effort to upgrade the team's rescue equipment with a custom-made toboggan, stoves, concentrated food and medical supplies, enabling them to deploy into the mountains on short notice.[117] That same year, the Skyliners ski patrol unit became part of the National Ski Patrol system.

With the start of World War II, several of the Skyliners entered military service. Some of the club members who remained at home worked closely with the Civil Air Patrol and Forest Service to provide rescue services when needed.[118] The squad, led by Chris Kostol, had an arrangement with leaders at the Redmond Army Airfield to provide search and rescue services in the event of mishaps involving military aircraft operating around Central Oregon.[119]

After the war, the Skyliners gradually rebuilt the group's rescue program. In 1952, the club committed to providing Central Oregon with a trained year-round rescue group.[120] The team was primarily an extension of the ski patrol but was also used to search for lost parties in the mountains and locate downed aircraft.[121]

The Skyliners maintained a dedicated rescue team until the early 1960s when the club decided to refocus its efforts on sports education. When the team disbanded, several members of the rescue squad joined a new group known as Central Oregon Search and Rescue (CoSAR), formed in January 1960. CoSAR served as Central Oregon's primary search and rescue entity into the mid-1960s.[122]

The Obsidians followed a similar path as the Skyliners. Several members of an informal hiking club from Eugene had joined the 1927 search for Guy Ferry and Henry Cramer. During discussions in their tent at night, the men concluded that Eugene needed an organized group to assist in such operations.[123] The Eugene Outdoor Club was formed shortly after the search.

The following year, the club was renamed the Obsidians. Forest Ranger Prince Glaze, who helped lead the search effort for Ferry and Cramer, became a charter member of the new club. Glaze led the group's first organized outing in December 1927, taking a group of thirty-seven hikers to Castle Rock above the McKenzie River Valley.

A month after the club's formation, the Obsidians received their first call for assistance when a thirteen-year-old boy from Swiss Home was reported missing. Over three hundred searchers went into the field for the weeklong operation directed by veteran Mazama rescuer, Ray Conway.[124] Unfortunately, the boy was later found dead, fatally injured by a malfunctioning rifle. The following year brought a more gratifying ending when the Obsidians went to assist in the search for a missing female hiker lost near Siuslaw Falls west of Eugene. The young woman was found cold, hungry and tired but alive after spending two days alone in the woods.

Like the Mazamas and the Skyliners, the Obsidians were, first and foremost, an outdoor recreation club and not focused on search and rescue. However, the group maintained an informal rescue unit that responded to hundreds of calls through the late 1960s. The Obsidians evolved into one of Oregon's legendary outing and mountaineering clubs during that time. However, by the late 1960s, the increasing demand for SAR services forced the club to reevaluate its role, leading to the formation of Eugene Mountain Rescue in 1969.

Wy'east Climbers

The Wy'east Climbers were a climbing club founded in 1930, conceived during a group hike up Larch Mountain. The plan was to limit the club's membership to a small, elite group of climbers who had already proven themselves on demanding routes.[125] The name Wy'east was adopted the following year, a reference to the native name for Mount Hood used by the Multnomah tribe of the Columbia River valley.

Even though the group's active membership was never more than fifty, the Wy'east Climbers were synonymous with Oregon search and rescue through the 1950s. Its roster included legendary rescuers Curtis Ijames, Joe Leuthold, Hank Lewis, James Mount, Ray Lewis, Everett Darr and Ole Lien, among others. The club also included prominent Oregonians from other fields, such as photographers Ray Atkeson and Al Monner and Hjalmar Hvam, winner of the first U.S. Nordic combined ski championship and inventor of the safety ski binding. Several club members were later instrumental in establishing the Mount Hood Ski Patrol.

From the start, the group viewed first aid and rescue skills as inseparable from their mountaineering exploits. By 1932, the club required all members to have training in basic first aid, while many received advanced training.

Answering the Call

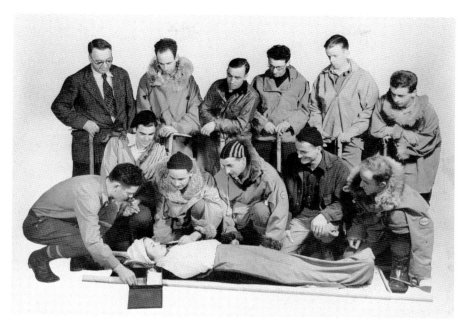

Members of the Wy'east Climbers during mandatory first aid training, 1932. The following year, Don Burkhart (*back row, second from right*) would die in a climbing accident on Mount Jefferson. Six other men in the photo would participate in the recovery effort: Al Monner, Jim Harlow, Ray Atkeson, Ralph Calkin, Curtis Ijames and Barrie James. *Oregon Historical Society.*

The following year, the club positioned a permanent cache of rescue equipment near Devil's Kitchen, east of Crater Rock and just below Mount Hood's summit. The cache included a small toboggan and gear to assist with higher-elevation evacuations.[126]

Ray Lewis was an accomplished mountaineer and the club's first rescue leader.[127] He worked intermittently for the Forest Service as a fire lookout on Mount Hood's summit during the early 1930s and was a dual member of the Mazamas.[128] Ray Lewis famously led a rescue over Labor Day weekend in 1933 involving the legendary Mount Hood guide Mark Weygandt and his son Wesley.

Weygandt was leading a group up the Sunshine route as Lewis was preparing to close the summit cabin for the season. The climbers ran into trouble at the top of Coe Glacier when three members slipped into a hidden crevasse, seriously injuring fifteen-year-old Esther Gilman of Hood River.[129] The team eventually escaped the crevasse, but Gilman had broken her leg and couldn't walk.

A rescue team searches the crevasses of Whitewater Glacier on Mount Jefferson, looking for missing climbers Don Burkhart, Davis McCamant and John Thomas, September 1933. *Oregon Historic Photo Archive.*

It was late in the day and the weather was deteriorating, so Weygandt decided it was safer to head for the summit hut to spend the night there and descend the next day. Ray Lewis was still on the summit and spotted the group as they struggled to move Gilman across the Queen's Chair area below Cathedral Ridge. With another climber, Lewis descended to the group, trailing a rope behind him, then helped them the rest of the way to the summit, arriving after dark.

Ray Lewis splinted Gilman's leg, then fed and warmed them in the hut. He radioed the Forest Service station at Summit Meadows but didn't receive a reply. The following day, Lewis led them down the mountain, moving the girl in a makeshift sled made of rope, canvas and blankets.[130] At Crater Rock, he transferred her to the Wy'east toboggan for the rest of the trip down the mountain.

The following day, Lewis returned to the summit to finish closing it for the season. Though Lewis didn't know it at the time, he would be the last person ever to staff the summit hut. Later that year, the Forest Service decided to close the fire lookout. The hut gradually fell into disrepair and finally collapsed in the mid-1940s.

While Lewis was busy rescuing the Weygandt party, to the south on Mount Jefferson, a tragedy was unfolding involving another Wy'east Climber named Don Burkhart. That weekend, Burkhart, John Thomas and Davis McCamant set out to climb a new route on Mount Jefferson's east face. At twenty-three, Burkhart was already an experienced climber and a dual member of the Mazamas. He served as the first president of the Wy'east Climbers and was a talented amateur photographer who honed his craft alongside fellow climbers Ray Atkeson and Al Monner.[131]

On Tuesday morning, after the holiday, the three men failed to show up for work in Portland. That began a massive weeklong effort to find them, involving nearly all of Oregon's search and rescue clubs. The first rescuers arrived at Jefferson Park on Wednesday morning and found the ground covered with several inches of fresh snow.[132]

Curtis Ijames of the Wy'east Climbers established a base camp at Olallie Lake next to a ranger station with a phone line connected to Portland. Meanwhile, Perlee Payton of the Mazamas led the initial ground search, having climbed on the mountain only two weeks before. As the mission continued, other teams joined the search, including the Obsidians, the Skyliners and members of the Forest Service.

Unlike rescues on Mount Hood, the area around Mount Jefferson was far more remote, with limited infrastructure and communications. The

search parties had to sustain themselves for days without support and used runners for communication between the ground teams and the base camp. By Thursday, calls went out for additional help and much-needed supplies. Workers from the Civilian Conservation Corps set up a field kitchen at the base camp to feed hungry searchers.

As the operation continued, it received significant coverage in Oregon newspapers, generating donations and additional volunteers. But given the rugged terrain and unfavorable weather conditions, only experienced mountaineers were allowed to access areas around the summit. A team of Crag Rats began searching from Jefferson Park. The Obsidians were assigned the southwest slopes above Pamelia Lake. Meanwhile, the Skyliners set out from the Metolius Valley to cover the southeast side around Waldo Glacier.[133]

On Thursday, improving weather conditions allowed a team to reach the summit via the east face. They discovered that Burkhart's group hadn't signed the summit register, suggesting that they never got to the top. On Friday, a team of veteran Wy'east Climbers, including Everett Darr, James Mount and

Forest ranger Rex Wilson leads a horse team near Olallie Lake carrying the bodies of Donald Burkhart, Davis McCamant and John Thomas. *Photograph by Ralph Vincent; Oregon Historical Society.*

Members of the Wy'east Climbers gather at the memorial cairn for Don Burkhart on Olallie Butte near Mount Jefferson, June 1934. The picture includes legendary rescuers: Hank Lewis, Everett Darr, Jim Harlow, Jim Mount, Barry James, Joe Leuthold, Bob Furrer, Ray Lewis, Ralph Calkin, Ole Lien, and Curtis Ijames. *Oregon Historic Photo Archive.*

Ralph Calkin, spotted a piece of yellow fabric near the summit pinnacle.[134] That led them to three bodies buried in the snow, still roped together.

A runner was sent to Breitenbush Lake to inform the authorities that the search was now a recovery operation. The Wy'east party, joined by several Crag Rats, began moving the bodies down the mountain by litter, arriving at Jefferson Park late that evening. Once there, Forest Ranger Rex Wilson met them with a team of packhorses to help transport the bodies to Olallie Lake.

Rescuers had found the climbers in a field of ice blocks, leading them to suspect that Burkhart and his companions were caught in an avalanche below the east face. Later that year, members of the search party returned to Olallie Butte and constructed a rock cairn in Burkhart's honor. A picture taken at the ceremony captured many of the most prominent figures from the golden age of Oregon search and rescue.

Formation of the Central Rescue Committee

The dramatic events on Mount Jefferson spurred the first effort to create a collective search and rescue enterprise among Oregon's various outings groups and climbing clubs. At the time, the Crag Rats were still the only volunteer club in the state fully dedicated to search and rescue.

In November 1933, one month after the recovery of Burkhart and his companions, John Scott of the Mazamas organized a gathering of leaders from several outdoor clubs. The purpose was to discuss how to share the burden of rescue operations.[135] Of particular concern were Mount Hood and other alpine areas in the vicinity of Portland that were seeing an increasing number of incidents. The meeting included representatives from the Portland Trails Club, the Wy'east Climbers, and the Mazamas.

The Central Rescue Committee was formed as a result of that meeting. Ray Conway of the Mazamas was selected to lead the group. By then, he was a highly regarded mountaineer and experienced rescue leader who had run several of Oregon's most extensive search operations.[136] After World War II, Conway, and fellow Mazama Lorenz Nelson would be instrumental in forming the Mountain Rescue Safety Council of Oregon (MORESCO), the first statewide entity focused on mountain search and rescue.

Since the Mazamas were the largest club of the Central Rescue Committee, they provided much of the personnel and resources when needed. However, other clubs, such as the Crag Rats and the Mount Hood Ski Patrol, became closely involved in its operations.[137] Each club was responsible for conducting

its own training and providing equipment. When missions arose, the clubs assigned personnel based on availability and the skills required. The group existed in some form until the mid-1950s, when MORESCO superseded it.

SKI PATROL'S ROLE IN SEARCH AND RESCUE

During the golden age of volunteer search and rescue, Oregon's ski patrols played a vital role in responding to missions in demanding terrain and conditions. Skiing began gaining popularity in Oregon during the 1920s, with most of the state's early ski areas, cross-country trails and lodges operating on national forest lands. As Oregon skiers took to the mountains, there was an inevitable surge of accidents, injuries and other mishaps. Because the Forest Service lacked the personnel to conduct wintertime search and rescue, much of that responsibility fell to volunteer ski patrols around the state.[138]

The Bend Skyliners was one of the first ski clubs that also served as an informal backcountry search and rescue unit.[139] The club's ski patrol had some of Oregon's top winter athletes. The original squad included Emil Nordeen, possibly the finest skier of his generation, famous for twice winning the forty-two-mile Fort Klamath–Crater Lake ski race.[140] Fellow Skyliner, Nels Skjersaa placed third in the same event. In 1938, Cliff Blann was named vice president of the Skyliner's rescue unit, the same year he won the Underdahl trophy awarded to Oregon's outstanding junior skier.[141] Blann would go on to serve as a paratrooper in the 82nd Airborne Division during World War II and later was the mountain manager at Mount Bachelor ski area for twenty-four years.

Like the Skyliners, the Obsidians of Eugene also organized a ski patrol that served as a backcountry rescue unit. The group, known as the Willamette Ski Patrol, was established in December 1938 and became affiliated with the National Ski Patrol (NSP) system.[142] The patrol eventually split into two separate entities: the Willamette Pass Ski Patrol and the Santiam Pass Ski Patrol. The Santiam patrol started in 1941 and was also part of the NSP system.[143] By 1945, the patrols had about a dozen volunteer members who assisted skiers and conducted backcountry search and rescue when needed.

A similar unit was created at Crater Lake in 1939.[144] After the park began year-round operations in the mid-1930s, there was an increasing number of emergency calls from guests recreating around the lake. The park's rangers were overwhelmed with their patrol duties and other tasks. The Crater Lake Ski Club formed a volunteer patrol to supplement the park's small

full-time staff. The patrol included men and women equipped for first aid and evacuation inside the park.[145] The patrol served for several years until it disbanded during World War II and was later reestablished in 1947.[146]

Of all Oregon's early ski patrols, the busiest unit by far was the one established on Mount Hood in 1938. Although skiing on Mount Hood had been popular since the 1920s, it exploded with the opening of Timberline Lodge and lift-serviced skiing in 1937. By 1940, as many as five thousand visitors were enjoying snow sports on Mount Hood each weekend.

When the Timberline Lodge opened, the Wy'east Climbers and the Nile River Yacht Club, a ski club, had their club cabins nearby. During busy weekends, club members witnessed scores of injured skiers on the slopes. In many cases, club members took it on themselves to help injured skiers.

Eventually, the president of the Wy'east Climbers, Everett Darr, and Barney McNabb of the Nile River Yacht Club approached Mount Hood forest supervisor A.O. Waha to ask about starting a ski patrol to deal with the rash of injuries.[147] Waha told them that the Forest Service didn't have money for a ski patrol, and only one staff member knew how to ski. But Darr and McNabb were ready with a proposal.

They suggested that the Forest Service hire longtime Wy'east Climber and Mazama Hank Lewis to organize a volunteer patrol. Lewis had been climbing around Mount Hood for years and had led numerous rescues during that time. Waha agreed to the proposal and hired Lewis as Mount Hood's first patrol chief, working for five dollars a day on weekends. By the end of the 1938 season, Lewis had organized a volunteer patrol of around fifty members. Members of the Wy'east Climbers and Mazamas represented most of the patrol's early leadership. The organizing committee included veteran rescuers James Mount, Everett Darr and Ralph Wiese.

Hank Lewis built much of the rescue gear during the first season. Later, the Forest Service supplied toboggans and first aid kits, although volunteers still had to provide their own personal equipment.[148] Patrollers communicated using Forest Service phone lines and radios and were allowed to use a government truck for moving patrollers and injured guests between Government Camp and Timberline Lodge.[149]

When the National Ski Patrol was organized, it used Mount Hood's patrol as a model for developing its rescue protocols and training standards. Patrol members received shields resembling the Forest Service emblem, with each patroller's number inscribed on the back. Mount Hood was the only ski patrol in the county permitted to use the Forest Service emblem as part of its uniform.[150]

The Mount Hood Ski Patrol poses with an early version of its rescue toboggan. The patrol was formally incorporated in March 1938, making it one of the oldest such units in the western United States. *Willamette Falls & Landings Heritage Area Coalition.*

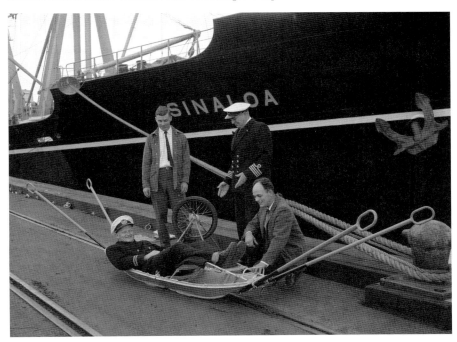

The Mount Hood Ski Patrol's first Austrian Akja sled being unloaded from SS *Sinaloa* in Portland, September 1958. The patrol eventually purchased ten Akjas, replacing their older toboggans. *Photograph by Al Monner; the Oregonian and the Oregon Historical Society.*

Wy'east Climbers member Ralph Wiese became the patrol's first chief of first aid. He helped develop the early medical kits and insisted that all patrollers become first aid certified.[151] During World War II, Wiese ran a dog-sled rescue unit in remote Newfoundland and Labrador, recovering downed Air Force crews. After the war and college at Oregon State, Wiese joined the Forest Service and became one of the agency's first avalanche science researchers while assigned at Mount Baker.[152] In 1953, he returned to Mount Hood as a ranger at Government Camp. His duties included liaising with the ski patrol and leading search and rescue operations around the mountain.

Although the Forest Service paid Lewis to run the patrol within the designated ski area, he and Wiese participated in numerous off-piste rescue missions while on duty. One of these involved the tragic recovery of climbers Roy Varney and Russell Gueffroy in March 1938.

Earlier that year, the Mazamas' climbing committee, chaired by Roy Varney, proposed a winter climb of Mount Hood's south side. Mazama members William Wood and Joe Leuthold led twenty climbers up the mountain in late March.[153] They left Timberline Lodge before sunrise, taking the summit route via the Old Chute. However, halfway up the Chute, the team encountered terrible weather and was forced to turn back. But as they descended, Roy Varney began complaining of trouble with his vision and couldn't continue. He collapsed and fell unconscious as the storm worsened. Trip leader Joe Leuthold realized that the team would have difficulty getting Varney down to Timberline Lodge and decided to ski ahead for help.

The Swiss-born Leuthold was one of Mount Hood's most skilled climbing guides and a longtime member of the Wy'east Climbers and Mazamas. He was among the original Mount Hood Ski Patrol members and during World War II served as a climbing instructor for the 10th Mountain Division.[154] After the war, he ran the Summit Ski area (now Summit Pass) and was later instrumental in the development of MORESCO.

After reaching Timberline Lodge, Leuthold tried to find a snowcat driver to retrieve Varney but was unsuccessful. By then, Leuthold was too exhausted to return up the mountain. Several climbers, still with Varney, tried to bring him down using an improvised toboggan but couldn't descend through the breakable crust. As the weather worsened, they were forced to leave Varney behind.

With the sun setting, another team went back for Varney, led by district forest ranger Harold Engles and three rescuers. Before leaving Timberline, Engles told ski patrol chief Hank Lewis to remain on duty at the lodge.

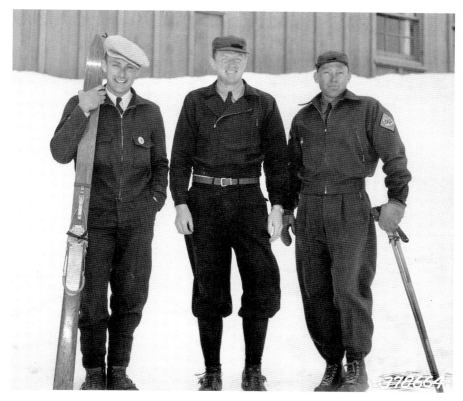

Mount Hood ski patrol chief and legendary rescuer Hank Lewis (*left*) with forest rangers Harold Engles and Max Becker outside the Timberline Lodge. All three men would lead field teams during the 1938 search for Russell Gueffroy. *U.S. Forest Service.*

However, Lewis disregarded the order and eventually caught up with the search party.

Around eight o'clock in the evening, they located Varney's body. The team used an improvised toboggan made from Lewis's specially designed skis and ice axe handles. However, due to the challenging conditions, it took four hours to descend just over a mile to Timberline. At the lodge, Ralph Wiese began a desperate effort to resuscitate Varney, but when a doctor arrived, Varney was declared dead.[155]

It appeared that the recovery mission had ended. However, the next morning, someone noticed an unattended car parked along the highway near Government Camp. A search of the vehicle revealed that it belonged to Russell Gueffroy of the Portland Trails Club, who had been helping with the Varney rescue. Gueffroy had been with the initial group trying to

bring Varney down from Crater Rock. When they decided to leave without Varney, Gueffroy continued alone, intending to ski down to his car parked near the Mazama lodge.

When Gueffroy was confirmed missing, a four-day intensive search involving hundreds of rescuers began. As search teams arrived at Timberline Lodge, Engles put ski patrol chief Hank Lewis in charge of the operation. Bad weather hampered the initial search, but a break in the storm on the third day allowed a large team to work as a human chain up the mountain from the Timberline Lodge to the Lone Fir lookout.

That effort eventually led searchers to discover Gueffroy's skis between the Sandy and Little Zigzag Canyons. Next, they found signs of footprints in the frozen crust buried under eighteen inches of fresh snow. Darkness ended the search, but it resumed the next morning as they followed the tracks deep into Sand Canyon. After several miles, the searchers located a ski pole and a backpack, then found Gueffroy's frozen body about a mile above the highway. He had a broken wrist and appeared to have stopped to rest during his descent but never got up.

After the incident, the Mazamas came under criticism for the double tragedy during their climb. One issue concerned the decision-making during the original summit attempt led by Joe Leuthold. There were also questions about Roy Varney's health before the incident and whether he should have been climbing.

The other issue concerned poor accountability during the effort to recover Varney. All rescue party members had supposedly been accounted for at the end of the first night. But somehow, they missed that Gueffroy had separated from his group and attempted to ski back to Government Camp alone.[156] In the aftermath, the Mazamas' climbing committee initiated an internal investigation under its new chairman, John Scott, and changed their climbing protocols.

Less than two months later, patrol chief Hank Lewis was asked to lead another mission, this time to recover the body of a sixteen-year-old climber named Milton Nelson from Portland, who died just below the summit ridge.[157] Hank Lewis served for two full seasons as patrol chief at Mount Hood before his job was interrupted by the attack on Pearl Harbor. He later served in Italy with the 10th Mountain Division during the war. Afterward, Lewis returned to Oregon and worked part time with ski patrol. He helped organize the Mountain Rescue and Safety Council and served as the president of the Mountain Rescue Association from 1954 to 1955.[158]

A team of Mazamas and Wy'east Climbers recover the body of Russell Gueffroy above Sand Canyon, March 1938. Days before, Gueffroy had been part of the rescue team helping recover Mazama climber Roy Varney. *William D. Hackett Collection, Mazama Library.*

Like many volunteer organizations, Mount Hood's ski patrol withered during the war. Some of its members joined the military. Those who stayed home were encouraged to work for the Forest Service, staffing lookouts and performing other duties related to civil defense. After the war, the ski patrol was reconstituted and continued training for off-piste search and rescue and response to climbing accidents on Mount Hood.[159] In 1947, the patrol became part of the Central Mountain Emergency Committee, the precursor to MORESCO, which the ski patrol joined in 1955.

The End of an Era

As the 1940s began, the United States was emerging from the depths of the Great Depression. With war raging in Europe, Americans weighed the prospect of being drawn into the conflict. The spring of 1940 saw one of the last major rescue operations before the start of the war. It began when two young climbers, Spike Hermann and Jay Lorentz, set out from Timberline Lodge with plans to summit Mount Hood on the last Sunday in March.

The pair had followed Forest Service policy by registering their climb but didn't return by nightfall. The following day, district ranger Harold Engles ordered a search. By that time, Engles was familiar with running rescue operations, having led the recovery of Roy Varney and Russell Gueffroy two years before. He was assisted in command by veteran Mazama rescuer Ray Conway.

Most clubs around Mount Hood respond to the call, including the Mazamas, the Wy'east Climbers, the Crag Rats and the Mount Hood Ski Patrol. On Monday morning, search teams assembled at Timberline Lodge and received their initial assignments. Two groups went out on skis. One team searched the Little Zigzag Canyon while another explored White River Canyon. At the same time, a group of Crag Rats began searching the mountain's north slopes.

Harold Engles and Joe Leuthold led a separate team up the mountain to check the summit register. There, they discovered that Hermann and Lorentz had made it to the top, but there was no sign of how they descended. The teams finished the day without any clues just as a major storm hit the mountain.[160]

The mission planners had to deal with considerable logistical challenges with so many teams in the field. Due to the large search area and the number of teams involved, the Forest Service set up a radio relay system, passing

Answering the Call

Rescue teams leave the Timberline Lodge searching for missing climbers Gerald Herrmann and Jay Lorentz, March 1940. *Photograph by Al Monner; The Oregonian and the Oregon Historical Society.*

messages between Silcox Hut, Little Zigzag Canyon, Timberline Lodge and Government Camp.[161] In addition to managing search operations, Ray Conway took charge of the fundraising effort to help feed and lodge the rescuers. He created an ad hoc entity called the Mount Hood Rescue Committee to help publicize the search effort in Oregon newspapers and collect contributions.

On the second day of the operation, a team led by veteran rescuer Ole Lien was searching Paradise Park when they spotted tracks in the snow. Lien insisted on following the tracks. Late in the afternoon, the team found Jay Lorentz exhausted and suffering from exposure and snow blindness. Unfortunately, they didn't have a radio to call for help. It was too late in the day to get back to Timberline, so the team spent the night in a rock shelter. The following morning, they began a challenging descent, carrying Lorentz down to Twin Bridges, where he was treated by a medical team.

When news of the rescue reached Timberline, Ray Conway redirected the search effort to focus on the area closer to where Lorentz was found. Joe Leuthold led one of the teams toward Mississippi Head through challenging

weather conditions. After seeing something unusual in the snow, the team spotted Hermann's frozen hand and ice axe sticking above the surface.

A review of the incident determined that Hermann and Lorentz became disoriented in the storm while descending from Crater Rock. They had drifted west and ended up in the cliffs above Mississippi Head when Herrmann collapsed and couldn't continue. Lorentz went ahead, hoping to reach Timberline Lodge. But after leaving his friend, Lorentz tumbled and broke his snowshoe. He wandered for almost two days before being spotted by Ole Lien's team.

That mission marked the symbolic closure of the golden age of Oregon's volunteer search and rescue. The search for Hermann and Lorentz brought together many of the leading rescuers of the day. It was particularly appropriate that Ole Lien was the hero of the operation, having been an active rescuer on Mount Hood from the start to the end of the era.

Lien first arrived at Government Camp in 1923 as a climbing protegee of Lige Coalman. He participated in dozens of missions, including the recovery of Don Burkhart's party on Mount Jefferson in 1933 and the search for Russell Gueffroy in 1938. By the time Lien retired from the Forest Service in 1960, he had been a Mazama for almost forty years, a member of the Wy'east Climbers and Mount Hood Ski Patrol. He climbed Mount Hood over four hundred times and was remembered as an exceptionally safe guide and skilled rescuer.[162]

The Start of a New Era for Search and Rescue

With America's entry into the war, most of Oregon's outdoor clubs curtailed their activities. With limited outdoor recreation, there was less need for search and rescue. Many members of the Mazamas, the Crag Rats, the Wy'east Climbers, the Skyliners, the Obsidians and Oregon's ski patrols joined military service. For those who stayed home, the government called on tens of thousands of volunteers to assist with civil defense duties.

These duties included staffing aircraft observation posts and fire lookouts and conducting coastal patrols. In collaboration with federal authorities, Oregon established an Aircraft Warning Service that comprised over five hundred observation posts operating twenty-four hours a day, seven days a week, by some twenty-eight thousand volunteers. The Forest Service had a similar program, working with the Army to place observers in remote forest posts across the state.

Despite the lack of search and rescue activity, the war would profoundly affect how SAR evolved in the decades after the conflict. Veterans returned from their military service with new experiences and training that they would apply to rebuild Oregon's search and rescue capability. The war also drew the federal government into domestic search and rescue for the first time, bringing new resources and technology that would dramatically transform how SAR functioned in the postwar era.

3

THE 1940s AND 1950s

World War II and the Birth of National SAR

The start of the war brought most outdoor recreation to a halt. Few people were camping, hunting and fishing, and many recreational facilities, such as Timberline Lodge, closed for the duration of the war.[163] Consequently, there was less demand for search and rescue as Oregonians devoted their limited leisure time to helping the war effort. But even with their ranks depleted, the state's outdoor clubs continued to meet and find different ways to serve.

The Mazamas maintained a regular schedule of hikes and climbs but also supported the war effort by volunteering with the Forest Service Reserve Program and joining work parties helping farmers during harvest time. By 1942, forty-four Mazamas were serving in uniform. The number was well over one hundred by 1944, coinciding with the club's golden anniversary.[164]

A handful of Mazamas had been recruited to serve in the 87th Mountain Infantry Regiment at Fort Lewis, Washington.[165] The unit was created early in the war by Charles "Minnie" Dole, the National Ski Patrol founder. The inspiration for creating a specialized mountain warfare unit came after American military leaders observed the brutal winter fighting conditions when the Soviet Union invaded Finland in 1939. In October 1941, General George Marshall, U.S. Army chief of staff, instructed Dole to begin recruiting soldiers for a unit to be trained and equipped for mountain warfare and operating in harsh winter conditions.[166]

Dole began recruiting soldiers using ski patrol rosters, selecting applicants based on mountaineering, rock climbing and skiing skills. The

Members of the 10th Infantry Division training at Camp Hale, Colorado. Many soldiers were recruited from ski patrol units and had to demonstrate mountaineering skills to qualify. Several notable Oregon rescuers served with the unit during World War II. *U.S. Army and the National Archives.*

87th Mountain Infantry attracted some of the best mountaineers from the Pacific Northwest, including veteran Oregon rescuers Joe Leuthold, Hank Lewis and Ralph Wiese.[167] The regiment was eventually assigned to the famed 10th Mountain Division and served with distinction during the Italian campaign of 1945.

Like the Mazamas, the Crag Rats continued to hold regular meetings while several members were away in military service. However, there were few documented rescues during the war years. Still, club members remained busy with civil defense duties such as auxiliary police, air raid wardens and as part of the state's militia force.[168]

Despite the lack of rescue activity at home, the war would dramatically transform search and rescue practices in the United States. For the first time, the federal government became actively involved in developing doctrine, technology and training for SAR activities. At the same time, the war became an important catalyst for the process of professionalization that would transform volunteer search and rescue during the 1950s. Many Oregon veterans returned from their military service with experiences and knowledge that they applied to improving the state's search and rescue operations after the war.

The Birth of American Combat Search and Rescue

When the war began, the United States was largely unprepared for the task of rescuing airmen and sailors lost at sea.[169] The Coast Guard had some experience with shore-based rescue, but its capabilities were not well adapted to the demands of operating far out in the ocean.

By the time the United States entered the war in December 1941, the British had already created an effective search and rescue capability. But that expertise had been hard-won through significant losses of aircrews over the English Channel and the North Sea during the Battle of Britain. By mid-1941, the British had developed an Air-Sea Rescue Service and a specialized training center at Blackpool, England.[170] Rather than starting from scratch, the United States borrowed many of their techniques as the military raced to establish its air-sea rescue units by 1943.

On the west coast, the U.S. Navy and Coast Guard created a unified Air-Sea Rescue Task Unit equipped with seaplanes, rescue boats and blimps under the operational control of the Western Sea Frontier command in San Francisco.[171] The unit conducted daily patrols, sometimes extending more

than one hundred miles offshore. When the Air-Sea Rescue Joint Operation Center received a notice of a missing plane or ship, it could dispatch a rescue team to the location in less than an hour. During the unit's first four months of operation in 1944, it saved more than eighty crewmembers involved in crashes along the west coast. The units rescued over three thousand airmen in the Pacific theater by the war's end.[172]

In 1944, the Coast Guard was placed in charge of the newly established Air-Sea Rescue Agency, later called the Search and Rescue Agency. The organization was tasked with analyzing data and developing technologies to improve search and rescue operations. Many of these tools would be adopted by civilian search and rescue organizations after the war. Wartime innovations included marker dye, pyrotechnic signals, cold weather exposure suits, modern life preservers, pneumatic rafts, chemical water filtration, desalinization units, survival rations, emergency medical kits and the use of aerial photography for search and rescue.

One of the more notable tools developed during the war was the "Gibson Girl" emergency transmitter, based on the design of a German rescue radio captured by the British. The American version was a ruggedized, hand-powered radio able to transmit a distress signal using Morse code.[173] It used a frequency of five hundred kHz and had a range of two hundred miles, enabling rescue crews to locate survivors of ship or aircraft incidents far out at sea. Versions of this device were used for military and civilian search and rescue through the 1970s.

The Coast Guard was instrumental in developing other technologies that transformed search and rescue in the postwar era. These included the LORAN system, which greatly improved the accuracy of long-range navigation and direction-finding during air searches.[174] The Coast Guard also led the early development of helicopters and amphibious fixed-wing aircraft designed for search and rescue. Shortly after the war, a Sikorsky R-5 helicopter performed the first-ever hoist rescue while hovering when it plucked two stranded sailors from an oil barge during a powerful storm off the Long Island Sound.[175]

One of the most underappreciated innovations of the war was the science of search theory, involving techniques for finding a person or object in a geographic area in the most efficient manner. In this case, efficiency was defined as minimizing the time required to find an object while maximizing the chances of locating it with available resources.[176]

The science of search theory was nonexistent before the war. The original impetus was not search and rescue but the detection of enemy submarines.[177]

Thus, the U.S. Navy was at the forefront of this research.[178] The French-born mathematician Bernard Koopman was the first to develop the theoretical basis for search theory while working for the U.S. Navy's Anti-Submarine Warfare Operations Research Group.[179]

During the war, Koopman authored his pioneering work *Search and Screening*, which established the mathematical basis for analyzing encounters between sensors (searchers) and moving and stationary targets. Through his research, Koopman developed the concept of detection probability. His work was classified during the war but was eventually published in the late 1950s, opening up an important new field of study within operations research.

The Coast Guard took Koopman's fundamental principles and applied them to its early peacetime search and rescue doctrine. Elements of his work informed the Coast Guard's first search and rescue manual published in 1957.[180] While Koopman's theories were embraced by maritime search and rescue practitioners, they didn't become widely used for land-based search planning until the 1970s.

The War Comes to Oregon

As the war began, fear of Japanese attacks on the coast was a significant concern for Oregonians. In June 1942, a Japanese submarine shelled Fort Stevens after mistaking the facility for a submarine base, marking the only hostile attack against a mainland military base during the entire war.[181] A few months later, a Japanese floatplane launched by catapult from a submarine dropped four improvised phosphorus bombs into the forests east of Brookings in the Siskiyou National Forest.

While these attacks had little military effect, they heightened anxiety over Oregon's vulnerability. In response, parts of the Pacific coast were declared a military theater of operations. The Coast Guard became actively involved in coastal patrols and port security, in addition to its traditional maritime safety function.[182] When the war began, the Coast Guard had fifteen stations at eight locations along the Oregon Coast, and by 1943 these bases were an important element of the Pentagon's air-sea rescue program.[183]

In December 1942, Naval Air Station Tillamook was commissioned to house K-class blimps used for coastal patrol and anti-submarine defense. The blimps were stored in two of the largest wood-frame buildings ever built, and they patrolled a five-hundred-mile stretch of coast from

Two Coast Guard members conducting a mounted beach patrol during World War II near Tahkenitch Lake, south of Florence. *Lincoln County Historical Society*.

California to the San Juan Islands.[184] The K-class blimps could remain aloft for over twenty-four hours and operated at low speeds just above the water, making them well-suited for search and rescue.[185]

A few months after the Tillamook station opened, the squadron received its first air-sea rescue mission, searching for a B-17 crew lost near Cape Lookout. The bomber had been on a training run departing from Pendleton, then flew north along the coast heading to Cape Disappointment. However, the pilot encountered dense fog on reaching the ocean, became disoriented and crashed into the southern side of Cape Lookout.

The following day, airship K-71 spotted the wreckage and directed a Coast Guard ground team to the site. Unfortunately, only one crewmember survived the crash, bombardier Willie Perez.[186] Today, a plaque on the Cape Lookout trail marks where the crash occurred and was spotted by the airship crew.

Later in the war, Tillamook Bay became the site for the first-ever demonstration of a water rescue by blimp. A naval aviator was put into the water just off the Garibaldi boat dock for the experiment. When the blimp came overhead, it lowered a breeches buoy connected to a winch. The test subject climbed into the buoy and was raised from the water into the

Above: K-Class airships in Hanger B at Naval Air Station Tillamook. During World War II, the airships were used for anti-submarine patrols, convoy escort and air-sea rescue missions. *Tillamook Air Museum.*

Left: A plane crash survivor being rescued at sea by a K-Class airship. The inflatable raft and line were dropped from a blimp hovering overhead before the subject was raised into the cockpit by winch cable. *Tillamook Air Museum.*

blimp's cabin. The experiment was a successful proof of concept; however, the method was not widely used because of the concurrent development of helicopters, which proved more versatile and practical for air-sea rescue after the war.[187]

Oregon's Civil Air Patrol and the Air SAR Program

The war would also become a catalyst in the formation of Oregon's Civil Air Patrol (CAP) and the development of its air search and rescue program. In the days after the attack on Pearl Harbor, Harry Coffey and Leo Devaney left Oregon for Washington, DC, to help establish the National Civil Air Patrol.[188] Coffey was president of the Aero Club of Portland and a driving force in promoting aeronautical training and education around the state. He would serve on the Civil Air Patrol's general planning staff at the national level during the war.

Leo Devaney had been the state's director of aeronautics and would go on to become the Oregon Wing's first commander.[189] After his return from Washington, DC, Devaney immediately began organizing squadrons around the state with units in Portland, Eugene, North Bend, La Grande, Bend, Medford, Salem, Albany, Corvallis, Klamath Falls and Roseburg. However, due to civil defense concerns, private aviation was grounded during the early months of the war, with all civilian flights restricted within 150 miles of the coast. Coffey eventually obtained a wartime exception for Oregon pilots who passed a security vetting.[190]

Oregon's Civil Air Patrol volunteers were required to complete eighty hours of initial training on military topics, communications, first aid and other skills. By the summer of 1942, around 60 members of the Oregon Wing, including 6 women, were placed on active duty outside Oregon supporting anti-submarine operations and border patrols. Meanwhile, in Oregon, the number of CAP volunteers surged to over 1,400 members.[191]

The war brought increased air traffic to Oregon's skies, given the state's location along the busy West Coast air corridors linking some of the country's largest aircraft production centers and military bases. McChord Field near Tacoma was the air defense headquarters for the Pacific Northwest and a major military training center. During the late 1940s, it would become the headquarters of the 43rd Air Rescue Squadron of the Air Rescue Service. That unit provided much of the air rescue capability in the Pacific

Northwest until the 304th Air Rescue Squadron was established at Portland International Airport in 1957.[192]

During the war, Civil Air Patrol squadrons across the nation flew some twenty-four thousand hours of search and rescue missions supporting military operations and were credited with saving hundreds of downed flyers.[193] After the war, the Oregon Wing continued to grow its SAR capabilities. Due to the region's rugged terrain, unpredictable weather and vast distances between population centers, the Pacific Northwest was considered the most challenging area for air search and rescue in the continental United States.[194]

In 1946, a new CAP squadron was established in La Grande, covering the vast area of eastern Oregon.[195] That group had over fifty private planes and pilots on-call from La Grande, Baker, Pendleton, Ontario, Lexington, and Enterprise. The following year, the Klamath Air Search and Rescue Unit (KASRU) formed independently of CAP, partnering with the Klamath Saddle Club and the sheriff's office mounted posse to assist with ground searches.[196]

In December 1951, KASRU would lead one of the most extensive air searches in Oregon to date when an Air Force C-47 disappeared somewhere over Klamath Falls on a flight from Spokane to Travis Field in California. KASRU was the first unit activated when the flight was reported missing. The search eventually involved around 150 aircraft flying search patterns along the Oregon-California border. Despite an extensive search, the plane wasn't found until June, when a hiker spotted the wreckage on the slopes of Mount Lassen. Eight crew members and passengers died in the crash.[197]

With surging interest in civil aviation after the war, Oregon authorities became concerned over the increasing number of accidents and lost planes. One notable incident occurred in August 1947 involving a Roseburg family whose private plane went down somewhere east of Bend on a trip to Spokane.[198] The pilot had not completed a flight plan, and the family was missing for eight days before state aviation authorities began a massive statewide search. The wreckage was eventually found in eastern Washington following a twenty-day search; however, none of the passengers survived.[199] The incident generated significant criticism of the state's air search and rescue system and calls for reform.[200]

After consultation with Civil Air Patrol officials, in late August 1947, the state announced a plan to create a new air search and rescue program financed by a one-dollar annual pilot's registration fee. The proposal called for a twenty-four-hour emergency number for reporting overdue flyers and

The Oregon Wing of the Civil Air Patrol operating a ground communications station during the historic Vanport flood near Portland, May–June 1948. *Civil Air Patrol National Archives and Historical Collections.*

missing planes. It would also create a search and rescue coordinating staff with a headquarters in Salem that would synchronize the efforts of various search and rescue groups around the state.[201] The Civil Air Patrol had around 120 pilots across the state able to respond within hours of notification for a missing aircraft.

Under the plan, notification of an aviation incident was sent to the Civil Aeronautics Authority (precursor to the FAA), airlines, state police, the military, the Civil Air Patrol and search and rescue entities across the state. The Forest Service pledged the cooperation of its 1,500 seasonal fire lookouts around the state. Pilots flying on search missions under the state program were volunteers but received compensation for fuel and incidental expenses. As part of the program, Oregon became the first state in the United States to provide insurance coverage for volunteer pilots and observers flying SAR missions. Lloyds of London insured each volunteer for up to $10,000.[202]

Oregon's new air search and rescue program would prove tragically prophetic. Two months after the announcement, a plane carrying Oregon's Governor Earl Snell, State Senate President Marshall Cornett and Secretary of State Robert Farrell went missing in stormy weather over rural Lake County. The group had departed Klamath Falls in the evening, flying in a privately owned Beechcraft Bonanza to Warner Valley for a hunting trip.

When the aircraft didn't arrive on time, state officials ordered a massive air search. The following day, eight private planes from the Klamath Air Search and Rescue Unit began searching. They were joined by four military aircraft from the 123rd Oregon National Guard Air Squadron in Portland and a B-17 from the 43rd Air Rescue Squadron at McCord Field.[203]

As ground teams were being organized, the air search focused on the area around Dog Lake after a ranch hand reported hearing a low-flying plane the night before. With that tip, air searchers spotted the plane's wreckage in a heavily wooded mountainous area twenty miles outside Bly. Because of the remote location, ground search parties, led by the Oregon State Police, didn't reach the crash site until the following morning.[204] When they arrived, they discovered no one had survived.

The accident killed Oregon's top three elected officials, presenting the state with an unprecedented political crisis. The following day, the speaker of the state house of representatives was sworn in as governor. Following the accident, the Oregon legislature passed a new law restricting top state officials from traveling together by air.[205]

The subsequent investigation revealed that the pilot flying Governor Snell and his companions didn't have an instrument rating. He likely lost control of the aircraft after becoming disoriented in the weather.[206] After the traumatic loss of three senior officials, the legislature quickly approved House Bill 139, formally establishing the new air SAR program under the State Board of Aeronautics. The plan was enacted in February 1948, with the rescue headquarters based in Salem.[207]

The Air SAR program divided the state into eighteen areas to facilitate search operations. Each county pledged to provide a coordinated ground unit under the direction of county sheriffs, the forest service, the state police and the highway department. However, the ground SAR aspect of the proposal was separate from the approved legislation and was only partially implemented. Later that year, the aeronautics board published its first search, rescue and air safety manual.[208] The program would remain under the state aeronautics board until it was transferred to the Oregon State Police and the Office of Emergency Management in 1994.

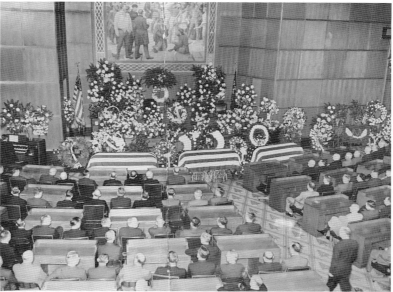

Above: An Oregon state trooper peers into the wreckage of Governor Earl Snell's fatal plane crash southwest of Dog Lake in rural Lake County, October 1947. *Below*: The caskets of Governor Snell, Secretary of State Bob Farrell and State Senate President Marshall Cornett during services on the House floor at the capitol in Salem. *The Statesman Journal and Salem Public Library.*

As Oregon's Air SAR program matured, it gained additional capabilities but still relied almost entirely on volunteers. In 1952, the Oregon aeronautics board reached an agreement between several western states and the U.S. Air Force. The plan was intended to create a unified regional search authority. Under the agreement, the Air Force had operational jurisdiction over the search for any military aircraft, with support from civilian search groups. Conversely, search operations for civilian aircraft would be led by the state aeronautics board, leveraging Civil Air Patrol assets, with the Air Force providing support as available.[209]

By the mid-1950s, Oregon's Air SAR program had seen a steady increase in its operations. In 1955, the board reported fifty-one alerts with six operational searches, four for missing aircraft and two in support of ground searches for missing persons.[210] But even as demand increased, the program was not without critics. In 1958, the aeronautics board director, Earl Snyder, became mired in controversy after a poorly coordinated search effort involving a private aircraft crash near Dayville. A California couple flying the Cessna 182 had survived the impact, but a female passenger was severely injured and trapped in the wreckage for three days while her husband walked out to find help.

Civil Air Patrol units from Bend and Hood River, joined by Air Force elements, responded to the call but were delayed by bad weather. On the third day of the search, a helicopter from the newly established 304th Air Rescue Squadron spotted the wreckage and was able to land and transport the injured woman to the hospital. However, in the days after the mission, several news reports accused the aeronautics board of mismanagement during the search effort. One major issue of concern was poor coordination among the state's Air SAR headquarters, the Civil Air Patrol and the Air Force.

Aeronautics board director Earl Snyder leveled counteraccusations against the Oregon Wing, faulting them for operational errors "bordering on the criminal."[211] Civil Air Patrol leaders called Snyder's accusations "pure nonsense" and accused him of trying to "kill the CAP program in Oregon."[212] Adding to the controversy was a strongly worded editorial in the *Bend Bulletin* criticizing the effectiveness of the Air SAR strategy. The editorial charged that the state's air search and rescue program operated on a "too little too late basis" and lacked coordination with other search assets. It claimed that most of the people rescued had been involved in observed crashes or walked themselves out to safety.[213]

In the end, Snyder was criticized for blaming Civil Air Patrol leadership for problems with the search. The incident led to a major review of the state's

air search and rescue procedures.[214] The following year, the aeronautics board formed a committee to review the state's Air SAR policy, CAP pilot qualifications, communication protocols, alert procedures and coordination between search agencies and volunteer organizations.[215]

Increasing Federal Involvement in Search and Rescue

During World War II, the Pentagon played a critical role in developing new doctrines and technologies for combat search and rescue. That precedent continued into peacetime as the federal government assumed new responsibilities as the national-level coordinator for civil search and rescue. In 1946, President Truman established the Air Coordinating Committee to advise him on issues relating to civil aviation.[216] The committee dealt with concerns such as modernizing the nation's air navigation systems and overseeing aviation safety. Its portfolio included a subcommittee tasked with overseeing the effective coordination of national resources for search and rescue.

In 1956, the SAR subcommittee released the first National Search and Rescue Plan.[217] The plan divided the country into search and rescue regions managed by federal SAR coordinators. The Coast Guard was designated as the SAR coordinator for maritime regions and the Air Force for aeronautical (inland) areas. The subcommittee also implemented the national policy for using frequency 121.5 MHz to coordinate aircraft, surface craft and ground vehicles engaged in SAR operations.

The federal government also played an essential role in developing SAR organizational structures and capabilities. This included support for expanding the Civil Air Patrol and establishing new military units with SAR capabilities, such as the 304th Air Rescue Squadron, activated in 1957 at Portland International Airport. New federally funded SAR capabilities were also being established on Oregon's coast, with Air Station Astoria opening in 1964 and Air Station North Bend a decade later. These stations came in response to a significant increase in demand for maritime SAR services on the coast in the late 1960s and early 1970s.[218]

While the federal government assumed a higher-level coordinating role for national SAR policy, most operational aspects were still managed at the local and state levels. In Oregon, volunteer organizations continued to provide the bulk of the personnel for search and rescue, but they increasingly did so

under the authority of local law enforcement. At the same time, lawmakers in Salem began passing legislation that would gradually shape how SAR entities evolved around the state.

Oregon's Volunteer SAR Organizations in the Postwar Era

For most of the war years, there was little activity for Oregon's search and rescue organizations. The Crag Rats, for example, went for several years without a single rescue call.[219] That lull ended dramatically in April 1948 when a small military plane crashed on Newton Glacier near Cooper Spur.[220] The pilot survived the crash but was injured and wandered away from the wreckage. A group of fourteen Crag Rats sprang into action and searched for several days before the pilot was spotted in Newton Canyon and retrieved by a snowcat.

The incident spurred the Crag Rats to revitalize their search and rescue program after a long wartime hiatus. They took the opportunity to reorganize formal rescue teams, develop new standard operating procedures and publish a written SAR manual. The manual was used within the club and distributed to other search and rescue teams around the Northwest.[221]

The Crag Rats wasn't the only club trying to rebuild its search and rescue capabilities after the war. The Mazamas, the Skyliners, the Wy'east Climbers and the Mount Hood Ski Patrol all resumed some aspects of their prewar search and rescue activities. The clubs welcomed returning veterans, many of whom came home with significant experience and knowledge concerning SAR operations. The Crag Rats even made an exception to their strict qualification standards, allowing some returning servicemembers to join without first satisfying the club's mountaineering requirements.[222]

The Wy'east Climbers also resumed their involvement in search and rescue after the war. Several of the club's most experienced rescuers from the "golden age" were still active members, such as Ole Lien, Joe Leuthold and Everett Darr, who had served as a civilian trainer with the 10th Mountain Division during the war. In August 1949, the three men would assist an Air Force rescue team during a technical recovery operation for the remains of a B-29 crew that crashed on Mississippi Head the previous spring.[223] The Wy'east Climbers also brought in new members after the war who would become instrumental in forming the Mountain Rescue and Safety Council

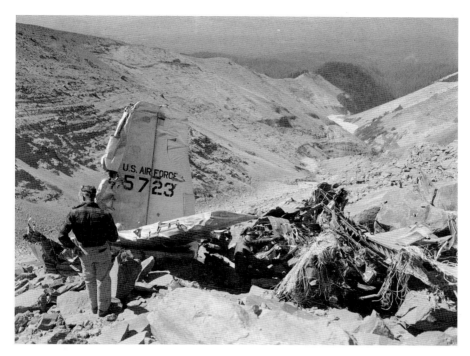

A search party from the military's air rescue service examines the wreckage of a B-26 crash near the foot of Mississippi Head, April 1949. *Oregon Historic Photo Archive.*

of Oregon (MORESCO) in 1955, including Keith Petrie, Dick Pooley and Ray Conkling.

Returning veterans played an important role in reviving the state's volunteer SAR organizations as well as starting new units, such as the Alpinees, organized in 1946. That group was founded by several Hood River men who had served together in the 10th Mountain Division: Dick Mansfield, Myron Weigant, Don Kresse and Bob Duckwall.[224] They were joined by Jack Baldwin, a combat engineer with the Seabees in the South Pacific who became the driving force in the club's formation.[225] Following in the footsteps of the Crag Rats, the Alpinees became the second volunteer club dedicated to mountain search and rescue around Mount Hood.[226]

According to the historian Jack Grauer, after returning from war, Jack Baldwin became frustrated by some of the more tradition-bound Crag Rats who refused to consider new search and rescue methods.[227] Conversely, Baldwin and his fellow Alpinees eagerly embraced the latest European rescue methods and climbing techniques and integrated these into their rescue operations.[228]

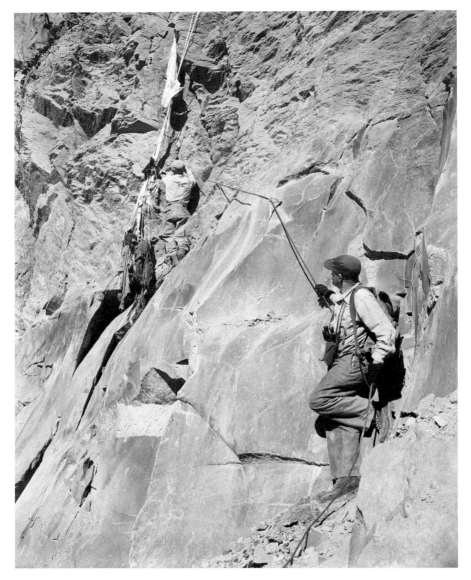

Everett Darr belays Joe Leuthold as he recovers the remains of a crew member from the B-26 crash, August 1949. *Oregon Historic Photo Archive*.

The club crafted its procedures based on a German-language mountain rescue textbook published by the Austrian Alpine Association in 1948. The text was later translated into English by founding members of the Mountain Rescue and Safety Council: Otto Trott, Wolf Bauer and Ome Daiber. The

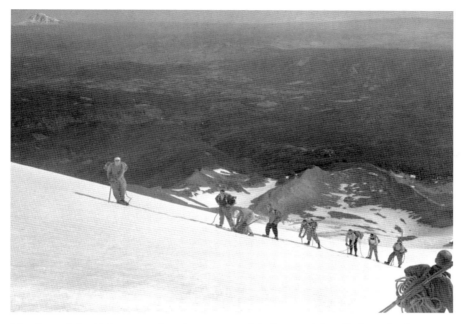

Members of the Alpinees search and rescue squad during a training climb on the Cooper Spur route above Eliot Glacier. *History Museum of Hood River County.*

manual was used extensively by other mountain rescue teams around the Pacific Northwest.[229]

The Alpinees integrated several new technologies and equipment into their rescue operations. They were one of the first SAR units in the United States to use the "trage" rescue litter. Also known as a mountain carrier, the trage was based on the design developed by Austrian mountain rescue pioneer Sebastian Mariner.[230] The device was an early prototype of the one-wheeled litter, like those used today by modern search and rescue units.

The club also developed some of its own rescue equipment. Alpinees founder Jack Baldwin was a talented engineer who invented a portable cable retrieval system used by mountain rescue groups around the northwest.[231] The system enabled a person to be raised or lowered while sitting in a bosun's chair or a litter. Alpinees teams used Baldwin's device to extricate injured subjects from crevasses or move them across fast-moving water.[232]

The group became proficient at employing aircraft and portable radios during search operations long before such methods were standard practice. They did this by partnering with the Hood River Squadron of the Civil Air Patrol. The partnership enabled the Alpinees to conduct coordinated air-

ground searches when only a few volunteer SAR teams in the county were doing such complex operations. The Alpinees also used the CAP for air-dropping supplies to ground teams during extended missions.[233]

During the 1950s, the club acquired surplus military equipment, including a rescue vehicle, radios, and litters.[234] They built a mobile radio truck for broad area searches, such as locating missing aircraft.[235] Baldwin's wife, Virginia, often operated the radio base station outside Hood River from the club's hut.[236] Starting in 1954, the Mount Hood Ski Patrol designated the Alpinees as the lead SAR group responsible for responding to emergencies on Mount Hood's north side.[237] The club was among the early members of the Mountain Rescue Council that became the basis of MORESCO.

The Alpinees remained exclusive in their membership, maintaining around one hundred active members. They generally shunned social activities in favor of training for search and rescue. The group was open to novices but required that everyone participate in training on mountaineering, first aid and search techniques. In 1959, the group became affiliated with the Mountain Rescue Association and eventually evolved into a multifunctional rescue team that included ground, ski and boat operations.[238]

Throughout the organization's history, the Alpinees worked closely with the Hood River County Sheriff's Office and frequently coordinated their efforts with the Crag Rats for missions around Mount Hood. The team was active during the late 1950s and 1960s but gradually evolved away from search and rescue into a more traditional outdoor club after founder Jack Baldwin died in 1989. As its membership dwindled, the club eventually disbanded in the early 2000s.

Formation of the Mountain Rescue Safety Council of Oregon (MORESCO)

During the early 1950s, Mazama president Robert Boden was closely involved with the Central Mountain Rescue committee, which had evolved out of the 1933 search for Don Burkhart and his companions on Mount Jefferson. But with the increasing demand for SAR services, Boden saw the need for a more robust capacity beyond the narrow scope of mountain rescue work. In 1952, he argued for creating a general search and rescue entity able to go anywhere "in the wilds or wilderness areas of Oregon."[239]

Boden's proposal was slow to materialize. However, two events in 1954 provided a catalyst that would change how SAR was being managed

around the state. The first incident occurred in early June when a group of University of Oregon students went missing during a weekend fishing trip around Badger Lake near Mount Hood. An aerial search by the Oregon National Guard spotted the men two days later.[240] Air Force rescue personnel parachuted into the area with food and water and then assisted the group back to a trailhead. However, a different team of four ground searchers went unaccounted for during the operation, necessitating a second search effort to locate the missing rescue party.

While the missing search party was eventually found, the incident led to accusations of poor coordination among military assets, the Forest Service, law enforcement and volunteer search and rescue groups. Wesley Weygandt, son of the famous Mount Hood guide Mark Weygandt, had been involved in the operation and was highly critical of the effort. He cited a lack of communication and poor centralized control as contributing factors in the embarrassing debacle.[241]

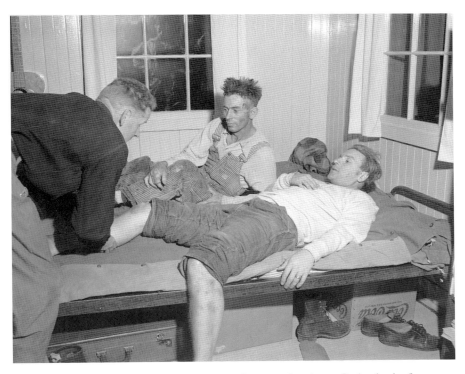

Two unidentified climbers receive medical care in a guard station at Breitenbush after being rescued from Mount Jefferson on the same weekend William Morley fell to his death, September 1954. *Photo by Al Monner. The Oregonian and the Oregon Historical Society.*

The second series of events came two months later, over Labor Day weekend, involving three separate climbing parties on Mount Jefferson. Two of the groups suffered climbing mishaps requiring medical assistance and complex evacuations. The Forest Service alerted the Central Mountain Rescue committee, which activated five Mazama members to conduct the rescues. They were assisted by a group of Seattle Mountaineers climbing in the area.[242]

The third incident that weekend involved a young climber from Portland named William Morley, who set out with a small party to summit Mount Jefferson. Somewhere near the top, Morley fell and was killed. His body was in a precarious spot on the Mill Creek Glacier, below an area of dangerous rockfall. Given the difficulty of the extraction, the Forest Service decided not to mount a recovery operation. Morley was a recent Stanford graduate and scheduled to leave for Boston the day after his death to begin law school at Harvard.[243] At the family's urging, a group of Crag Rats agreed to retrieve Morley's body.

The Crag Rats team arrived at the Detroit Ranger station several days later and established a base camp at Pamelia Lake. Although the Forest Service had declined the mission, they offered support to the Crag Rats team. Veteran rescuer Ralph Wiese, the Forest Service's liaison to the Mount Hood Ski Patrol, ran the operation for his agency.[244] The Civil Air Patrol also offered help by dropping equipment high on the mountain to help with the extraction.

The Crag Rats team was joined by William's younger brother Sam, who had been with the climbing party during the mishap. After locating the body, the Crag Rats slowly moved Morley down the glacier to Mill Creek but were forced to stop at nightfall and return to Pamelia Lake. The next day, with the help of additional rescuers, they carried Morley's body by litter to the Skyline Trail and eventually back to Pamelia Lake.

After the successful recovery operation, William Morley's family made a sizable donation to the Crag Rats as a gesture of thanks. Morley's mother had heard about the organizational challenges encountered during the previous mission at Badger Lake. Discussions with Morley's family spurred Central Mountain Rescue committee members to propose a more formal structure for managing search and rescue operations in Oregon.[245]

Although the Central Mountain Rescue committee and Emergency Rescue Group had existed in various forms since the 1930s, it lacked an organizational structure for responding effectively to the increasing number of rescues on Mount Hood and the surrounding areas. A series of meetings were held in Portland in early 1955 to discuss revamping the program.

The body of William Morley being recovered from Mount Jefferson after his fatal fall. William's brother Sam (*left*) guides the litter as the team glissades down Milk Creek glacier, September 1954. *Photograph by Al Monner. The Oregonian and the Oregon Historical Society.*

The concept was formally introduced during a Mazamas-sponsored rescue training event on Mount Hood in October 1955.

On Saturday evening after training, leaders from the Mazamas, the Wy'east Climbers and the Crag Rats gathered at the Cloud Cap Inn to discuss the matter. Before the weekend was over, they had agreed to form the Mountain Rescue and Safety Council of Oregon (MORESCO) and began developing the articles of incorporation.[246] The first board meeting was held a month later in Portland.

Dick Pooley was the driving force bringing the proposal to fruition. Pooley moved to Hood River after World War II and became a member of the Crag Rats in 1946. He joined the Mazamas in 1953 and served on the group's executive council. Pooley was an avid mountaineer who also joined the Wy'east Climbers and served on the Mount Hood Ski Patrol.[247] He later became the first president of the Mountain Rescue Association when the group was formally established in 1959 at Timberline Lodge.

Pooley helped draft MORESCO's articles of incorporation and outlined its objectives: to provide search and rescue personnel for emergencies in the mountain and wilderness areas of the Pacific Northwest; to provide training in search and rescue techniques; to acquire, maintain and provide search and rescue equipment for use in emergencies; and to conduct educational programs to promote safety and safe practices in mountain and wilderness activities.[248]

The Mazamas, the Wy'east Climbers and the Crag Rats provided most of the new organization's initial leadership and personnel. Pooley, an authority on mountain rescue techniques, was named education chairman and went on to serve several terms as MORESCO's president. Hank Lewis, the 10th Mountain Division veteran, Wy'east Climber and former chief of the Mount Hood Ski Patrol, was nominated as the rescue chairman. Jim Simmons of the Mazamas took responsibility for managing callouts using a personnel roster kept at his desk in Portland.[249]

By 1957, all MORESCO rescue team members were required to have at least a basic Red Cross first aid certification. Two years later, the requirement was upgraded to an advanced first aid card. The group instituted a policy of operational reviews after each mission, sometimes involving input from their subjects. Its membership roster eventually included organizations from around the state: the Trails Club, the Red Cross, the Alpinees, the Oregon Highway Patrol and the Highway Commission, Cascade Ski Club, the Forest Service and Explorer Scout troops.

It wasn't long before the new organization was alerted of a major climbing accident on Mount Hood involving a group of nineteen teenagers visiting from the Midwest. A young guide from Portland led the group on a single rope as they descended through the Chute on the south side route. One climber fell and dragged the entire party past Crater Rock into a crevasse.[250]

A nearby group witnessed the fall and went to help. When they reached the party, they discovered one woman dead and several others seriously injured. Only a few could walk. Forest rangers at Timberline Lodge began organizing the rescue effort. Meanwhile, two MORESCO members who were having dinner at Government Camp heard about the accident and called for additional help.[251]

As night fell, MORESCO rescuers began assembling at Timberline Lodge, with around ninety personnel responding to the call. This included an Air Force medical team, Coast Guard helicopters and additional rescuers from other teams. During the night, rescuers brought thirteen patients down the mountain in stretchers, including the deceased climber. The Air Force

Crag Rats loading a snowcat at Mount Hood Meadows during a search operation, mid-1960s. The rescuers include Bob Sheppard, Keith Petrie and Rob Hukari. *Photo by David Falconer; History Museum of Hood River County.*

set up a triage station at Silcox Hut, with Timberline Lodge serving as a makeshift clinic until the injured could be evacuated to Portland.

The tragic incident proved the importance of having a coordinated search and rescue response among various volunteer entities, medical units, law enforcement and government agencies. By the late 1950s, MORESCO held annual training events involving SAR agencies, law enforcement and volunteer rescue groups across the state.[252] Over the next two decades, MORESCO and its member units responded to hundreds of calls around Oregon.

After MORESCO's formation, there was a similar push to improve collaboration between mountain rescue activities in Oregon and Washington. A meeting was held in November 1958 in Olympia, Washington, to discuss the idea. Dick Pooley and John Arens of the Crag Rats represented the Oregon contingent. Washington's representatives included legendary climbers Ome Daiber and Dr. Otto Trott of Seattle Mountain Rescue.

Many considered Daiber the "father of mountain rescue" in the United States. By the 1930s, he was well known in the Northwest climbing community. In 1935, Daiber made the first ascent of Liberty Ridge on Mount Rainier

along with Will Borrow and Arnold Campbell. During World War II, he served as the 10th Mountain Division advisor. In 1948, when Wolf Bauer formed the Seattle Mountain Rescue Council, Daiber became the group's rescue leader, while Otto Trott served as its medical advisor.

The 1958 meeting in Olympia laid the groundwork for another session the following summer at Timberline Lodge, where they formally established the Mountain Rescue Association (MRA). The meeting included the Mount Hood rescue groups and newer units from Portland, Corvallis and Salem.[253] Law enforcement representatives and a large contingent of Explorer Scouts also attended the meeting.

Unlike MORESCO, the MRA was not created to run SAR operations. That authority would remain with the local teams and law enforcement. Instead, the organization focused on coordination, training and education. An important goal was creating performance standards for mountain rescue while disseminating information about rescue techniques, equipment, safety and training. At the first meeting, Dick Pooley was elected president. Eleven rescue teams from Washington and Oregon signed the original bylaws.

In 1961, the MRA published its first code of rescue responsibility, reflecting how search and rescue management was evolving in the postwar era. The document stated that "responsibility for a rescue cannot be assumed by volunteers. The responsibility can only be delegated by a political body such as a federal, state, county, or city government....These agencies are responsible to their political bodies for the success or failure of every rescue operation."[254]

The code was equally clear about establishing standards for volunteer SAR organizations. It noted that volunteer groups had to prove they were assets and not liabilities during rescue operations. That meant building well-organized teams with qualified personnel, rigorous training and appropriate equipment. Specialized medical training was considered a must for all rescue team members.

Of note, the initial MRA rescue code recommended that units remain independent organizations, not directly affiliated with, or under the control of, a responsible agency. Instead, it suggested that rescue groups work closely with local authorities but remain organizationally independent, making their own "decisions as to where to operate, without being hampered by county or state lines."[255]

That guidance would become relevant as two types of SAR units emerged within Oregon's search and rescue community. One model

followed the MRA guidance, with SAR groups operating as independent entities, separate and distinct from the bureaucratic structure of the responsible agency. A second path saw volunteer SAR units operating directly under the authority of a county sheriff's office, making them eligible for funding but also limiting their autonomy. Both organizational models became essential parts of Oregon's SAR community as they evolved through the 1960s and 1970s.

4

THE 1960s AND 1970s

Outdoor Recreation and Growing Demand for SAR Services

The 1960s saw a steady increase in demand for search and rescue as more and more Oregonians began recreating outdoors. Consequently, some of the traditional outdoor clubs that had provided SAR services from the 1920s through the 1950s could no longer sustain their commitment. Groups like the Mazamas, the Skyliners and the Obsidians began stepping back from search and rescue work as more specialized volunteer groups emerged.

The gradual development of dedicated SAR groups accelerated the process of professionalization that began in the postwar period. Part of this process involved volunteer groups training for more technical operations. Many SAR teams during this era began developing specialized units such as swiftwater, mountain rescue, dive teams, K-9 and communications. However, such developments were happening at different speeds across the state.

Counties with larger populations and budgets tended to have the most well-resourced SAR units that were able to respond to a wide range of mission types. But smaller, more rural communities often lacked the volunteers and resources to respond when needed. This situation led to calls for more state involvement in search and rescue, as well as discussions about state funding and developing common standards for volunteers.

During this growth period in the 1960s, two types of SAR organizations emerged in Oregon. The first type was the independent SAR organization that cooperated with law enforcement but was not directly affiliated with a responsible agency. Such organizations were free to establish their own bylaws and membership requirements but didn't receive government funding.

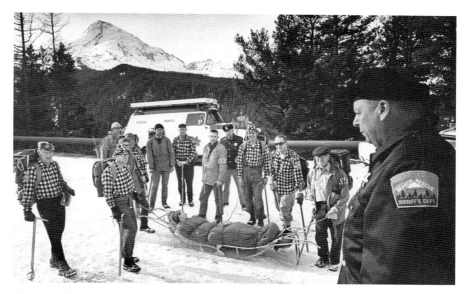

Crag Rats during a training exercise in the mid-1960s, joined by a SAR deputy from the Hood River County Sheriff's Office. *John Arens Collection, History Museum of Hood River County.*

A second model involved organizations working directly under the authority and supervision of county sheriffs. These organizations operated with certain restrictions but could often access more resources and capabilities. Each model had advantages and disadvantages, and both would remain part of Oregon's search and rescue community as it evolved into the modern era.

New Search and Rescue Units at the County Level

Deschutes County Search and Rescue offers one example of how these different organizational structures evolved during the 1960s. The Skyliners ski club had served as Central Oregon's de facto search and rescue unit from the late 1920s through the 1950s. However, by the late 1950s, the Skyliners had decided to refocus their activities on sports education and step back from their search and rescue role. In its place, a separate volunteer organization emerged in the early 1960s to fill the need for a dedicated multipurpose search and rescue capability.

The new group was known as Central Oregon Search and Rescue (CoSAR). Around fifty people attended the first organizational session in

January 1960, held at the Bend Municipal Airport. Participants included members of the Deschutes Civil Defense group, the sheriff's office, the Forest Service, Skyliners ski patrollers, the High Desert Skin Divers club and a local Jeep club.[256]

The manager of the Bend Municipal Airport organized the meeting and called for "skiers, hikers, mountaineers, and airmen" to join the new group.[257] Eventually, CoSAR included ten affiliated organizations, each providing its own personnel and equipment. While these independent groups cooperated with the county sheriff's office, they were not directly under its control and did not receive government funding.

CoSAR's first missions came just weeks after the group's formation when an off-duty forester was severely injured during a winter camping trip near Lava Camp Lake, west of Sisters.[258] He couldn't walk after cutting his foot with an axe and lost a great deal of blood. His companion, Lorena Shinn, was an experienced alpinist and Obsidian member. She provided first aid to stop the bleeding and made a hasty shelter where they spent the night as a major storm hit the Cascades.

The following day, Shinn skied ten miles back to Sisters to alert the authorities, arriving late in the day. Due to darkness and blizzard conditions, the rescue team waited until the next morning to deploy. The following day, the team reached the injured man using a snow tractor owned by the state game department and evacuated him back to Sisters. The rescuers credited Shinn's actions with saving the man's life.[259]

Days later, CoSAR was called out again to search for a family reported missing after not returning from a trip to Benjamin Lake in the high desert southeast of Bend. This time, CoSAR volunteers used a plane to conduct a route search over the area and spotted the family's vehicle stuck in the mud. The aircraft alerted Forest Service rangers, who brought the family back to safety.[260]

During CoSAR's first year, it performed over a dozen missions involving fourteen people while responding to six additional callouts.[261] CoSAR continued as an informal coalition of volunteers through the early 1960s. However, it wasn't well organized to meet the growing demand for SAR services in Central Oregon.[262] That left Deschutes County without a dedicated SAR unit by the end of the 1960s. Around that time, the county sheriff had to request assistance from units in the Willamette Valley for several calls in Deschutes County.

The issue came to a head in 1970 when a private helicopter was used to rescue an injured hiker from Broken Top in the Three Sisters Wilderness,

violating Forest Service prohibitions against motorized vehicles operating in a wilderness area.[263] The combination of these incidents finally led Deputy Sheriff Chris Williams to call for a dedicated SAR team for Deschutes County. Williams vented his frustration in the local paper, noting that when SAR was needed in Central Oregon, "there was no one to take command, no organized group to function automatically, no specifically trained volunteers."[264]

In July 1970, the Deschutes County Commissioners, the sheriff's office and the Department of Emergency Services called a meeting to discuss establishing a formal SAR group under the sheriff's office. Deputy Williams called on the local jeep, equestrian and snowmobile clubs to the first organizational meeting. This led to the formation of Deschutes County Search and Rescue in September 1970.

By organizing under the authority of the sheriff's office, the group gained access to supplies, funding and equipment previously unavailable to the unaffiliated volunteer groups under CoSAR. Williams obtained $60,000 in surplus military equipment from the federal government to build the team's initial capabilities. That included six jeeps, four all-terrain vehicles, a one-hundred-kilowatt generator, a mobile command truck and a field kitchen unit.

In addition to funding and equipment, the new organizational structure had other advantages. The county could request state support for air operations through the sheriff's office, including reimbursement for aviation fuel and accident insurance for pilots and air observers. The sheriff could also ask for help from the Air National Guard and the 304th Rescue Squadron through the Department of Emergency Services in Salem.[265] Previously, the unaffiliated volunteer SAR organizations under CoSAR couldn't coordinate such resources independently.

In many respects, the structure that developed in Deschutes County during the early 1970s became the model for how affiliated SAR units would organize after 1975 when the state legislature mandated a SAR capability in each county. However, other counties continued to rely on cooperation with independent organizations for their SAR capability. Lane County was one such example.

Lane County's SAR unit began in the late 1950s under the auspices of the Lane County Disaster Unit. Several Oregon communities had developed similar "disaster units" during the 1950s and 1960s, which began from the state's Civil Defense organizations during World War II. They included Douglas, Lake, Klamath and Jackson Counties. Those groups primarily

conducted disaster response for incidents such as floods and fires but also performed limited search and rescue functions.

Lane County's Disaster Unit fell under the sheriff's department and was funded by the county.[266] It included a uniformed dive team for water rescue and worked closely with several unaffiliated volunteer SAR organizations, including the Obsidians, the Civil Air Patrol, Explorer Post 178 and the sheriff's mounted posse.[267]

Benton County was another example of an unaffiliated model that depended on several independent groups providing specialized capabilities. That unit began with the Mary's Peak Four Wheel Search and Rescue Team, organized in 1972.[268] The county also partnered with the Civil Air Patrol, Explorer Post 170 and the mounted posse. The reorganized Corvallis Mountain Rescue Unit would affiliate with Benton County SAR in 1975. However, unlike Deschutes County, Benton County's units remained independent organizations, not directly under the sheriff's office.

Around Oregon, other counties began standing up SAR units during this period. In Central Oregon, Jefferson County established its SAR unit in 1961 after a group of Good Samaritans helped locate a five-year-old boy who was lost for several days in Cove Palisades State Park.[269] Within two years, Jefferson County's SAR unit had almost sixty members and had participated in a dozen operations.[270] Around the same time, a Crook County unit formed, starting with a mounted posse before it became a multifunctional SAR unit under the sheriff's office.[271] Volunteers in Pendleton and Burns started similar SAR units in 1971.[272]

Coos County search and rescue began in 1974 as a volunteer nonprofit corporation that was a hybrid between an affiliated and a nonaffiliated model. The collective group was organized under a search and rescue committee or SARCOM.[273] That entity was a liaison between the sheriff's office and eight other independent entities, including four-wheeler groups, a radio club, a mounted posse and Explorer Post 554. However, it would eventually transition to an affiliated SAR organization under the Coos County Sheriff's Office.

Many county-level SAR organizations came about after tragedies that demonstrated the need for a local search and rescue capacity. One such incident occurred in November 1965 in the Wallowa Mountains when a Corvallis hunter named Roy Barbour went missing, leading to one of eastern Oregon's most extensive SAR operations up to that time.[274]

Barbour, a research chemist at Oregon State University, was separated from his hunting partner during a snowstorm in the mountains east of

Cove. When his companions couldn't find him, the outfitter who had brought them into the backcountry contacted the Union County sheriff for help.[275] The sheriff informed them that the county didn't have funding to mount an air search effort and suggested that the outfitter hire a private helicopter to find their client. At the time, Union County had only $200 allocated annually for search and rescue, which was already spent for that year, according to the sheriff.

The following day, the outfitter hired a private helicopter and a small plane after the pilots agreed to charge them only for fuel and operational expenses. Eventually, the search effort included more than one hundred of Barbour's friends from Corvallis and Portland and volunteers from neighboring counties. The Forest Service took command of the operation. However, observers reported that the search effort was beset by confusion, miscommunication and a lack of resources.

In early December, searchers found Barbour's body several miles from a cliff band where he had likely fallen. An investigation revealed that he had walked for a time, injured and cold, before lying down and dying from exposure. His death probably happened long before the search began, but that was beside the point. The outfitter had paid thousands of dollars for the helicopter, supplies and other equipment used in the search and was forced to ask for donations to help cover their expenses. The mismanagement of the search effort opened a serious debate about how the state was running its search and rescue operations.

An investigation by the *Corvallis Gazette-Times* gave a scathing review of the operation and criticized the state's apparatus for managing search and rescue. The paper insisted that every county in Oregon needed a SAR capability led by someone with the legal authority to coordinate SAR activities among federal, state and local agencies. It urged each county to appoint a SAR coordinator and develop plans for utilizing volunteer organizations and other special resources. Finally, the newspaper recommended the establishment of a state search and rescue fund to help support SAR activities in rural areas without sufficient resources.

Many of the recommendations offered in the editorial would be similar to what emerged a decade later when legislators in Salem finally took up the issue of search and rescue. In the aftermath of the incident, the paper noted that if the state committed to its search and rescue program, "Oregon could well take its place as a leader in this field," ensuring that Roy Barbour's death was not in vain.

Explorer Search and Rescue

A unique element of Oregon's search and rescue history came about during the same period as new county-level SAR entities were being established around the state. The Explorer Search and Rescue (ESAR) program was created in the mid-1950s by the Boy Scouts of America and began in the Pacific Northwest around King County, Washington. The teams originated as regular Boy Scouts troops who started training for wilderness search and rescue.

Early explorer units trained much like other SAR organizations, focusing on wilderness survival, navigation and first aid skills. They included advanced training in search techniques such as tracking, grid search and various types of rescue skills. A 1961 profile of the Explorer program in *Boy's Life* magazine described their missions as "just plain, hard, laborious brush monkey work—beating the brush for lost hunters, fishermen, and hikers."[276]

Youth participants received training in leadership skills, incident command procedures and radio communications. As with other search and rescue entities, ESAR units typically operated under the authority of local law enforcement agencies and a designated incident commander.

Several ESAR units were established in Oregon during the late 1950s and early 1960s. One of the first units in the Pacific Northwest was Explorer Post

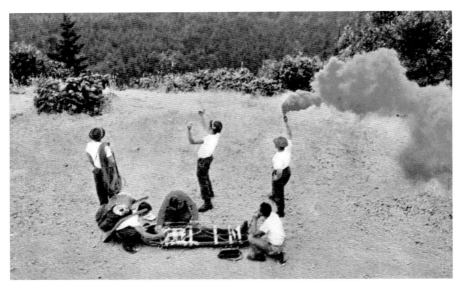

An Oregon ESAR team prepares a landing zone to evacuate an injured hiker during a training exercise. *Photo by Stan Meseroll,* Boy's Life *Magazine.*

A training event for Boy Scout Explorer Post 631 of Portland, circa early 1960s. As one of oldest continually operating teams in the region, Post 631 eventually evolved into the Multnomah County Sheriff's Office Search and Rescue. *Photos courtesy of Jake Keller and MCSOSAR.*

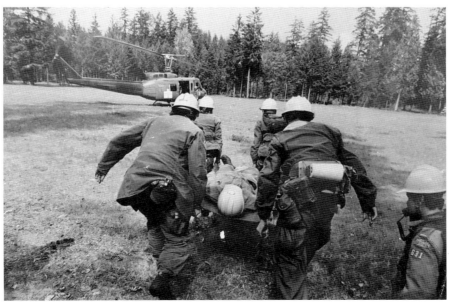

18, started in Salem by Bill McVay during the mid-1950s. McVay realized the need for such an organization after participating in a poorly organized search for a family that had died in Tillamook State Forest.[277]

Explorer Post 18 drew members from Marion and Polk Counties. Recruits attended a nine-month training course assisted by the Oregon State Board of Forestry and the State Police.[278] The training course included six to eight "field trips" and one practice search mission before a new member was considered fully qualified. Post 18 eventually became a member of the Mountain Rescue Safety Council of Oregon (MORESCO) and, by the end of the 1960s, had conducted over sixty missions.[279]

Several other ESAR units began around the same time. Explorer Post 21 was established in Bend in 1962 and participated in missions with the CoSAR unit.[280] Explorer Post 178 was formed the same year with members from Eugene, Springfield and Pleasant Hill.[281] In 1966, the Benton County Sheriff's Office sponsored Explorer Post 170 and used them to assist with ground search efforts.[282] In 1971, the Linn County Sheriff's Mounted Posse sponsored Explorer Post 64, based out of Albany, and modeled after the successful programs in Salem and Eugene.[283] In 1973, Coos County established its Explorer Post 554.[284]

Several existing SAR organizations trace their origins to the ESAR program. Boy Scout Explorer Troop 631 began in 1944 in Portland, organized by parents and students at David Douglas High School. In 1960, the troop volunteered to help with a search for a lost boy near the Bear Paw Forest Camp on Mount Hood.[285] Shortly after that search, the troop became an ESAR unit and joined MORESCO in 1965.

For many years, Troop 631 served as an unaffiliated SAR team working in the tri-county area and in the late 1970s began sharing a facility with the Multnomah County Sheriff's Office.[286] By the early 2000s, the troop had formally separated from the Boy Scouts and became an independent nonprofit SAR team operating under the Multnomah County Sheriff's Office. Washington County Search and Rescue followed a similar path, first organizing in 1966 as Explorer Post 877 in Hillsboro.[287]

Tragedy Spurs Adoption of New Technology

A reality of search and rescue is that progress often comes in the aftermath of tragedy. One famous search in southern Oregon during the spring of 1967 fell into this category. It began in early March when pilot Alvin Oien

left Portland with his wife, Phyllis, and fifteen-year-old stepdaughter, Carla Corbus. They were bound for San Francisco and flying in the family's single-engine Cessna 195.

During the week prior, icing conditions had been reported across southern Oregon. The day before their trip, a Fairchild F-27, operated by West Coast Airlines and bound for Medford, crashed after taking off from Klamath Falls. The plane struck Stukel Mountain, six miles from the airport, killing three crew members and a passenger.[288] Heavy snow made for a challenging recovery operation, and several rescuers were hospitalized for exposure after the mission.[289]

The day after the crash in Klamath Falls, Alvin Oien took off from Beaverton airport in overcast conditions. He made radio contact with controllers over Medford, but the plane never arrived in Oakland. The Oakland flight center sent an alert to the 41st Rescue Squadron at Hamilton Air Force Base, the unit responsible for coordinating air search and rescue along the West Coast.[290] That alert initiated a massive two-week search focused on the planned flight path south of Medford.

Rugged terrain and a powerful storm system hampered the initial operation. One tool the searchers lacked was a "crash-locator beacon," also known as an emergency locator transmitter (ELT). At the time, the technology wasn't required for general aviation. Thus, the only clues that searchers had were the flight plan and the plane's last known position over Medford. Although searchers were unaware, Oien and his family had survived the crash, injured but alive. However, their location was far south of the Oregon border in the Trinity Mountains of California.

After receiving word of the missing plane, Oien's son Alvin Jr. joined the search. Alvin Jr. was a Reed College graduate who learned to fly in the Oregon National Guard before joining the Air Force. After his active-duty service, Alvin Jr. became a pilot with Delta Airlines. He continued serving as a reservist with the 304th Rescue Squadron, where he flew the unit's SA-16 Albatross, a specially designed amphibious SAR aircraft built to land in the open ocean for water rescues.[291]

The 41st Air Rescue Squadron searched for several days during the initial response before standing down and turning operations over to the Civil Air Patrol. With his strong connections in the Oregon SAR community, Alvin Jr. convinced leaders in the Oregon Air Guard to extend their search beyond what the 41st Air Rescue Squadron could offer. For two weeks, the Oregon Air Guard and CAP crews conducted over 350 sorties, primarily focused on areas south of Medford while ground teams followed up on

Alvin Oien Jr. piloting his SA-16 Albatross over Mount Hood while assigned to the 304th Rescue Squadron. Alvin would spend months searching for his father's lost plane during the spring and summer of 1967. *Photograph by Dr. William Dugan; Courtesy of Carol Oien.*

potential clues, but nothing was found.[292] Toward the end of March, state authorities officially called off the search. However, Phyllis and Carla were just beginning an ordeal that would last another forty days.[293]

The plane had crashed at an elevation of nearly five thousand feet, leaving everyone inside injured. The family sheltered in the wrecked cockpit, providing some protection from the elements, but the ground outside was covered by deep snow. After several days, their limited supply of food was exhausted. On the fifth day, Alvin Sr. left to find help and never returned. Phyllis and fifteen-year-old Carla survived eight weeks of waiting for a rescue that never arrived. On April 30, nearing the end, Carla wrote in her diary, "This is my 16th birthday. I hope you are happy, Search and Rescue. You haven't found us yet."[294]

Alvin Jr. continued searching for months after the official operation ended. Some of his search patterns took him within miles of where hunters eventually found the plane's wreckage the following October.[295] Inside the cockpit, they discovered Carla's diary describing how she and her mother survived almost two months. Her entries contained mentions of hearing aircraft overhead, sustaining hope that they would be found.

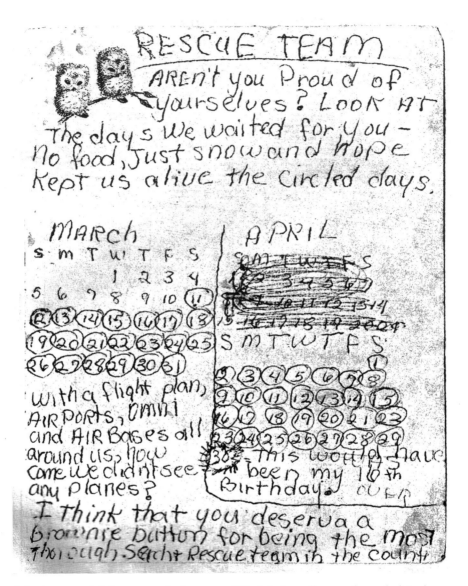

A final message left for rescuers in the pages of Carla's diary, discovered months later in the plane's wreckage. Excerpts from her diary were read aloud during congressional debate in Washington DC concerning a bill mandating the use of emergency locator transmitters (ELT) in civilian aircraft. *Courtesy of Carol Oien.*

Other entries revealed fear and frustration, wondering why rescue teams had not located the plane.

After the wreckage and Carla's diary were discovered, the event gained worldwide attention. In the aftermath, Alvin Jr. publicly criticized aspects of the search operation, but Oregon SAR officials defended their efforts.[296] The tragedy came at a critical moment as Congress debated a proposal mandating ELTs in civilian aircraft. Senator Pete Dominick of Colorado used excerpts from Carla's diary in his fight for the bill on the Senate floor, which President Nixon signed into law in late 1970.

The crash occurred along a busy air corridor where hundreds of commercial planes flew each week. At the time of the incident, several companies were developing a civilian version of the beacons already used by military aircraft. Although CAP patrols never spotted the aircraft, experts on the new technology insisted that searchers would have quickly located the plane if it had been carrying such a device, given that the crash site was only eight miles from the busy California State Route 299.[297]

Lawmakers in Salem Consider Legislative Changes for Search and Rescue

By the end of the 1960s, there was a growing disconnect between the rising demand for SAR services and the lack of support for SAR at the state level. By 1970, there were over two hundred incidents each year in Oregon of lost or injured persons requiring a response by search and rescue volunteers. That number was growing every year. In response, Oregon governor Tom McCall took up the issue and vowed that "action must be taken now to make search and rescue operations more prompt and effective."[298]

In 1971, McCall gave the State Emergency Services Division new powers under an executive order to help local authorities create or expand existing search and rescue units. The plan created a new state-level SAR headquarters to help local sheriffs coordinate mutual assistance and request military and national guard support. The order tasked the Emergency Services Division to begin collecting and analyzing data on all search and rescue missions conducted around the state, a task not previously mandated.

The governor's plan didn't remove any responsibility for managing SAR incidents from local law enforcement. Nor did it affect existing units, such as the mountain rescue teams operating under MORESCO. Instead, the executive order was meant to streamline coordination and enable county

sheriffs to request specialized SAR assets when needed. These assets included trackers, a dive team, snowmobile teams, several aircraft and boats for use on the Willamette and Columbia Rivers.[299]

Another critical initiative that helped professionalize Oregon SAR came two years later from the Oregon State Sheriffs' Association (OSSA). In 1973, the OSSA approved the first plan establishing standardized qualifications for all search and rescue personnel across the state.[300] The initial requirements included training on basic first aid, navigation, communications and survival techniques. Under the proposal, individuals not certified by a county-level responsible authority could not participate in SAR operations.

The statewide certification program was intended to ensure that there would be no concerns about qualifications when a SAR member was sent to a different county to assist with an operation. Benton County was closely involved in the plan's development and was the first county in the state to have all its volunteer members certified under the new standard.

The changes begun by Governor McCall and the OSSA represented an important step in the continuing professionalization of the state's SAR apparatus. But at that time, none of the measures were enshrined in Oregon law. Nevertheless, they would soon provide the basis for the most significant piece of SAR-related legislation to come out of Salem since the air search and rescue program was established in 1948.

In 1975, Senate Bill 996 would formally recognize the authority of local law enforcement over Oregon's search and rescue operations.[301] The new law stipulated that each Oregon county's sheriff was responsible for search and rescue activities within their jurisdiction. It outlined specific functions to be performed by the state SAR coordinator and tasked the Emergency Services Division with coordinating state and federal agencies supporting ground search and rescue.

According to the new legislation, the Emergency Services Division would coordinate and process requests for the use of search and rescue volunteers and equipment; gather statistics and reporting on statewide search and rescue operations; and centralize information on personnel, equipment and materials available for search and rescue.

Before 1975, Oregon search and rescue had operated primarily through informal practices that varied greatly from county to county. Involvement at the state level was generally limited. This created a wide disparity in SAR resources and capabilities from county to county. The 1975 law was an essential first step in modernizing Oregon's SAR enterprise and establishing standardized rules and practices among the state's many search

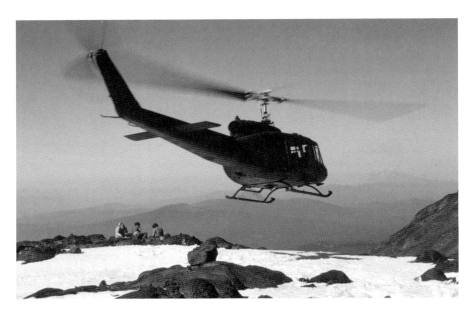

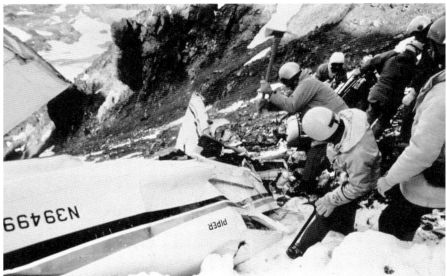

Above: Oregon Air Guard helicopter shuttling Eugene Mountain Rescue personnel to a landing zone between Collier and Hayden Glaciers after a plane crash on North Sister, September 1978. *Below*: The recovery operation involved extracting four fatalities then airlifting wreckage off the mountain. *Photos courtesy of Jim Blanchard.*

and rescue entities. The legislation also established a more prominent role for state authorities in overseeing the training, equipping and organization of volunteer search and rescue units.

Despite the significant step forward, the legislation didn't offer any solution to the challenge of funding shortfalls as mission requirements increased. Between 1971 and 1975, the number of SAR missions across the state increased by approximately 25 percent each year.[302] In 1975, the state reported a record number of 412 missions.[303] The following year, that number jumped up to over 550.[304]

Even though unpaid volunteers completed most of the missions, their equipment and operational costs still amounted to around $750,000 annually across the state. At the time, most SAR funding came from the fundraising effort of individual units rather than government sources. For example, Marion County's Explorer Post 18 was spending around $1,200 per year to maintain over $10,000 worth of SAR equipment. Most of those funds were donated by county residents with no reimbursement from the state.[305]

At the time, the state's SAR coordinator noted that with the increasing operational requirements, "volunteers are becoming very hard-pressed, as are counties."[306] Some counties, particularly in rural parts of the state, had limited budgets for search and rescue. Meanwhile, many volunteer SAR units needed extra help to fund their training and equipment.[307]

In 1977, the legislature considered two bills that would have allocated money from the state's general fund to support county search and rescue operations.[308] The state's SAR coordinator and the Oregon State Sheriffs' Association strongly supported the bills.[309] The OSSA lobbied for $400,000 to be appropriated semiannually from the general fund to support county search and rescue. However, neither measure passed.

As lawmakers in Salem debated the issue, an editorial in the *Medford Mail Tribune* reflected on the complexities of Oregon's funding scheme for search and rescue.[310] The editorial noted that the state's aeronautics board maintained a search and rescue fund paid for by aviation gasoline taxes and registration fees. Meanwhile, the Coast Guard and 304th Rescue Squadron were subsidized by the federal government, as were SAR operations conducted by the Forest Service and the National Park Service at Crater Lake. Civil Air Patrol received funding and support from the Air Force. Highway funds paid for Oregon state police contributions to SAR operations. However, the county level, where most SAR operations were conducted, had the least access to funding, particularly in the state's less populated rural counties.

Changes for Oregon's Mountain Rescue Community

The 1970s also brought about a significant organizational change for the state's mountain rescue community, notably the end of the Mountain Rescue and Safety Council of Oregon (MORESCO). The group had formed in 1955 after William Morley's recovery on Mount Jefferson. However, by the mid-1970s, MORESCO was no longer functioning as an effective coordinating body for teams around the state.

Although MORESCO was still responding to dozens of calls a year, most of these missions were focused on Mount Hood.[311] But MORESCO also had chapters in Corvallis, Eugene, Bend and Medford. These groups preferred to train and manage their SAR operations locally rather than under the umbrella of a statewide organization.[312] Despite MORESCO's demise, during the decades that it operated, Oregon had developed some of the country's best mountain rescue units. Several of those teams had established a long legacy of volunteer search and rescue in the state.

One of the oldest units was the Corvallis Mountain Rescue Unit (CMRU), which originated in 1947 with the founding of the Suski Ski Club at Oregon State University. Shortly after the club's establishment, it changed its name to the Oregon State College Mountain Club and expanded its activities to include mountaineering.[313] The club sponsored student ski outings into the Cascades and formed a rescue unit in the 1950s.

That club became the basis for the Corvallis Mountain Rescue Unit, which joined MORESCO in the late 1960s.[314] After a period of dormancy, Corvallis Mountain Rescue was reestablished in the mid-1970s. It would later join the newly created Oregon Mountain Rescue Council (OMRC) following the infamous Oregon Episcopal School tragedy on Mount Hood in 1986. In 1993, CMRU became a charter member of the Benton County SAR Council and continued to support the Benton County Sheriff's Office search and rescue.

Another MORESCO member unit was Eugene Mountain Rescue (EMR). That group initially evolved from the Obsidians, who had performed search and rescue informally since the club's founding in 1927. By the mid-1960s, the Obsidians maintained a call list of two dozen local climbers who responded on behalf of the Lane County Sheriff's Office. Eugene climbers Jim Blanchard and Mark McLaughlin kept the list of responders and served as the group's unofficial leaders.[315] McLaughlin had served three terms as the chair of the Obsidians' search and rescue group during the 1960s.[316]

While the Obsidians' rescue group had many talented climbers, the team was informally organized and did little collective training. Its capabilities for any given mission depended on who happened to show up for the call.[317] A series of demanding missions in 1967 brought those organizational shortfalls to a head. The first call involved a challenging technical recovery on Mount Thielsen of a seventeen-year-old boy who died after falling six hundred feet from the summit. Due to the technical terrain, a team of Crag Rats had to be called in to assist with the recovery.[318]

That mission was followed by an evacuation of three climbers on Mount Jefferson injured in a rockslide. Finally, there was a recovery of a man killed on Middle Sister after an uncontrolled slide on a glacier. For that mission, only one member of the Obsidians rescue unit was able to respond. The growing number of SAR calls and technical demands convinced the Obsidians that a dedicated mountain rescue group was needed.[319]

That same year, Mark McLaughlin, who had organized the Obsidians' rescue group with Jim Blanchard, died along with six other climbers on Denali—at the time, it was the deadliest mountaineering accident in American history. The following year, Blanchard went on to found EMR in July 1969 with Tom Taylor and Jim Harrang.[320] The new rescue group was initially known as the Eugene Unit of the Mountain Rescue and Safety Council of Oregon. Its mission, as described in the articles of incorporation, was "to provide search and rescue personnel for emergencies in mountain wilderness areas and other areas requiring mountaineering proficiency in Oregon."[321]

Before founding EMR, Blanchard had previously served as president of MORESCO. While serving as a faculty member at the University of Oregon, he developed the Outdoor Pursuits and Leadership Training Program. Blanchard served many years as a rescue coordinator and board member of EMR. Also on the board was Mel Jackson, an accomplished climber who taught mountaineering, wilderness survival and first aid as the first director of Eugene's Outdoor and Environmental program.

Among EMR's early rescue leaders was Dr. Stuart Rich, a World War II veteran who had served as a Navy assault boat commander at Normandy on D-Day. After the war, he earned a PhD at Harvard and eventually moved to Eugene as an assistant professor in the business school at the University of Oregon.[322] He took up technical climbing in his mid-forties after taking a course on Mount Rainer with Jim Whittaker, the first American to summit Mount Everest.

Rich began climbing with the Obsidians and, in 1967, participated in an impromptu rescue of an injured Mazama climber on Three Fingered

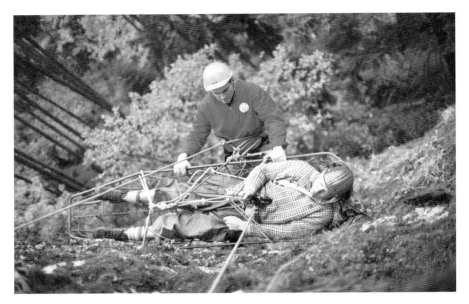

Eugene Mountain Rescue team leader Mel Jackson using a Stokes litter during a training exercise in the Coburg Hills outside Eugene, 1967. *Courtesy of Jim Blanchard.*

Jack. After that experience, Rich joined EMR the following year and was instrumental in developing the team's early rescue procedures. He remained an active member of Lane County Search and Rescue well into his seventies.

When EMR was formed, the group was explicit about its intention of including women on the team, with some twenty on the original roster, drawn mainly from the Obsidians. Initially, their roles were limited to "organizational functions" such as radio operations, establishing base camps and driving vehicles. However, that changed over time as women began filling key leadership roles and field positions. Within the group, it was recognized that "experience, not gender," was the deciding factor in running successful rescue operations.[323]

By the mid-1970s, when MORESCO dissolved, its Portland-area members established Portland Mountain Rescue (PMR), becoming the state's newest rescue group. In 1977, PMR filed formal articles of incorporation.[324] At the time of its formation, PMR's roster included the names of several legendary Oregon rescuers.

Among those signing the articles of incorporation was Hank Lewis, a PMR board member and living legend from the golden age of Oregon search and rescue. Lewis had been a longtime member of the Wy'east Climbers

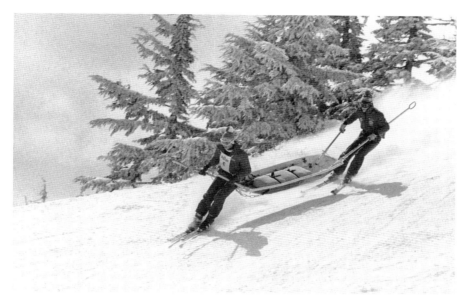

Mt. Bachelor ski patrol training with an Akja rescue toboggan. *Deschutes County Historical Society.*

and Mazamas during the 1930s. He was the first chief of the Mount Hood Ski Patrol, a member of the 10th Mountain Division during World War II, a founder of the Mountain Rescue and Safety Council in the 1950s and president of the Mountain Rescue Association.[325]

Other prominent rescuers on PMR's roster included Dick Pooley, a longtime Crag Rat, president of MORESCO and the first president of the national Mountain Rescue Association, which started at Timberline Lodge in 1958. Also on the list was Wy'east Climber and veteran Mount Hood skier patroller Keith Petrie. He had been one of MORESCO's first rescue directors and was credited with introducing the Akja rescue sled to Oregon's ski patrols and rescue units during the late 1950s.[326]

Two Decades of Progress

By 1980, Oregon's search and rescue units had professionalized and greatly expanded their capabilities. This was in response to the growing demand for SAR services and exploding interest in outdoor recreation around the state. Dozens of volunteer SAR units had been created during the 1960s and 1970s. Meanwhile, Governor McCall's 1971 executive order

established the Emergency Services Division as a centralized coordinator of the state's SAR resources.

The 1975 mandate, making county sheriffs responsible for local SAR operations, clarified what had previously been accepted practice but not enshrined in Oregon law. With that mandate came improved data collection providing essential insights into the nature of the state's SAR program.

That data helped challenge widespread assumptions that high-risk activities like alpine mountaineering accounted for most SAR calls in the state. In fact, the data showed that climbing accidents represented only 6 percent of all SAR calls in 1975. Conversely, accidents and searches involving hunters represented the single largest category of the state's SAR missions.[327] Another 23 percent were categorized as searches for missing persons, drownings and assistance with evidence searches. The data further revealed that most of Oregon's backcountry deaths involved river and boating incidents and accidents relating to hunting and camping activities.

The most important trend of the previous decades had been the continuing professionalization of volunteer SAR units. Several factors contributed to this process. By and large, Oregon's modern SAR organizations were becoming specialized units dedicated to that mission rather than conducting SAR activities as a sideline to other recreational endeavors. This meant better training and organization, with more focus on technical skills. The efforts of the OSSA to establish statewide training standards significantly accelerated that process.

While Oregon's search and rescue capability had progressed dramatically in the postwar era, funding disparities at the county level continued to impact the quality and resources of many SAR units. Additionally, there remained challenges concerning coordination and communications among the various SAR entities across the state. Several high-profile tragedies in the coming decades would reveal these shortfalls and bring about calls for additional reforms.

5

1980s TO THE PRESENT

SAR Professionalization and State Involvement

The 1975 legislation mandating a SAR capability at the county level was essential for professionalizing the state's volunteer organizations. However, SAR units still faced significant shortfalls in funding while experiencing steady increases in mission demands. Furthermore, in 1980, amid a state budget crisis, the legislature abolished a civil defense injury fund covering medical expenses for SAR volunteers injured while participating in rescue missions.[328] While the insurance issue was eventually resolved, it exemplified the ongoing challenges facing Oregon's volunteer SAR organizations.

In addition to funding shortfalls, the state's emergency management enterprise remained fragmented and outdated. It operated under a legislative mandate that hadn't been updated since the Emergency Services Act of 1949. That legislation was focused on the state's military department within the context of the Cold War and offered little guidance on managing the state's increasingly complicated search and rescue apparatus.

In 1983, lawmakers debated a major update to Oregon Revised Statute Chapter 401, with a new emphasis on preparing for natural disasters and creating an integrated emergency management system that would improve coordination among local and state agencies.[329] That effort led to House Bill 2977. The bill's initial version offered an updated definition of search and rescue that could have streamlined the state's SAR apparatus. However, that language potentially threatened the state Aeronautic Division's authority over Air SAR operations.

Due to bureaucratic infighting, the bill's final version upheld the organizational status quo, leaving the state's search and rescue enterprise divided under separate authorities and with different funding sources. The Aeronautics Division retained jurisdiction over Air SAR operations, working closely with the Civil Air Patrol. Meanwhile, ground operations fell under the Emergency Management Division, part of the State Military Department. While the 1983 legislation helped to improve coordination among local and state agencies, it failed to resolve other lingering challenges facing the SAR enterprise. An incident the following year on Mount Hood revealed some of these issues.

In early December 1984, two boys became lost while skiing above Government Camp and spent the night in a snow cave.[330] One of the boys died the next day from cardiac arrest resulting from severe hypothermia after being evacuated to Portland by the 304th Rescue Squadron. After the incident, the boy's family publicly raised concerns about the timeliness and effectiveness of the search effort.[331]

A few months after that incident, a legislative research report examined some of the ongoing issues with how the state was managing its SAR operations. The report noted that despite county sheriffs' authority over SAR, "areas of responsibility and coordination of duties in SAR operations are not clearly delineated" from county to county.[332] This situation created a great deal of variation in how SAR operations were conducted across the state.

The report highlighted how the day-to-day duties of SAR coordinators differed significantly among jurisdictions, noting that there was no formal training requirement for individuals holding that position. The report concluded that "elements and processes of SAR operations fluctuate[d] from one county to another," with some counties assigning search and rescue as a "low priority."[333] Budgetary constraints were cited as the primary reason SAR was not prioritized in some rural counties.

While the Oregon State Sheriffs' Association (OSSA) had established minimum training standards for SAR volunteers during the mid-1970s, those standards were not mandated statewide. The legislative research report noted that "each county trains its personnel in SAR skills as the sheriff deems necessary." This led to significant variation in capabilities across the state. However, one area of explicit agreement cited in the report was that "without the aid and expertise of volunteer workers, search and rescue would be financially and physically impossible to conduct."[334]

After the tragic incident on Mount Hood and the findings of the legislative research report, House Bill 2978 attempted to address some of the concerns

later that year. The legislation required that each county sheriff develop a search and rescue plan describing the materials, equipment and personnel available for SAR missions within their county. The bill stipulated that county SAR plans had to include procedures for contacting and requesting volunteer personnel from other agencies. Additionally, county plans were required to identify minimum training standards for eligible SAR personnel and be updated annually.[335]

The 1985 legislation helped bring greater consistency among the various SAR entities operating across the state. However, operational coordination between counties and among SAR organizations remained a persistent concern. This was particularly true during large, complex missions where multiple units came together for ad hoc operations. The tragic events the following year on Mount Hood were a reminder of the lingering challenges facing the state's SAR enterprise.

THE OREGON EPISCOPAL SCHOOL DISASTER AND THE AFTERMATH

The infamous climb began before sunrise on Monday, May 12, 1986, from the Timberline Lodge. The party of twenty included fifteen students from the Oregon Episcopal School (OES) in Portland, climbing Mount Hood as part of the school's outdoor education program. School chaplain Thomas Goman, an experienced mountaineer; administrator Marion Horwell; and parent Sharon Spray accompanied them. They were joined by professional guides Dee Zduniak and Ralph Summers.[336]

The group left Timberline Lodge just after two o'clock in the morning. During the preceding days, the weather had been a mix of rain and snow, with conditions expected to worsen during the climb. Nevertheless, Goman proceeded with the plan, believing they would beat the incoming weather. The group encountered several inches of fresh snow and strong winds as they set out early on Monday morning. Sharon Spray and her daughter soon turned back for Timberline Lodge while the others continued to Silcox Hut at seven thousand feet.[337] Shortly after that, four more students returned to the lodge.

As the weather worsened, the remaining fourteen climbers reached the top of the Palmer ski lift at 8,500 feet around eight o'clock in the morning. The group pushed on through soft snow toward the Hogsback, a ridgeline extending from Crater Rock toward the final approach to the summit.

Around that time, one of the guides, Dee Zduniak, turned back after experiencing snow blindness. Goman pushed the rest of the group ahead, struggling against high winds and poor visibility. Finally, the second guide, Ralph Summers, convinced Goman to turn around.

By that time, several party members were suffering from hypothermia as they descended. Unable to see Timberline Lodge, they veered off course and headed toward White River Canyon. As the situation became desperate, Summers stopped to dig a snow cave that was large enough to shelter most, but not all, of the remaining thirteen climbers. Sometime later that evening, Summers left to find help, joined by a student, Molly Schula. The remaining eleven climbers stayed behind at the snow cave, taking turns inside as the storm intensified.

When the group didn't return to the lodge on Monday evening, the Clackamas County Sheriff's Office alerted Portland Mountain Rescue (PMR). The Alpinees and the 304th Rescue Squadron were notified shortly after.[338] The first PMR team arrived at Timberline Lodge early

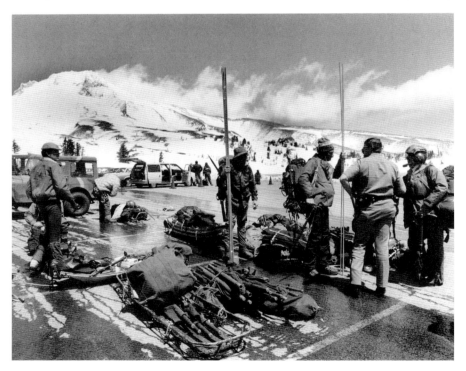

Rescue teams staging in the Timberline Lodge parking lot during the search for missing climbers from the Oregon Episcopal School, May 1986. *The Oregonian.*

Answering the Call

A rescue team heads up Mount Hood in a snowcat during the Oregon Episcopal School operation. *The Oregonian.*

the next morning on Tuesday. Later in the day, they were joined by a ground team from the 304th Rescue Squadron. By Wednesday, over 150 SAR personnel were operating in fifteen teams around the mountain.[339] Responders included teams from PMR, Corvallis Mountain Rescue, the Crag Rats, the Mazamas, Mount Hood Ski Patrol and Seattle Mountain Rescue, among others.

The rescuers had no luck on Tuesday, the first full day of the search. After sunrise on Wednesday, five PMR volunteers left on foot to search the east rim of White River Canyon. Meanwhile, several other PMR members, including Tom Stringfield and Scott Russell, left Mount Hood Meadows at dawn in a snowcat.[340] One of the teams spotted two bodies in the snow just over the west edge of White River Canyon. Another team found a third victim nearby. The bodies were brought down by helicopter to the mission headquarters at Timberline Lodge as the search for the others continued.

On Thursday, the third day of the operation, search teams redirected their efforts based on the previous day's discovery and help from Ralph Summers, the guide who had made it back to the lodge. The search was about to be called off late in the day due to hazardous weather when searchers discovered the snow cave after combing the slope with avalanche probes. When rescuers excavated the opening to the cave, they found only two of the eleven climbers still alive. One of the students suffered severe frostbite and later had his legs amputated at Providence Medical Center.[341]

In the aftermath of the tragedy, much blame would fall on Goman for continuing climbing as the party struggled. The event became the second-deadliest alpine accident in North American history. For Oregon's SAR

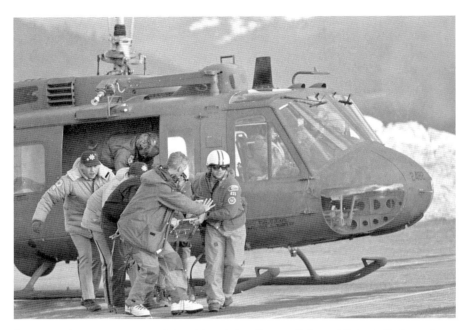

Rescue workers evacuate one of the eight missing Oregon Episcopal School climbers after they were discovered in a snow cave on Mount Hood, May 1986. *AP Photo/Michael Hinsdale.*

community, it was an opportunity to reflect on the response and consider what might have been done differently.

An after-action review by the Clackamas County sheriff identified several areas for improvement, described as "fine-tuning."[342] One recommendation concerned the need for an overall incident commander to run such large operations. Another issue was improving coordination, such as having all search teams working on a single radio channel. However, the mission review concluded that none of the recommended changes would have altered the outcome.

NEW SAR TECHNOLOGIES AND ORGANIZATIONS EMERGE FROM TRAGEDY

The OES tragedy revived the idea of having climbers carry emergency beacons to aid in search and rescue. A similar concept had been proposed in the mid-1970s following two extended search operations on Mount Hood. The first mission occurred in 1974, involving over one hundred

SAR members and two thousand work hours, ending successfully when three climbers were located after a four-day search.[343] The second mission in 1976 was even larger, involving a search for three young climbers who survived sixteen days in a snow cave near Illumination Rock, a prominent basalt spire separating the Zigzag and Reid glaciers on Mount Hood's west side.

In the wake of those operations, the Oregon Mountain Rescue Council and other SAR units proposed creating an emergency mountain transmitter program. But in the mid-1970s, the technology was still in its infancy, and available prototypes cost thousands of dollars each.[344] Due to the cost and technical challenges, the program wasn't implemented at the time. However, the idea was revived after the OES tragedy under the auspices of the Mountain Signal Committee, a nonprofit corporation led by Scott Russell and Craig Petrie.

Russell was a mechanical engineer, survival instructor and member of the team that located the bodies of three missing OES climbers near White River Canyon.[345] Craig Petrie was head of the Mount Hood Ski Patrol and participated in the OES rescue mission. Together, they led the development of the Mountain Locator Unit (MLU), an emergency radio transmitter based on technology used for wildlife tracking.

The beacon issue also entered the debate in the state legislature in the form of Senate Bill 915 in 1987. That proposal was intended to encourage the voluntary use of portable emergency transmitters. However, getting to that seemingly simple goal proved extremely difficult. The main issue preventing their use was not technical but concerns over product liability.[346] Device manufacturers were hesitant to market the beacons over fears of lawsuits in cases where they didn't result in a successful outcome.

State Senator James Simmons, a former Mount Hood Ski Patrol chief who sat on the judiciary subcommittee, introduced Senate Bill 915. The law was written to prohibit lawsuits against device manufacturers unless the maker knowingly supplied defective equipment. The measure also extended legal safeguards for search and rescue volunteers, protecting them from liability under Oregon's Good Samaritan Act.[347]

Several family members of the OES disaster, including survivors Giles Thompson and Brinton Clark, offered support for the legislation, as did Oregon's search and rescue community.[348] But before its passage, the final language was modified so that it didn't offer sufficient protection for device manufacturers. In the end, SB 915 did little to encourage the use of the devices or change how search and rescue organizations operated on Mount

Hal Lillywhite of Portland Mountain Rescue and Chris Bernard of the 304th Rescue Squadron test a directional antenna, part of the Mount Locator Unit system developed in the aftermath of the Oregon Episcopal School disaster. *Photo by Ruby Zarzyczny; U.S. Air Force.*

Hood.[349] However, the Mountain Locator Unit, spearheaded by Russell and Petrie, did produce tangible results.

The MLU system came into operation in 1988, supported by the Forest Service and Clackamas County Sheriff's Office.[350] Although the MLU was a custom-made unit and not approved by the Federal Communications Commission, it was available for rent at locations around Mount Hood. The MLU was credited with assisting in numerous rescues until it was discontinued in 2017 as other technologies became more practical.

Another shortcoming identified during the OES operation was managing SAR communications during large, multi-jurisdictional operations. Russell Gubele was a paramedic involved in the OES response and observed these challenges firsthand when dozens of different agencies and volunteer SAR teams came together for the mission. Gubele owned a communications and electronics business in Clackamas and had managed a 911 call center, providing him with unique insight into the technical aspects of the problem.[351]

After the OES tragedy, Gubele collaborated with David Billstrom on improving SAR communications. Billstrom was a Reed College graduate, firefighter and technology entrepreneur. They were joined by Ernie Lesley, a

sound and audio engineer, hot air balloon pilot and paramedic. Together the men founded Mountain Wave Search and Rescue. Mountain Wave began with a focus on SAR radio communications, developing a command vehicle using a retired neonatal intensive care ambulance donated by American Medical Response. The team used grants and donations to fund the custom fabrication of the communications suite. As the unit evolved, it expanded into a multidisciplinary organization with ground teams, a K-9 unit, off-road vehicles and unmanned aerial vehicles.[352]

As Mountain Wave evolved, it was on the leading edge of applying cellphone tracking technology to search and rescue. During a December 2006 search for three missing climbers on Mount Hood, the team would prove the concept's utility. During that mission, one of the climbers called his family from a snow cave below the summit.[353] The Mountain Wave team, in collaboration with law enforcement authorities, narrowed the search area by tracking the cellphone's signal.[354] Although that mission did not end successfully, it proved that cellphone tracking could be a vital tool for locating missing subjects.

The OES mission was generally considered a well-executed operation. Nevertheless, the disaster brought about several changes for Oregon's

Interior workstations of Mountain Wave's "Com 4" vehicle. The unit has deployed across Oregon and Washington helping with SAR missions, wildfire and disaster response. *Courtesy of Russell Gubele and Mountain Wave SAR.*

mountain rescue community. Most notable was the creation of the Oregon Mountain Rescue Council (OMRC) later that year. The previous mountain rescue entity, MORESCO, had dissolved in the mid-1970s and was no longer serving as a coordinating body for the state's mountain rescue teams.

In the aftermath of the OES disaster, some lawmakers in Salem discussed legislation to regulate climbing and mountain rescue. OMRC was formed partly as a preemptive measure to keep state legislators out of the business of managing the state's climbing practices.[355] Instead, OMRC offered a collaborative mechanism to improve coordination among Oregon mountain rescue groups and advocate for safer practices.

It also provided a single voice in Salem, representing the interests of the state's mountain rescue community. OMRC's original members included Corvallis Mountain Rescue, Eugene Mountain Rescue, the Hood River Crag Rats, Portland Mountain Rescue and, later, Deschutes County Search and Rescue. In 1990, the Oregon State Sheriffs' Association designated OMRC as the lead entity for establishing and maintaining the accreditation of the state's mountain rescue teams.

Another entity to emerge from the tragedy was the Mt. Hood SAR Council, an umbrella organization composed of regional SAR groups from northwest Oregon. The council was created to identify and apply best practices for search and rescue and grew to include numerous county sheriff offices and volunteer SAR teams, as well as the Forest Service. The council also provides training programs, medical insurance and equipment for member organizations.

Continuing Debate Over SAR Funding

Oregon's SAR community used the OES disaster to improve coordination among search and rescue entities and accelerate the process of professionalization. But the early 1990s also saw the continuation of challenges that had been dogging the SAR community for decades. These included a rising number of SAR calls, a lack of state funding, concerns with coordination among units and standardizing the training of SAR personnel. Even though Oregon had some of the best volunteer SAR teams in the nation, a few highly public failures would expose the system's shortcomings.

By 1990, the state was averaging over six hundred search and rescue calls per year.[356] These missions were accomplished by some seven thousand registered SAR volunteers across Oregon. That number included a wide

range of volunteer groups such as Explorer Search and Rescue posts, mounted posses, four-wheel drive clubs, mountain rescue units, the Civil Air Patrol, dive teams, K-9 trackers and even a kayak club that conducted searches along the Columbia River shoreline.

At the time, Oregon was one of many states experiencing sharp increases in SAR mission numbers. By the early 1990s, the National Park Service was seeing record-setting numbers of rescues, deaths and skyrocketing costs for its search and rescue operations. The agency was even debating whether it would begin charging subjects for rescues inside the parks.[357]

In addition to record call numbers, the expense of individual SAR missions was rapidly rising. A high-profile 1991 search for a young hunter named Corey Fay in Wasco County cost the county over $200,000, not even counting additional operational support from outside the county.[358] The boy's remains were discovered almost a year later, outside the designated search area. It was one of Oregon's most extensive and expensive search efforts to date. The operation received significant media attention and later led to the establishment of Pacific Northwest Search and Rescue in 1993, by Irv and Joan Wettlaufer.[359] But afterward, Corey's family was highly critical of how the operation was managed, citing "jurisdictional problems and lack of coordination."[360]

The high cost of the Corey Fay search reflected a trend across the state with large operations sometimes costing counties as much as $100,000.[361] One major factor in the skyrocketing costs of SAR operations was the increasing use of helicopters.[362] In response to rising costs, the Oregon legislature passed a measure in 1995 allowing for limited cost recovery from victims in cases of willful negligence. The law was passed in the wake of an extensive search for three missing climbers on Mount Hood who later turned out to be waiting out a storm in their tent.[363]

The new legislation allowed Oregon sheriffs to charge up to $500 to reimburse expenses relating to SAR operations. However, that amount was a drop in the bucket compared to rising SAR operational costs. Furthermore, the law was rarely applied out of fear that people might delay calling for help due to fear of being penalized and concerns over the perception that the state was charging innocent victims of backcountry mishaps.

A proposal that evolved from the expensive Wasco County search for Corey Fay was adding a one-dollar surcharge to the state's hunting, fishing, and snowpark permits. Under the plan, funds would help to reimburse counties for conducting extended search and rescue operations.[364] However, the legislature failed to take action on the proposal.

Although the issue of funding remained unresolved, the state was making some progress in modernizing its SAR bureaucracy. During the early 1980s, there had been an unsuccessful attempt to resolve jurisdictional divisions between the state's separate authorities for air and ground SAR. The two positions were finally combined into a unified state SAR coordinator position within the Office of Emergency Management in the mid-1990s. In 1994, Georges Kleinbaum was hired as the state's first SAR coordinator under the new organizational structure.

Kleinbaum came into the job with exceptional credentials. During the 1980s, he served with the U.S. Air Force as a SAR pilot in South Korea and Alaska. Later in his career, he became the executive officer of the Air Force Rescue Coordination Center (AFRCC) at Langley Air Force Base in Virginia. In that position, he worked on SAR incidents at the national level, supporting local search and rescue authorities across the United States. When he assumed his new position in Salem, Kleinbaum was the leading force in the creation of the state's SAR database, which published its first annual report in 1996–97.[365]

Despite progress in many areas, the state's SAR enterprise still faced occasional challenges with public perception about its capabilities and function. Some of these issues came to a head following two searches occurring within weeks of each other in late 1999. The first incident involved an eight-year-old boy separated from his family in Klamath County while searching for a Christmas tree near Pelican Butte during a snowstorm.

Late in the evening, approximately five hours after the boy was reported missing, Klamath County teams began searching the woods. Teams from Jackson County later joined them for a two-week search effort. The operation eventually included helicopters, K-9 units and hundreds of volunteers.[366] Unfortunately, the boy was never found.

After the search was called off, the family publicly criticized the Klamath County sheriff and SAR teams for what they perceived to be a slow response and bungled search. They charged that the decision to deploy the SAR unit had been "too political" and should have been executed sooner and with more oversight by the state.[367] The incident raised concerns that county sheriffs had too much discretionary power over decisions to deploy SAR assets and that the state had limited oversight over how those operations were conducted.[368]

In response to the criticism, officials from the Emergency Management Division noted that nearly all the state's SAR operations ended successfully, with subjects found alive in over 90 percent of searches. Around 4 percent

were later found dead, and an equal number remained missing. However, officials noted that it was the few unsuccessful searches that gained the most media attention.

Similar concerns surfaced the following month in Linn County when a thirteen-year-old boy was lost in the South Santiam River near Lebanon after his boat capsized.[369] The search was executed quickly but wasn't successful. The boy's body was spotted in the river by his father the following day, adding to the family's frustration over the operation. Nevertheless, the Linn County sheriff defended his agency's actions and allocation of resources, noting that his county responded to dozens of searches each year across an enormous territory with a budget of only $6,500.

That response did little to satisfy the grieving family, but it gained the attention of lawmakers in Salem, who again began discussing possible reforms to the state's search and rescue system. An editorial in the *Statesman Journal* noted that more state involvement likely wouldn't have changed the outcome of the two unsuccessful missions. However, it demonstrated that "Oregon's hard-working volunteer searchers deserve better financing and more training."[370]

The editorial continued with a scathing critique of the state's SAR enterprise, noting that "Oregon requires each county to provide search-and-rescue services but provides no money. The state has set no standards, much less guidelines, for operations. It hasn't established minimum training requirements for sheriff's officials who oversee operations, nor has the state required counties to keep rescue plans up to date."

The paper offered several suggestions for reforming the system, including developing improved training standards for SAR volunteers and coordinators, creating a special unit at the state level for assisting with high-risk operations, providing increased funding for training and equipment and formalizing agreements among counties for mutual assistance. But at the time, state officials had no such authority over search and rescue. They could review the conduct of SAR operations but had no real enforcement power in cases of negligence or incompetence.[371]

A separate article in the *Albany Democrat-Herald* offered an equally damning judgment, suggesting that Oregon's rescue crews were "unregulated, underfunded, and improperly trained."[372] The article noted that some Oregon counties didn't prioritize search and rescue or dedicate adequate resources. One county SAR coordinator acknowledged challenges within the system, noting that the level of "aggressiveness" in SAR operations varied greatly from county to county.[373]

While the decade had brought few significant changes in how SAR was managed at the local level, the state Office of Emergency Management was taking essential steps to quantify the scale of the challenge. In 1996, OEM developed a state SAR database providing unprecedented detail about Oregon's SAR operations.[374] For the first time, the database enabled a detailed analysis of incidents, locations, manner of response, workhours expended and outcomes. That data would quantify the steady increase in SAR calls over previous decades and provide valuable information for improving search and rescue operations.

Problems Linger as Oregon SAR Is Thrust into the Spotlight

Despite the widespread awareness of shortcomings within the SAR system, the new millennium didn't bring about dramatic changes. The first years of the decade saw no new legislation or changes in SAR funding. Counties continued to have significant autonomy in managing their SAR operations while also bearing responsibility for funding them and providing volunteers.

The early 2000s brought several high-profile SAR missions, including one that would generate dramatic video footage from Mount Hood that was broadcast worldwide. That mission occurred in May 2002 when nine climbers from three separate parties fell into the Bergschrund crevasse after a team went into an uncontrolled slide near the Pearly Gates, a narrow chute leading to the summit.[375]

While nearby climbers were helping the injured subjects, the Clackamas County Sheriff called for assistance. An American Medical Response Reach and Treat Team of volunteers were the first organized unit to arrive on the scene, assisted by a member of the Mount Hood Ski Patrol. A five-member team from Portland Mountain Rescue arrived soon after.

Given the location of the incident and the number of climbers involved, both the Oregon National Guard's 1042nd Air Ambulance Company and the 304th Rescue Squadron responded to the call. Two Blackhawk helicopters from the 1042nd were the first to arrive on the scene. They hoisted two injured climbers off the mountain and evacuated them to Legacy Emanuel Hospital in Portland.

A Pave Hawk helicopter from the 304th, with a crew of six, arrived next. A pararescue specialist with a Stokes litter was lowered to the scene and began packaging a climber for evacuation. As the crew was preparing to hoist a

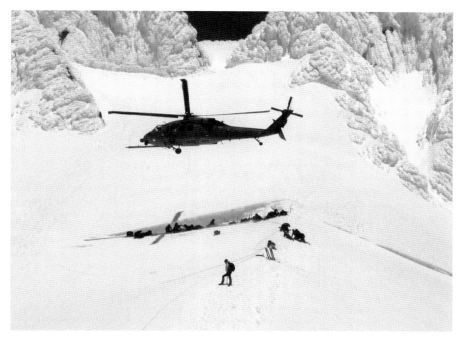

A Pave Hawk helicopter from the 304th Rescue Squadron hovers over the Bergschrund crevasse on Mount Hood seconds before it strikes the ground and rolls down the mountain, May 2002. *Courtesy of Steve Rollins and PMR.*

third victim from the edge of the crevasse, the aircraft suddenly lost altitude. A crewman cut the winch cable just as the helicopter's nose and rotor blades struck the side of the mountain. The aircraft and crew rolled eight times before coming to rest one thousand feet below.[376]

A local television helicopter crew captured the crash on film and broadcast the dramatic footage worldwide. Somehow the crew survived after the pilot managed to maneuver the helicopter away from the rescue teams to avoid injuring anyone on the ground. After the crash, PMR rescue lead Steve Rollins took over the scene and began directing rescue efforts to the downed aircraft.[377] Two National Guard helicopters and a second 304th Pave Hawk continued evacuating injured climbers and the crew of the wrecked helicopter.[378] Operations continued into the next day to recover the body of the last climber. Three climbers were killed, and another three were critically injured.

Two years later, Oregon SAR teams were again thrust into the spotlight. This time it involved a lengthy search and recovery operation after a small

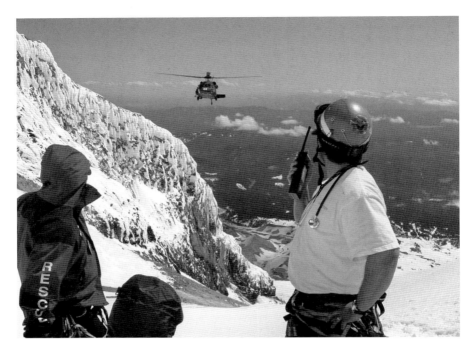

Members of the American Medical Response Reach and Treat Team and Portland Mountain Rescue guide a Blackhawk helicopter from the Oregon National Guard's 1042nd Air Ambulance Unit following the crash of a Pave Hawk helicopter on Mount Hood, May 2002. *Courtesy of Steve Rollins and PMR.*

private plane carrying three young adults from Salem crashed into the side of Three Fingered Jack.[379] The operation began with the Civil Air Patrol trying to locate the aircraft after the Air Force Rescue Coordination Center in Virginia narrowed the search area. The downed plane was spotted a few hours later in a remote location, about two thousand feet below the summit ridgeline. An Oregon National Guard helicopter was able to lower a paramedic to the site, but there were no survivors.

The mission became an extended three-day recovery operation involving over one hundred SAR personnel from multiple teams. On the second day, rescuers attempted to reach the site using snowmobiles, Argo snow machines and skis but were forced back by deep snow and hazardous weather conditions. By the end of the mission, rescuers had collectively clocked nearly one thousand workhours. The mission cost more than $30,000, but it helped bring closure to the grieving families. Afterward, the *Statesman Journal* praised the high level of cooperation among rescuers, citing it as an example of the "professionalism and compassion" of Oregon's SAR community.

The two high-profile missions on Mount Hood and Three Fingered Jack helped restore confidence in Oregon's search and rescue community. However, it didn't change the fact that there had been little fundamental change in the status quo. Oregon's statewide SAR apparatus was functioning as it had for the previous two decades. It would take several dramatic events in late 2006 before lawmakers finally took a hard look at how the state managed its search and rescue enterprise and how the system could be improved.

The first of these events involved a high-profile search for an eight-year-old boy named Samuel Boehlke, who went missing in October at Crater Lake National Park. Because the search was conducted inside the park, it was led by an outside team of crisis management experts using the Incident Command System (ICS), a standardized approach to command, control and coordination during emergency response. That system was developed in Southern California in the early 1970s to improve command and control during wildfire response. In 2004, it became the standardized approach to incident management among federal, state and local agencies.[380]

The Crater Lake mission involved over two hundred ground personnel, supplemented by horse and dog teams, air support, boat crews and technical

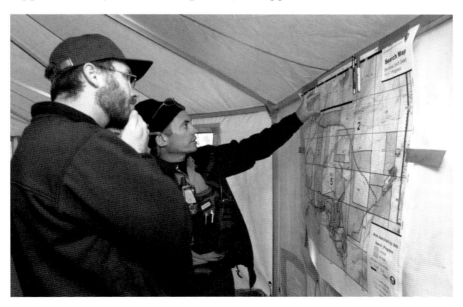

Park Service supervisor Pete Reinhardt (*right*) and air operations supervisor Brad Reed discuss the search for Sammy Boehlke in Crater Lake National Park, October 2006. *AP Photo/Jeff Barnard.*

climbers, in what was one of the largest search operations in the park's 104-year history.[381] Although the boy was never found, the mission was considered well executed and an example of how ICS could be used to better coordinate major SAR operations.[382]

Two months later, the next incident provided a different example of how to manage an extensive search operation. That mission drew worldwide attention to Oregon when the family of James Kim, a well-known technology reporter, disappeared while driving through the southwestern part of the state over the Thanksgiving holiday.[383] James Kim was traveling with his wife, Kati, a University of Oregon graduate, and their two young children.

The family was reported missing after departing Portland and failing to arrive at their hotel in Gold Beach. Because authorities didn't know the family's route, the initial search involved an enormous area between Salem, Grants Pass and Gold Beach.

Unbeknownst to the searchers, the family had missed their exit for Oregon Route 42 off Interstate 5 and took Bear Camp Road instead. They eventually became stuck on a Bureau of Land Management logging road in a remote part of the Siskiyou National Forest along the Curry and Josephine County lines. The family waited for six days in the car without food or

A staging area for rescue crews on Bear Camp Road in the Siskiyou National Forest during the search for James Kim, December 2006. *AP Photo/Don Ryan*.

A SAR member and his scent dog preparing to search for James Kim after Kati Kim and their two children were found on a snow-covered road west of Grants Pass, December 2006. *AP Photo/Don Ryan.*

proper clothing before James Kim left to find help, hoping to make it to the town of Galice.

The initial search effort involved state police, county law enforcement and air searchers. The following weekend, teams from five counties joined in a massive ground search effort. Meanwhile, frustrated with the pace of operations, James Kim's father hired private helicopters to help in the search. He later described the search effort as "plagued by confusion, communication breakdowns, and failures of leadership."[384]

Ten days after the family was reported missing, a helicopter pilot, not part of the formal search effort, spotted Kati Kim and her two daughters walking on a road near their car. The three were transported by air to Three Rivers Community Hospital in Grants Pass for treatment. The discovery helped narrow the search area for James Kim as horse teams, dog handlers and swiftwater personnel joined the operation. Over one hundred ground searchers were in the field, assisted by an Oregon Air National Guard helicopter equipped with night-vision and heat-sensing equipment.[385] Two days later, the body of James Kim was found in Big Windy Creek Canyon, about sixteen miles from their car. The cause of death was hypothermia.

Days after the search for James Kim ended, three climbers were reported missing while attempting to scale Mount Hood's north slope.[386] The men were experienced climbers, but they encountered hazardous weather. After receiving a cellphone ping from one of the missing climbers, search teams from PMR and the Crag Rats departed from Timberline Lodge and Cloud Cap Inn, hoping to find the missing climbers somewhere on Eliot Glacier. However, the search effort was cut short due to dangerous weather conditions.

Later in the week, as weather conditions improved, the Oregon National Guard was able to join the search and help move rescuers around the mountain. Eight days after the search began, the body of one climber was discovered in a snow cave below the summit in the direction of Newton Clark Glacier.[387] After eleven days, the authorities suspended the search for the other two men. The following summer, over one hundred SAR members from four counties joined a search effort for the remains of the missing climbers, but their bodies were never found.[388]

Although it was not the desired outcome, family members of the climbers later donated around $90,000 to several groups involved in the operation, earmarked for equipment and training. Recipients of the funds included the Hood River and Clackamas County Sheriff's Offices, the Crag Rats, Portland Mountain Rescue, the National Guard's 1042[nd] Air Ambulance Company and the 304[th] Rescue Squadron.[389]

Attention Turns to Salem Following Three Tragedies

The dramatic events of late 2006 again raised the topic of search and rescue among lawmakers in Salem. The Oregon State Sheriffs' Association (OSSA) led an initial review of the Kim family search and found that the operation was "marred by personality conflicts, confusion, and poor communication."[390] The initial search effort cut across four counties and lacked a unified command.[391] There was significant confusion over who was in charge, leading the Oregon State Police to assume overall command early in the operation.[392]

The OSSA after action review came amid allegations in the media that Josephine County authorities had not effectively used tips in directing their search effort.[393] In the end, the most important breakthroughs came from individuals not involved in the official search: a private pilot who spotted the family's car off Bear Camp Road and the assistance of a technician working for Edge Wireless in Medford who was able to narrow the search area by tracing the path of text messages through cellphone tower towers to the family's mobile phone.[394]

The two high-profile incidents of December, preceded by the well-managed search for the missing boy at Crater Lake, revealed significant variations in how SAR operations were conducted across jurisdictions.[395] One critical observation in the OSSA report was that Oregon SAR entities were not consistently using the Incident Command System, exacerbating the challenges of operational coordination during large missions. For example, during the Kim search, teams were using different map coordinate systems, there was poor tracking of units in the field and no system was in place for debriefing search teams after missions were completed.[396]

After the OSSA review became public, Oregon governor Ted Kulongoski signed an executive order creating a state search and rescue task force, providing a "close examination of Oregon's search and rescue system and infrastructure."[397] Joe O'Leary, the governor's senior advisor for public safety, was tapped to lead the task force.[398]

The group met for several weeks to study command and control issues, communications, training and resources dedicated to the state's SAR enterprise.[399] However, at the time, the state was mired in a budget crisis and facing an $850 million deficit.[400] As the task force began its work, it was understood that new state-level funding for SAR was off the table.[401]

The task force finalized its report at the end of March 2007 with a focus on improving cross-jurisdictional coordination among the state's

Oregon governor Ted Kulongoski reviews the final report of the Search and Rescue Task Force during a committee meeting in Salem, April 2007. *AP Photo/Don Ryan.*

SAR entities.[402] The study reaffirmed the OSSA conclusion that Oregon's SAR coordinators needed to adopt the Incident Command System. It also recommended technological changes, such as improving law enforcement access to cellphone and credit card records, that could assist during searches. The task force also noted that Oregon's public safety communication network was a patchwork of "dangerously out-of-date" systems. It recommended increasing funding for SAR training and equipment and a $665 million upgrade of the state's public safety communications system.

Notably, the final report didn't recommend changes to local authority over search and rescue. The task force insisted that Oregon sheriffs were "best positioned to know their jurisdictions, the terrain, and their constituents."[403] However, the report noted that the Office of Emergency Management remained understaffed and underfunded for managing search and rescue and lacked resources and personnel to assist in search efforts around the state. At the time, the state office operated on a budget of less than $100,000 with limited ability to assist local search efforts.

Meanwhile, there was a vast variation in the budgets and capabilities of SAR teams around the state. Some jurisdictions, such as Hood River,

Lane, Jackson and Deschutes Counties, had significant search and rescue capabilities and sufficient funding. For example, in 2006, Jackson County was on the higher end of the spectrum with a SAR budget of $192,000. At the same time, Grant County reported a budget of $2,000 for its annual SAR operations.[404] During the early 2000s, some rural counties also faced a major decline in federal payments from timber sales that were used to supplement SAR funding.

In the end, the task force recommended increased funding for SAR training but was hesitant about making major changes based on a small number of "high-profile incidents." In the year before the Kim search, there were well over eight hundred SAR incidents around the state, with the vast majority resulting in favorable outcomes.[405] Thus, the task force urged the state legislature to "exercise caution so as not to over-legislate in an effort to fix SAR and unintentionally inhibit a system that has worked well for so many years."[406]

Despite its generally conservative approach to reform, the task force advised several important updates to Oregon Revised Statute Chapter 401 to reflect changing circumstances and practices. Several of these recommendations were debated during the 2007 legislative session and eventually included as part of Senate Bill 1002 and House Bill 2370.

The specific measures signed into law included a rule authorizing the use of civil investigatory subpoenas, allowing greater access to credit card and cellphone records to help locate missing subjects. Other changes included a requirement for counties to implement ICS during SAR operations to improve command, control and communication. OSSA was also tasked with developing a standardized format for after-action reviews of SAR operations.

Among other changes in HB 2370 was a plan for creating an Office of Emergency Management within the Oregon Military Department. Since 1993, the Emergency Management Division had operated under the Department of State Police. Under the reorganization, the new agency would retain responsibility for coordinating activities of state and local emergency services agencies, including search and rescue. HB 2370 was passed unanimously by the house and signed into law by Governor Kulongoski.[407]

Another task force recommendation concerned the formation of regional search and rescue councils modeled after the Mt. Hood SAR Council, an entity formed to capture best practices and lessons learned from search and rescue operations around Mount Hood. The task force report noted that regional SAR councils provided excellent training and coordination opportunities that would increase the effectiveness of local SAR operations.

The California/Oregon Regional Search and Rescue Task Force (CORSAR) was formed in February 2007 in response to the challenges encountered during the Kim family search. Like the Mt. Hood SAR Council, its purpose was to improve communication and share resources across southern Oregon and Northern California jurisdictions.[408] It included the sheriffs of Jackson, Douglas, Josephine, Klamath, Curry, Siskiyou, Del Norte and Coos Counties; the Oregon State Police; the Bureau of Land Management; the Forest Service; Crater Lake National Park; the American Red Cross; and the Civil Air Patrol.

In addition to improving coordination among Oregon SAR units, CORSAR provided a mechanism to facilitate state-to-state mutual aid across the border, allowing Oregon SAR volunteers to work across the state lines through an Emergency Management Assistance Compact (EMAC) request.

THE BEACON DEBATE REEMERGES

The events of 2006 also renewed debate in the legislature about emergency locator beacons. After careful study, the governor's SAR task force considered the issue but didn't support making beacons mandatory for climbers. The task force was concerned that mandating signaling technologies could diminish personal responsibility by "giving climbers a false sense of security and a false expectancy that activating a signaling device will automatically result in a rescue."[409]

The report pointed out that in more than half of the deaths on Mount Hood, a signaling beacon wouldn't have changed the outcome. This was because the incidents involved avalanches, crevasse falls or rockfalls where the subject likely would not have been able to activate the beacon. The task force concluded that climbers had "a duty to exercise personal responsibility and assume the inherent risks of wilderness travel and mountain climbing."[410]

Nevertheless, the beacon issue was debated during the 2007 legislative session as House Bill 2509. That bill would have mandated electronic locator beacons for climbers traveling above ten thousand feet on Mount Hood.[411] State Representative John Lim was the bill's chief sponsor and received support from Hood River County sheriff Joe Wampler, who was involved in the eleven-day search for the three missing climbers in late 2006.

Wampler argued that the mandate would help reduce the cost of rescues and lower the risk to SAR volunteers.[412] That operation had involved over

Answering the Call

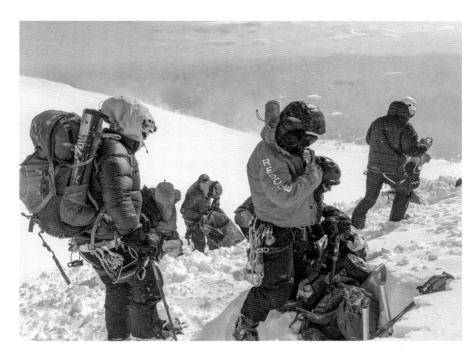

Above: A team from the 304th Rescue Squadron assists injured climbers in the Leuthold Couloir area on Mount Hood, March 2022. *U.S. Air Force.*

Right: Hood River County sheriff Joe Wampler at the Cooper Spur ski area talking on the radio with a helicopter crew searching for three missing climbers on Mount Hood, December 2006. *AP Photo/ Rick Bowmer.*

one hundred SAR volunteers and cost Hood River County around $5,000 per day, not including the cost of military aircraft supporting the search.[413] Despite Wampler's argument, most of Oregon's mountain rescue and SAR communities opposed the measure.

Members of the Mt. Hood SAR Council, the Oregon Mountain Rescue Council and the Mazamas all signed a strongly worded letter noting that "a law requiring climbers to carry electronic devices will have unintended consequences that will increase the risk to both climbers and rescuers."[414] Opponents also noted that the mandate would do little to reduce the state's SAR operational costs since searches for missing climbers accounted for only around 3 percent of all missions statewide.[415] Ultimately, the measure failed to pass.[416]

Lingering Challenges with SAR Training and Funding

The governor's task force and legislative reform measures of 2007 helped move Oregon's SAR program forward, but several issues remained unresolved. These included funding for search and rescue and training standards for volunteers. The task force noted that Oregon's county-based SAR construct was "increasingly challenging, as sheriffs' budgets shrink."[417] The issue disproportionately affected rural counties, where funding shortfalls had a "detrimental effect on counties' ability to address critical SAR needs such as training, equipment, and personnel."

Observers also noted that SAR training involved high costs for local governments and placed a financial burden on volunteers. Estimates suggested that SAR volunteers spent thousands of dollars annually to be part of a team, including expenses for transportation, food, training and equipment.[418] The task force recommended increased support for training SAR volunteers on a regional level. Unfortunately, little progress was made on funding SAR operations down to the county level.

Another area of concern was inconsistency in the training of SAR volunteers. The task force report noted that across Oregon, "training for volunteers is performed by the search coordinators on a volunteer and somewhat inconsistent basis."[419] The issue was partly addressed during the 2009 legislative session with the passage of House Bill 3021, clarifying the definition of a "qualified search and rescue volunteer." That bill required that SAR volunteers be registered with OEM or a county sheriff before

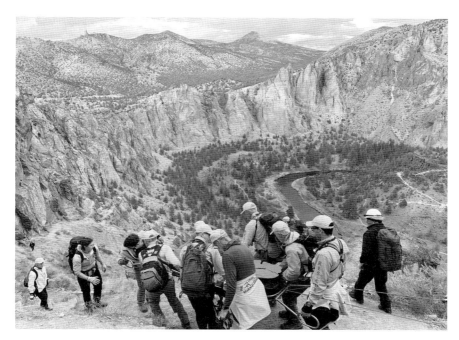

A SAR team evacuates an injured hiker from the top of Misery Ridge Trail at Smith Rock State Park. *Deschutes County Sheriff's Office Search and Rescue.*

conducting search and rescue activities. This included members of designated search and rescue organizations.[420]

Creating a clear legal definition for SAR volunteers was important for several reasons. It firmly placed responsibility on county sheriffs to identify and certify their qualified SAR volunteers. It also established the foundation for two important aspects of the bill. The first was extending coverage under the Oregon Tort Claims Act to SAR volunteers, offering indemnity against claims arising from an alleged act or omission while performing their SAR duties. Secondly, it enabled the state to provide workers' compensation coverage for qualified search and rescue volunteers. Both issues had been priorities identified in the 2007 SAR task force final report.

The issue of volunteer training and certification was taken up outside the legislative process, spearheaded by the OSSA. In 2013, the OSSA published the state's search and rescue certification criteria. That document established a minimum standard of core competencies and training for search and rescue volunteers. The tasks included training on emergency survival skills, incident management, radio communications, land navigation, search techniques, tracking, wilderness medicine, searcher safety and rescue techniques.

The standard was crafted to ensure each county sheriff had a body of trained and qualified personnel to accomplish its SAR function. Although the measures were not mandated under Oregon law, each sheriff was encouraged to apply them to certify their county's SAR volunteers. The performance standards included a written exam as well as objective skills tests. The new standard represented the minimum core competency for ground search and rescue personnel. However, there were additional requirements for specialty units such as mountain rescue, swiftwater, tracking, medical teams and other technical skills.

State SAR Data Reveals Patterns and Enables Research

When the Office of Emergency Management developed its SAR database in 1996, it began collecting unprecedented details about Oregon's SAR operations. In 2013, OEM published its first detailed snapshot of SAR operations covering the first sixteen years of data collection.[421] The numbers revealed steady increases in statewide SAR missions from the 1990s into the early 2000s, stabilizing around 2010.

From 1997 through 2013, there were an average of 826 operational missions per year. The statistics reflected over twelve thousand subjects assisted by SAR personnel during that period. Of those operations, searches for missing people on land accounted for around 40 percent of all missions. The second-largest category involved rescues on land, accounting for 17 percent of all missions. Approximately 90 percent of the subjects from those missions were recovered alive, and around 8 percent were deceased. The remainder were not found and were listed as missing.

The data showed that July was consistently the busiest month for SAR operations across Oregon. Mission numbers tended to be lowest during the period from January through April. Clackamas, Deschutes and Lane Counties were the three busiest jurisdictions. Lane County, with the McKenzie, Willamette, and Siuslaw Rivers, was notable for having more than twice the number of water rescues than the next highest county in the state. Notably, over 90 percent of the subjects involved in SAR operations did not live in the county where the incident occurred.[422]

The data also revealed that most of Oregon's SAR missions occurred on public lands, with 49 percent on Forest Service system lands and 9 percent within Bureau of Land Management jurisdiction; 17 percent of missions

Oregon was one of the largest data contributors to the International Search & Rescue Incident Database, a collection of statistics used by Robert Koester in his book *Lost Person Behavior*. *Image courtesy of Robert Koester.*

were on state land, and 4 percent were on county land. Hikers and hunters were the most frequent subjects of SAR operations, followed by individuals traveling by motorized vehicles. Perhaps unsurprisingly, the most prevalent demographic of SAR subjects was young adult males.

The state's SAR data collection program enabled new research into search methods and mission outcomes. Oregon's SAR data contributed significantly to the International Search & Rescue Incident Database (ISRID), a collection of statistics for over fifty thousand SAR incidents worldwide. Researcher and SAR member Robert Koester used that database for his groundbreaking work on lost person behavior and search methodology.

Koester's book *Lost Person Behavior* became the standard reference for search management in the United States. At the time of the original research, Oregon was among the largest contributors of detailed incident information to the ISRID database. Koester described Oregon's data as one of the most comprehensive and complete sets used in his work.[423]

In 2007, a group of Oregon Health and Science University medical researchers used similar data to examine over four thousand search and rescue missions between 1997 and 2003.[424] The research group found that time was the most critical factor in determining whether a search subject would be found alive. That study found that subjects located within the first fifty-one hours of a search were found alive 99 percent of the time, while the success rate of searches dropped off rapidly outside that window.

Oregon Search and Rescue: Now and into the Future

With Oregon's growing recreation-based tourist economy, the demand for SAR services has continued to expand in recent years. During the most recent ten-year average through 2021, SAR missions rose from 952 per year

to 1,089, a 14 percent increase.[425] In the United States, only California and Arizona reported a similar number of SAR missions annually.

A sharp upward trend began in 2018 with 1,065 missions. In 2019, the Office of Emergency Management reported the highest number of SAR missions in history, exceeding 1,300 missions statewide. During 2020, there was a slight drop in missions to 1,128, with 1,081 recorded during 2021.[426] While dramatic mountain rescues continue to capture headlines, the data show that they represent only a tiny fraction of Oregon's search and rescue missions. Among recreational activities, hiking accounts for around 75 percent of all SAR missions.[427]

Volunteers remain the backbone of Oregon's SAR capability, making up 99 percent of all county-level SAR teams. In 2020, the dollar value for annual volunteer man-hours was assessed at over $2.5 million. But the most striking statistic from the last ten years is that over 98 percent of Oregon's SAR missions ended with subjects being found alive. That number ranks Oregon's SAR volunteers in the top three in the United States in terms of operational proficiency.[428]

Another important trend within Oregon's SAR community has been the increasing number of female volunteers. Women have been actively involved in search and rescue since the 1920s through outdoor clubs like the Mazamas and Obsidians; however, those roles were often behind the scenes. For that reason, their contributions were often overlooked in the historical record. That began to change in the early 1940s as the newly created Civil Air Patrol cadet program allowed young women to join. By 1944, a quarter of CAP members were women, with many of them flying inland search and rescue missions during the war.[429]

Women were actively involved with many Oregon ski patrol units as they began forming in the 1930s. Mount Hood Ski Patrol became one of the first major units in the nation to invite female volunteers as rescue patrollers starting in 1946. During the 1960s and 1970s, more women became involved in county-level SAR groups as they formed across the state. When Eugene Mountain Rescue was established in the late 1960s, it had around twenty women in a variety of support roles and by the 1970s they were becoming fully qualified rescue members.[430] Today, women represent nearly half of SAR volunteers on many teams and in some cases are the majority on specialty units such as K-9 and medical.[431]

Despite its long and distinguished history, Oregon's SAR community continues to struggle to fund its operations, particularly for cash-strapped smaller counties. A recent estimate suggested that equipment and operations

Answering the Call

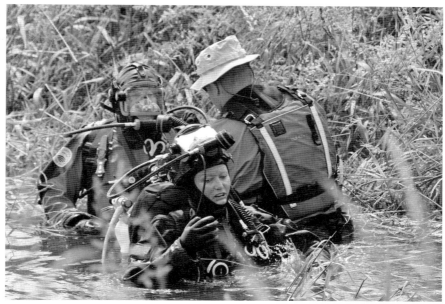

Women take on leadership roles in Oregon's search and rescue community. *Top*: SAR divers searching a pond near Skyline Elementary School in Portland during the ten-day search for seven-year-old Kyron Horman. It was one of the largest search operations in Oregon history, involving over one thousand SAR volunteers from multiple states. *AP Photo/Don Ryan*. *Bottom*: Chris Ledoux with her colleagues from Portland Mountain Rescue during the search for three missing climbers on Mount Hood in December 2006. *AP Photo/Kevork Djansezian*.

can cost counties between $100,000 and $500,000 per year.[432] In response to rising costs, in 2019, Oregon's legislature directed the Office of Emergency Management to develop recommendations regarding funding for search and rescue operations.[433]

In 2020, that directive generated House Bill 4111, authorizing the Office of Emergency Management to enter into agreements with nonprofit organizations to produce and sell outdoor recreation cards supporting search and rescue. The Oregon proposal was modeled after other states with similar programs. In 2015, New Hampshire began its voluntary "hike safe card," with proceeds supporting state SAR operations. Colorado developed a similar card program generating hundreds of thousands of dollars for its SAR operations.[434]

Under House Bill 4111, revenues from Oregon's card program can be used to reimburse SAR-related administrative costs and expenses, reimburse county sheriffs for certain operational costs and provide grants for search and rescue. As implemented, the new law allows the Oregon State Sheriffs' Association (OSSA), under agreement with the Office of Emergency Management, to sell search and rescue cards through authorized retailers. Card purchases help fund search and rescue training, equipment, and missions across Oregon by contributing to a Search and Rescue Fund managed by OSSA.

While voluntary contributions to search and rescue funds offer some help for offsetting budget shortfalls, in Oregon and across the nation, SAR teams are facing a record number of calls with few additional resources. In Oregon, these demands are reflected in a 15–20 percent increase in mission numbers over the last five years.[435] The surge in calls may be partly due to a substantial increase in recreational activities on public lands since 2019.[436] Other contributing factors could be less experienced users accessing the backcountry and a proliferation of emergency satellite communication devices making it easier to call for help. All these factors suggest that the rising demands placed on SAR volunteers are unlikely to decrease in the foreseeable future.

Conclusion

Oregon's strong tradition of search and rescue volunteerism began with the earliest settlers, who answered the call when neighbors needed help. It continued into the early twentieth century with outdoor clubs like the

Answering the Call

A SAR team evacuates an injured hiker near Broken Top in the Three Sisters Wilderness, September 2021. *Deschutes County Sheriff's Office Search and Rescue.*

Mazamas, the Skyliners, the Obsidians and the Crag Rats. These groups and others performed formally and informally as search and rescue units long before the government took an active role in managing these activities.

World War II formalized the concept of search and rescue as the federal government became involved in SAR to support the war effort. Many Oregonians returned from military service with new skills and experiences that they applied toward professionalizing the state's volunteer SAR organizations during the 1950s.

As outdoor recreation exploded in popularity during the 1960s and 1970s, so did the demand for search and rescue. SAR groups formed in counties across the state while legislators in Salem worked to standardize practices and improve coordination among SAR entities. The modern era brought increasing demands and new challenges for the state's SAR volunteers but few additional resources. Today, Oregon's search and rescue volunteers continue a long tradition of selfless service and professionalism, answering the call when neighbors need help, so that "others may live."

NOTES

Preface

1. Canwell and Sutherland, *RAF Air Sea Rescue Service*, 1–11.
2. White, "Sea Shall Not Have Them!"
3. "Evolution of SAR," *Air Sea Rescue Bulletin*, 10.
4. United States Coast Guard, *National Search and Rescue Manual*, 1.
5. National Search and Rescue Committee, *National Search and Rescue Plan*, 2.

Chapter 1

6. Harris, *Native Sons Scrapbooks*, 56.
7. Nokes, "Black Harris."
8. Victor, *History of Oregon*, 13.
9. DeVoto, *Across the Wide Missouri*, 252.
10. McLynn, *Wagon's West*, 267.
11. Clark and Tiller, *Terrible Trail*, 62–89.
12. Clyman, *American Frontiersman*, 55.
13. Palmer, *Palmer's Journal of Travels*, 123.
14. Ibid.
15. Nokes, "Black Harris."
16. Owen, *Lost Rescue*, 76.
17. Clyman, *American Frontiersman*, 56

18. Hazelett, "To the World," 201.
19. Thornton, "Letter," 2.
20. Hazelett, "To the World," 204.
21. Holt, "Journal," 4; Clyman, *American Frontiersman*, 56.
22. Hendrick, "Bits for Breakfast," 3.
23. Brogan, *East of the Cascades*, 44.
24. Sullivan, "Hiking a Lost Wagon Trail."
25. Williams, "Willamette Pass."
26. Collins and Tiller, "Cutoff Fever," 306.
27. Williams, "Willamette Pass."
28. Victor, "First Oregon Cavalry," 124.
29. Beckham, *Oregon Central Military Wagon Road*, 11.
30. Sawyer, "Beginnings of McKenzie Highway," 4.
31. Brogan, *East of the Cascades*, 75.
32. Richardson, "John Craig," 30.
33. "Found," *Eugene City Guard*.
34. "Lost in the Mountains," *Eugene City Guard*.
35. Grover, *Unforgiving Coast*, 23.
36. Noble, *Legacy*, 2.
37. Pinyerd, "U.S. Life-Saving Service in Oregon."
38. Noble, *Legacy*, 6.
39. Pinyerd, *Lighthouses and Life-Saving*, 55.
40. Pinyerd, "Preservation of Pre-World War Two," 45.
41. Ibid., 26.
42. "Shipwrecks of the Oregon Coast," Cannon Beach History Center and Museum.
43. Pinyerd, *Lighthouses and Life-Saving*, 39.
44. Noble, *Legacy*, 5.
45. Pinyerd, *Lighthouses and Life-Saving*, 92–93.
46. "U.S. Lifeboat Station and Capstan," National Park Service.
47. "Beach Apparatus Drill," U.S. Life-Saving Service Heritage Association.
48. La Follette, "Czarina."
49. Oregon Coast Beach Connection, "Coos Bay's Czarina Shipwreck."
50. United States Life-Saving Service, "Wreck of the Steamer Czarina," 62.
51. Ibid., 65.
52. Grover, *Unforgiving Coast*, 73.
53. McClary, "SS Rosecrans Wrecks."

54. Pinyerd, "U.S. Life-Saving Service in Oregon."
55. Department of the Interior, *Forest Reserve Manual*, 8.
56. Mitchell, "Ambivalent Landscapes," 53.
57. Tweed, *History of Outdoor Recreation Development*, 4.
58. Page, "Statesmanship of Forestry."
59. Duhse, "Saga of the Forest Rangers," 7.
60. Randall, "Adolf Aschoff."
61. Grauer, *Mount Hood*, 191.
62. Williams, *U.S. Forest Service*, 94.
63. Rakestraw and Rakestraw, *History of the Willamette*, 64.
64. Edmonston, "Extraordinary Life of Oliver C. Yocum."
65. Grauer, *Mount Hood*, 97.
66. Ames, "Rescue on Mount Hood," 157–63.
67. Grauer, *Mount Hood*, 230.
68. White, *Story of Lige Coalman*, 54.
69. Randall, "Snow Saga of Lige Coalman"; White, *Story of Lige Coalman*, 87.
70. McArthur, "Man Who Made 586 Ascents," 47.
71. Howard, "Life on Top of Mount Hood," 4.
72. Grauer, *Mount Hood*, 232.
73. Ibid., 133.
74. "Search for Boy Futile," *Oregonian*, 4.
75. "Act to Establish a National Park Service," 1–4.
76. Farabee, *Death, Daring & Disaster*, xxvi.
77. National Park Service, *Search and Rescue Reference Manual*, 2.
78. Farabee, *Death, Daring & Disaster*, 26.
79. Arant, "Report of the Superintendent," 5–13.
80. Unrau, *Administrative History of Crater Lake*, 127.
81. "Perished at Crater Lake," *Mail Tribune*, 4.
82. Dwyer and Howell, "Evolution of Enforcement in the Service," 7–11.
83. Farabee, *Death, Daring & Disaster*, 60.
84. "Act to Facilitate and Simplify the Work of the National Park Service," 16 U.S.C. 12. HR 12264. Public No 513. Chap. 792. July 3, 1926.
85. Unrau, *Administrative History of Crater Lake*, 325.
86. Ibid., 386.
87. "William C. Godfrey," Crater Lake Institute.
88. Unrau, *Administrative History of Crater Lake*, 389.
89. Ibid., 395.
90. Ibid., 405.

Chapter 2

91. Brock and Grauer, "Mazamas."
92. Grauer, *Mount Hood*, 136.
93. Molenaar, *Mountains Don't Care*, 72.
94. Grauer, *Mount Hood*, 236.
95. Scott, "Lorenz A. Nelson Obituary," 70.
96. Scott, "Thomas Raymond Conway Obituary," 68.
97. Onthank, "Mount Hood, 1927," 51–54; "Mount Hood, 1927, The Accident," *Mazama Bulletin*, 52.
98. Scott, *We Climb High*, 30.
99. Scott, "Rescues Are Not Romantic," 25–29.
100. Pattison, "History of the Crag Rats."
101. Annala, *Crag Rats*, 1.
102. "Blanchar Baldwin Lost Sunday Night," 9.
103. Molenaar, *Mountains Don't Care*, 129.
104. Annala, *Crag Rats*, 2.
105. Molenaar, *Mountains Don't Care*, 85.
106. "Crag Rats First Rescue," Hood River County Museum.
107. Annala, *Crag Rats*, 3.
108. Pattison, "History of the Crag Rats."
109. Grauer, *Mount Hood*, 187.
110. Muldoon, "Cloud Cap Inn."
111. Brogan, *East of the Cascades*, 64.
112. Pajutee, "Prince Glaze and the Lost Mountaineers."
113. Hanson, "History of the Skyliners."
114. "Skyliners Birthday," *Bend Bulletin*.
115. "Rescue Squad and Ski Patrol," *Bend Bulletin*.
116. "Dreams of Skyliners," *Bend Bulletin*.
117. "Skyliners Plan Rescue Effort," *Bend Bulletin*.
118. "Bend Ski Patrol Plans," *Bend Bulletin*.
119. "Bend Ski Patrol," *Bend Bulletin*.
120. "Paul Hosmer Jr.," *Bend Bulletin*.
121. "Training Taken in First Aid," *Bend Bulletin*.
122. "Tentative Form Taken by Group," *Bend Bulletin*.
123. Jacobsen, "Obsidians Search and Rescue…Part 1," 4.
124. Bovard, "Story of the Obsidians 1927–1933"; Jacobsen, "Obsidians Search and Rescue…Part 1," 4.
125. Conrad, *Mount Hood*, 21.

126. Grauer, *Mount Hood*, 160.
127. Conrad, *Mount Hood*, 24.
128. Ibid., 65.
129. "Three Are Injured," *Oregon Statesman*.
130. Conrad, *Mount Hood*, 78.
131. Mathieu, "Of Mountains and Metadata."
132. Conrad, *Mount Hood*, 81.
133. Ibid., 84.
134. Grauer, *Mount Hood*, 135.
135. Ibid., 178.
136. Scott, "Thomas Raymond Conway Obituary," 68.
137. Grauer, *Mount Hood*, 178.
138. Arave, "Forest Service Takes to the Slopes," 341–55.
139. "Marooned Party Is Reported Safe," *Bend Bulletin*.
140. Brauns, "Annual Great Nordeen Cross-Country Ski," 4.
141. Waston, "Cliff Blann."
142. Mosley, "Willamette Pass Ski Patrol History."
143. Dillin, "Ski Boom Hits Patrol," 21.
144. "Crater Lake Skiers Organizing Patrol," *Register-Guard*.
145. "Ski Patrolmen Display Equipment," *Evening Herald*.
146. "Ski Patrol May Be Organized," *Herald and News*.
147. Randall, "Mt. Hood Ski Patrol."
148. Grauer, *Mount Hood*, 165.
149. Laman, "Mt. Hood Ski Patrol," 21.
150. "History of the Mount Hood Ski Patrol," Mount Hood Ski Patrol.
151. Grauer, *Mount Hood*, 164.
152. Molenaar, *Mountains Don't Care*, 187.
153. Scott, *We Climb High*, 47.
154. Petrie, "Joseph R. Leuthold."
155. Grauer, *Mount Hood*, 243.
156. Ibid., 244.
157. Conrad, *Mount Hood*, 244.
158. Larabee, "Hank Lewis."
159. Grauer, *Mount Hood*, 166.
160. Ibid., 245.
161. Conrad, *Mount Hood*, 275
162. Grauer, *Mount Hood*, 122.

Chapter 3

163. Williams, *U.S. Forest Service*, 128.
164. Nelson, "President's Report," 40.
165. Hackett, "Military Mountaineering," 37.
166. Kennedy, "Mountaineers Take the Ridge."
167. Conrad, *Mount Hood*, 330.
168. Annala, *Crag Rats*, 41
169. "Air-Sea Rescue's Part in War," *Air Sea Rescue Bulletin*, 3.
170. "Development of Air-Sea Rescue," United States Coast Guard Aviation Association.
171. "Planes, Boats, Blimps," *Medford Mail Tribune*.
172. "Evolution of SAR," *Air Sea Rescue Bulletin*, 7.
173. Lee, "Lifeboat Radio Test," 32.
174. *Coast Guard at War*.
175. Sikorsky, "Development of the Helicopter Rescue," 5.
176. Cooper, Frost and Robe, *Compatibility of Land SAR Procedures*, 8.
177. Ibid., 6.
178. Ibid., 4.
179. Morse, "In Memoriam," 417–27.
180. *Review of Search Theory*.
181. Webber, *Retaliation*, 55; "Bombs Fall on Oregon," Oregon State Archives.
182. "Life on the Home Front," Oregon State Archives.
183. Pinyerd, "Preservation of Pre-World War Two," 55.
184. Hardt, "Tillamook Air Museum."
185. Grossnick, *Kite Balloons to Airships*, 37.
186. King, "B-17 Plane Crash"; Naval Air Station Tillamook ZP-33 Squadron Diary, August 3, 1943.
187. Worcester, "Man in the First."
188. Walker, *History of the Oregon Wing*, 1.
189. "Civil Air Patrol," *Capital Journal*.
190. Walker, *History of the Oregon Wing*, 2.
191. "Life on the Home Front," Oregon State Archives.
192. Little, *Aerospace Rescue and Recovery Service*, 13.
193. "History of Civil Air Patrol," United States Civil Air Patrol.
194. Morello, "Air Rescue Service Suggests Plan," 14.
195. "La Grande Forms Air Search," *Herald and News*
196. Biggs, "Air Search Unit Flies to Redmond"; "KASRU Unit to Expand," *Herald and News*.

197. Myers, "Lassen Park Peak Scene."
198. "Search Finds No Trace," *Bend Bulletin*.
199. "Roseburg Family Airplane Found," *Medford Mail Tribune*.
200. Burns, "Handicaps Faced in Oregon."
201. "One Reason for Lost Airplanes," *Capital Journal*.
202. Miller, "Story in Back of Air Search."
203. "Snell, Farrell, Cornett, Pilot," *Capital Journal*.
204. "Snell, Farell, Cornett Sought," *Corvallis Gazette-Times*.
205. Horton, "75 Years Ago."
206. Civil Aeronautics Board, *Accident Investigation Report*.
207. "Plane Search Program Set," *Stateman Journal*.
208. "State Board Releases Air Safety," *Statesman Journal*.
209. "Four-State Air Search Plan," *Eugene Guard*.
210. "51 Alerts Sounded," *Capital Journal*.
211. "Rescue Delayed by CAP," *Oregon Statesman*.
212. "CAP, State Air Board," *Bend Bulletin*; "A.F. Hearing Set," *Capital Journal*.
213. "We Knew Jim Welch," *Bend Bulletin*.
214. "Unfortunate Hassel," *Bend Bulletin*.
215. "Search, Rescue Mission Hearing," *Bend Bulletin*.
216. U.S. Air Coordinating Committee, *Annual Report*, 1.
217. Ibid., 2–3.
218. "Coming of Age," United States Coast Guard Aviation Association.
219. Annala, *Crag Rats*, 48.
220. Grauer, *Mount Hood*, 247.
221. Annala, *Crag Rats*, 50.
222. Ibid., 41.
223. Grauer, *Mount Hood*, 248.
224. Molenaar, *Mountains Don't Care*, 135.
225. "Alpinees/Hood River Civil Air Patrol Continue Legacy," Gorge Community Foundation.
226. Gillmouthe, "Hood River County Rescue Groups," 28–31.
227. Grauer, *Mount Hood*, 161.
228. King, "History of Pacific Northwest."
229. Phillips, *National Park Service Technical Rescue*, 1.
230. Bell, "Short History of Stretchers."
231. "L.C. 'Jack' Baldwin Obituary," American Alpine Club.
232. Gillmouthe, "Hood River County Rescue Groups," 28–31.
233. Molenaar, *Mountains Don't Care*, 136.
234. Grauer, *Mount Hood*, 213.

235. "Rescue Group," *Heppner Gazette-Times*.
236. Virginia C. Baldwin obituary.
237. Molenaar, *Mountains Don't Care*, 136.
238. Grauer, *Mount Hood*, 181.
239. Scott, *We Climb High*, 70.
240. "5 Lost Students Found Safe," *Oregon Statesman*.
241. Grauer, *Mount Hood*, 179.
242. "Rescuers Ascend Jefferson," *Medford Mail Tribune*.
243. "Portland Youth Dies," *Bend Bulletin*.
244. Grauer, *Mount Hood*, 217.
245. Ibid., 179.
246. Molenaar, *Mountains Don't Care*, 137.
247. Ibid., 189.
248. Mountain Rescue and Safety Council of Oregon, "Articles of Incorporation."
249. Molenaar, *Mountains Don't Care*, 138.
250. "19 Climbers Slide," *Oregon Statesman*.
251. Molenaar, *Mountains Don't Care*, 90.
252. "Mountain Rescue Council," *Statesmen Journal*.
253. Molenaar, *Mountains Don't Care*, 141.
254. Mountain Rescue Association, "Rescue Responsibility and Rescue Group Formation."
255. Ibid., 3.

Chapter 4

256. "Tentative Form Taken by Group," *Bend Bulletin*.
257. "Search, Rescue Group Forming," *Bend Bulletin*.
258. Brogan, "Injured Man Brought Out"; "Toboggan, Snow Tractor, and Truck," *Bend Bulletin*.
259. Uhrhammer, "Eugene Women Skis Ten Miles."
260. "Fliers Spot Bransetetters," *Bend Bulletin*.
261. "Search, Rescue Group Issues Report," *Bend Bulletin*.
262. Yates, "Co-ordination of Searches Improved."
263. Cooper, "Rescued by Helicopter."
264. Yates, "Co-ordination of Searches Improved."
265. Ibid.
266. "Lane's Latest Addition," *Eugene Guard*.

267. "Public Protected," *Eugene Guard*.
268. "Rescue Group Being Formed," *Corvallis Gazette-Times*.
269. "Plans Underway for Search," *Bend Bulletin*.
270. "Priday Names New Chairman," *Bend Bulletin*.
271. "Search, Rescue Procedure Set," *Bend Bulletin*.
272. "Search, Rescue Groups Started," *Capital Journal*.
273. "Coos Search, Rescue Group Seeks," *World*.
274. Pannell, "Many Volunteers in Search."
275. McAfee, "Roy Barbour's Death."
276. Meseroll, "Brush Monkeys," 38–39.
277. Liao, "When You're Missing."
278. Gustafson, "Post 18 Professional Rescue."
279. "Prepared—For Anything," *Albany Democrat-Herald*.
280. "Activities for Year Planned," *Bend Bulletin*.
281. Frear, "Scouts Find 'Lost' Hikers."
282. "Sheriff's Office to Sponsor Search," *Corvallis Gazette-Times*.
283. Arends, "Linn County Sheriff Organizes Scout Search."
284. Jackson, "Honor to Work with Explorers."
285. "About Us," Multnomah County Sheriffs' Office Search and Rescue.
286. Keller, discussions and correspondence with author.
287. King, "History of Pacific Northwest Search."
288. "Airline Crash Takes 4 Lives," *Eugene Register-Guard*.
289. "Deep Snow Prevents Probe," *Eugene Register-Guard*.
290. Nixon, *Finding Carla*, 50.
291. "Alvin F. Oien Jr. Obituary," PCN Flight West.
292. "California," *Time*.
293. "Girl Kept Diary," *Madera Tribune*.
294. Nixon, *Finding Carla*, 131.
295. "Family Loses Fight for Life," *Times-News*.
296. Nixon, *Finding Carla*, 150.
297. Ibid., 156.
298. "Search, Rescue Groups Started," *Capital Journal*.
299. "Search, Rescue Units," *Statesman Journal*.
300. Monroe, "Sheriff's Adopt Plan."
301. Oregon Revised Statute 1975 c.401 §1.
302. "Legislature Asked for Funds," *Corvallis Gazette-Times*.
303. "Funds for Rescue Proposed," *Capital Journal*.
304. Eden, "Help Sought for Mountain Rescue."
305. Eden, "Who's to Pay for Rescues?".

306. Ibid.
307. Eden, "Help Sought for Mountain Rescue."
308. Reyes, "Some Gather, Lobby for Funding."
309. "Sheriffs Seeking Search-Rescue Funds," *World*.
310. "Taxpayers Underwrite Search," *Albany Democrat-Herald*.
311. Sass, "Rescue Is More."
312. Grauer, *Mount Hood*, 218.
313. Oregon State University Mountain Club Records, 1947–1975.
314. Freund, "Corvallis Mountain Rescue Unit."
315. Blanchard, interview and correspondence with author.
316. Jacobsen, "Obsidians Search and Rescue…Part 1," 6.
317. Cash, "The Beginning," 3.
318. Jacobsen, "Obsidian Search and Rescue…Part 1," 4.
319. Jacobsen, "Obsidians Search and Rescue…Part 2," 3.
320. Blanchard, interview and correspondence with author
321. Cash, "Beginning," 3.
322. Cash, "EMR—The People," 5.
323. Jacobsen, "Obsidians Search and Rescue…Part 2," 3.
324. Stringfield, "Founding Father."
325. Larabee, "Hank Lewis."
326. Molenaar, *Mountains Don't Care*, 191.
327. "Funds for Rescue Proposed," *Capital Journal*; "Deer Season," *Statesman Journal*.

Chapter 5

328. Wisner, "Legislature Abolished Insurance."
329. Lee, testimony before the Oregon House State. Lee was director of the Multnomah County Office of Emergency Management.
330. "Boy Dies After Rescue," *Corvallis Gazette-Times*.
331. "Search-Rescue Bill Advances to the House," *Statesman Journal*.
332. Donahue, *Oregon Search and Rescue*, 3.
333. Ibid., 4.
334. Ibid., 5.
335. Oregon Revised Statute 401.573 (1985) C470 S2.
336. Toutonghi, "Mount Hood's Deadliest Disaster."
337. Williamson, "Improper Decision," from a condensed twenty-two-page investigative report submitted to the Oregon Episcopal School by John E.

Williamson, chair of the inquiry committee, whose other members were Cameron Bangs, MD; Andrew Harvard; Peter Lev; and Bruce Shaw.
338. Grauer, *Mount Hood*, 365.
339. "Critique Is Closed," *World*.
340. Stringfield, interview and correspondence with author.
341. "Doctors Remove Legs," *New York Times*.
342. "Rescue Report Suggest," *Corvallis Gazette-Times*.
343. "Mt. Hood Rescue," *Albany Democrat-Herald*.
344. "Radio Beepers Would Aid," *Capital Journal*.
345. Colton, "Signals That Can Save Lives."
346. "Rescue Teams Test Signal," *Albany Democrat-Herald*.
347. "House Will Vote," *Statesman Journal*.
348. "Keep Hope Alive," *Statesman Journal*.
349. "Rescue-Device Bill OK'd," *Corvallis Gazette-Times*
350. Dooris, "End of an Era."
351. Gubele, interview and correspondence with author.
352. Stevenson, "Life-Support-Mountain Wave Emergency."
353. Crombie, "Mountain Locator Unit Can Help."
354. Zeller, "Different Outcome on Mt. Hood."
355. Stringfield, interview and correspondence with author.
356. Tomlinson, "Lost Hikers Keep Volunteers Busy."
357. Farabee, *Death, Daring & Disaster*, 410; "Park Service Will Charge," *Statesman Journal*.
358. "Fees to Fund Searches," *World*.
359. King, "History of Pacific Northwest."
360. "Investigators Work to Positively Identify Remains," *Albany Democrat-Herald*.
361. "Rescue Teams May Bill You," *Statesman Journal*.
362. O'Shea, "Risky Business."
363. Kasindorf, "Recent Searches Revive Debate."
364. "Fees to Fund Searches," *World*.
365. Kleinbaum, interview and correspondence with author.
366. "Family of Missing Boy Threatens," *World*.
367. "Family of Missing Boy Criticizes," *Albany Democrat-Herald*.
368. Shipley, "Search, Rescue Criticized."
369. Petroccione, "Anatomy of a Search."
370. "Search-and-Rescue Crews," *Statesman Journal*.
371. Barnard, "Rescue Attempts Draw Eye."
372. "State Rescue Teams Operate," *Albany Democrat-Herald*.

373. Ibid.
374. Oregon Military Department, *Search and Rescue Accumulated Totals*.
375. "Three Dead, Many Injured," Portland Mountain Rescue.
376. "May 2002," Clackamas County Sheriff's Office.
377. Rollins, correspondence and interview with author.
378. Shimanski, "Chopper's Going Down!"
379. Casper, "Tragic Homecoming."
380. Jamieson, "NIMS and the Incident Command."
381. Preusch, "Search, Hope for Portland Boy."
382. Barnard, "Rescue Attempts Draw Eye."
383. Austin and Larabee, "On the Road."
384. Kim, "Lessons of My Son's Death."
385. Sleeth, "Clues Push Search."
386. Melton, "Three Men Missing."
387. Wilson, "Grim News."
388. Grauer, *Mount Hood*, 398.
389. Tomlinson, "Generosity Springs from Grief."
390. Suo, "Conflicts, Confusion Undermine."
391. Barnard, "Review Cites 'Frequent Confusion'."
392. Sleeth, Suo, Roberts and Suh, "Confusion Hampered Search."
393. "Phone Tip to Kim's Location," *Albany Democrat-Herald*.
394. Roberts, "Inside the Search."
395. Barnard, "Recent Searches Point Out."
396. Suo, Sleeth and Suh, "Conflicts, Confusion Undermine.".
397. "Kulongoski Orders Search," *Corvallis Gazette-Times*.
398. Kulongoski, *Executive Order No. 07-01*.
399. "Governor Pledges His Support," *Statesman Journal*.
400. Kost, "Oregon Is Falling."
401. O'Leary, correspondence and interview with author.
402. Ibid.
403. "Search-and-Rescue Task Force," *World*.
404. Sleeth, "State to Sharpen Search."
405. Ibid.
406. *Governor's Search and Rescue Task Force Report*, 15.
407. "Search-and-Rescue Reform Bill," *Corvallis Gazette-Times*.
408. "Task Force Formed," *Mail Tribune*.
409. *Governor's Search and Rescue Task Force Report*, 10.
410. Ibid.
411. "Mount Hood Rescue Efforts," *World*, 4.

412. Cain, "Climbers Plead Against Requiring Locators."
413. Fought, "After Climber Deaths."
414. Oregon Mountain Rescue Council, Letter Opposing HB 2509.
415. Cain, "Should Mountaineers Use Tracking."
416. Cain, "Climbers Plead Against Requiring Locators."
417. *Governor's Search and Rescue Task Force Report*, 7.
418. Peruzzi, "America's Search and Rescue."
419. *Governor's Search and Rescue Task Force Report*, 12.
420. Oregon Revised Statute, 2009, Chapter 718, HB 3021, Section 2.
421. Oregon Military Department, "Search and Rescue Accumulated Totals."
422. McGuire, Oregon State Sheriffs' Association Annual Report, 2020.
423. Koester, correspondence and interview with author.
424. Skidmore, "OHSU Study Looks at When."
425. McGuire, Oregon State Sheriffs' Association Annual Report, 2020.
426. Urness, "Number of Outdoor Rescue."
427. Hale, "Rise of the Rookie Hikers."
428. Urness, "Number of Outdoor Rescue."
429. Cox, "Civil Air Patrol."
430. Jacobsen, "Search and Rescue…Part 2," 3.
431. Lucas, correspondence with author.
432. Urness, "Recreation Card Eyed."
433. Oregon Legislative Assembly, House Bill 2503.
434. Peruzzi, "America's Search and Rescue."
435. Urness, "Number of Outdoor Rescue."
436. Avitt, "National Forest Visits Surged."

BIBLIOGRAPHY

Books and Monographs

Annala, Eino. *The Crag Rats*. Hood River, OR: Hood River News, 1976.

Brogan, Phil. *East of the Cascades*. Portland, OR: Binford & Mort Publishing, 1965.

Canwell, Diane, and Jonathan Sutherland. *The RAF Air Sea Rescue Service 1918–1986*. Barnsley, UK: Pen and Sword Aviation, 2005.

Clark, Keith, and Lowell Tiller. *Terrible Trail: The Meek Cutoff*. Caldwell, ID: Caxton Printers, 1966.

Clyman, James. *American Frontiersman, 1792–1881: The Adventures of a Trapper and Covered Wagon Emigrant as Told in His Own Reminiscences and Diaries*. Edited by Charles L. Camp. San Francisco: California Historical Society, 1928.

Conrad, Ric. *Mount Hood: Adventures of the Wy'east Climbers, 1930–1942*. Beaverton, OR: Kahuna Books, 2014.

DeVoto, Bernard. *Across the Wide Missouri*. Boston: Houghton Mifflin Company, 1947.

Farabee, Charles. *Death, Daring & Disaster: Search and Rescue in the National Parks*. Lanham, MD: Taylor Trade Publishing, 2005.

Grauer, Jack. *Mount Hood: A Complete History*. 8th ed. Vancouver, WA: Jack Grauer, 2010.

Grover, David. *The Unforgiving Coast: Maritime Disaster of the Pacific Northwest*. Corvallis: Oregon State University Press, 2002.

McLynn, Frank. *Wagon's West: The Epic Story of America's Overland Trails*. New York: Grove Press, 2002.
Molenaar, Dee. *Mountains Don't Care, but We Do: An Early History of Mountain Rescue in the Pacific Northwest and the Founding of the Mountain Rescue Association*. Boulder, CO: Mountain Rescue Association, 2009.
Nixon, Ross. *Finding Carla: The Story That Forever Changes Aviation Search and Rescue*. Newcastle, WA: Aviation Supplies & Academics, 2016.
Noble, Dennis. *A Legacy: The United States Life-Saving Service*. Washington, DC: U.S. Coast Guard, 1976.
Owen, Daniel. *The Lost Recue: The Story of the Lost Wagon Train and the Men Who Tried to Save It*. Scotts Valley, CA: CreateSpace Independent Publishing, 2015.
Palmer, Joel. *Palmer's Journal of Travels over the Rocky Mountains, 1845–1846*. Cleveland, OH: Arthur H. Clark Company, 1906.
Pinyerd, David. *Lighthouses and Life-Saving on the Oregon Coast*. Charleston, SC: Arcadia Publishing, 2007.
Victor, Frances Fuller. *History of Oregon*. San Francisco, CA: History Company, 1888.
Webber, Bert. *Retaliation: Japanese Attacks and Allied Countermeasures on the Pacific Coast in World War II*. Corvallis: Oregon State University Press, 1975.
White, Victor. *The Story of Lige Coalman*. St. Paul, MN: St. Paul Press, 1974.
Williams, Gerald. *The U.S. Forest Service in the Pacific Northwest*. Corvallis: Oregon State University Press, 2009.

Periodicals, Magazines, Journals and Newsletters

Ames, C.H. "The Rescue on Mount Hood." *Mazama Annual* 2, no. 3 (1903): 156–63.
Arave, Joseph. "The Forest Service Takes to the Slopes: The Birth of Utah's Ski Industry and the Role of the Forest Service." *Utah Historical Quarterly* 70, no. 4 (Fall 2002).
Bouchard, Nancy. "Bureaucracy Could Make Some Backcountry Less Safe." *Outside Magazine*, April 9, 2020. https://www.outsideonline.com.
Bovard, John F. "The Story of the Obsidians 1927–1933." *Obsidian Bulletin* 78, no. 5 (May 2018).
"California: Death in Trinity Mountains." *Time* 90, no. 15 (October 1967). https://time.com.

Cash, Steve. "The Beginning." *Belay Line: Eugene Mountain Rescue Newsletter* 37, no. 1 (March 2010): 3–4.

———. "EMR—The People: Hardman Stuart Rich." *Belay Line* 34, no. 1 (March 2007): 5–7.

Clark, Robert Carlton. "Military History of Oregon: 1849–59." *Oregon Historical Quarterly* 36, no. 1 (March 1935): 14–59.

Collins, Leah, and Lowell Tiller. "Cutoff Fever." *Oregon Historical Quarterly* 78, no. 4 (December 1977): 293–331.

Colton, Larry. "Signals That Can Save Lives: Researchers Are Coming to the Rescue of Mt. Hood Climbers." *Sports Illustrated* 66, no. 9 (March 1987): 80–84.

Davis, Don. "Harold Engles: Cascade Forester." *Mountaineer* 53, no. 4 (March 1960): 57–65.

Duhse, Robert. "The Saga of the Forest Rangers." *Elks Magazine*, July–August 1986.

Dwyer, William, and Robert Howell. "The Evolution of Enforcement in the Service." *Ranger: The Journal of the Association of National Park Rangers* 1. no. 2 (Spring 1985): 7–11.

Hackett, William. "Military Mountaineering." *Mazama Annual* 25, no. 12 (December 1943): 35–38.

Hazelett, Stafford. "To the World: The Story Behind the Vitriol." *Oregon Historical Quarterly* 116, no. 2 (Summer 2015): 196–219.

Jacobsen, Janet. "Obsidians Search and Rescue, 1927–2018: Part 1." *Obsidian Bulletin* 78, no. 5 (May 2018): 4–6.

———. "Obsidians Search and Rescue, 1927–2018: Part 2." *Obsidian Bulletin* 78, no. 6 (June 2018): 2–3.

Jamieson, Gil. "NIMS and the Incident Command System." *International Oil Spill Conference Proceedings* 2005, no. 1 (May 2005): 291–94.

Laman, Harold. "Mt. Hood Ski Patrol." *Ski Illustrated*, February–March 1940.

McArthur, Lewis L. "The Man Who Made 586 Ascents of Mt. Hood." *Mazama Annual* 52, no. 13 (December 1970): 46–49.

Meseroll, Stan. "Brush Monkeys of the Cascades." *Boy's Life*, July 1961.

Morse, Philip M. "In Memoriam: Bernard Osgood Koopman, 1900–1981." *Operations Research* 30, no. 3 (May–June 1982): 417–27.

"Mount Hood, 1927, the Accident." *Mazama Bulletin* 9, no. 12 (August 1927): 52.

Nelson, Ed. "The President's Report." *Mazama Annual* 24, no. 12 (December 1942): 39–40.

"Obsidian Search and Rescue." *Obsidian Bulletin* 27, no. 11 (September 1967): 2–3.

Onthank, Donald G. "Mount Hood, 1927, the Rope Squad, the Stryker Accident." *Mazama Annual* 68, no. 13 (December 1986): 51–52.

Richardson, Ruth Ellsworth. "John Craig: A Pioneer Mail Carrier." *Lane County Historian* 3, no. 2 (November 1958): 29–31.

Peruzzi, Marc. "America's Search and Rescue Is in a State of Emergency." *Outside Magazine*, January–February 2020). https://www.outsideonline.com.

Petrie, Ross. "Joseph R. Leuthold, 1906–1965." *American Alpine Club*, 1966. http://publications.americanalpineclub.org.

Sawyer, Robert W. "Beginnings of McKenzie Highway, 1862." *Oregon Historical Quarterly* 31, no. 3 (September 1930): 261–68.

Scott, John D. "Lorenz A. Nelson Obituary." *Mazama Annual* 47, no. 13 (1965): 71.

———. "Rescues Are Not Romantic." *Mazama Annual* 24, no. 12 (1942): 25–29.

———. "Thomas Raymond Conway Obituary." *Mazama Annual* 53, no. 13 (1971): 68–69.

———. *We Climb High: A Chronology of the Mazamas: 1884–1964*. Portland, OR: Mazamas, 1969.

Sikorsky, Sergei. "Development of the Helicopter Rescue Hoist." *Sikorsky Archives News*, January 2006.

Stevenson, Roy. "Life-Support-Mountain Wave Emergency Communications." *Popular Communications* 26, no. 11 (July 2008): 10–11.

Thomas Holt. Journal excerpt from the *Oregon Spectator*, March 4, 1847. In James Clyman and Charles Camp. "James Clyman: His Diaries and Reminiscences." *California Historical Society Quarterly* 4, no. 3 (1925): 307–60.

Toutonghi, Pauls. "Mount Hood's Deadliest Disaster." *Outside Magazine*, November 2018. https://www.outsideonline.com.

Victor, Frances Fuller. "The First Oregon Cavalry." *Oregon Historical Quarterly* 3, no. 2 (June 1902): 123–63.

Worcester, Thomas. "The Man in the First Air-Sea Rescue Experiment." *Northwest Magazine*, September 1980.

Bibliography

Newspapers

Albany (OR) Democrat-Herald. "Family of Missing Boy Criticizes Search and Rescue." January 13, 1999.
———. "Investigators Work to Positively Identify Remains of Teen-ager." September 19, 1992.
———. "Mt. Hood Rescue Takes Thousands of Man-hours." March 14, 1974.
———. "Phone Tip to Kim's Location Not Heeded." December 21, 2006.
———. "Prepared—For Anything." May 26, 1969.
———. "Rescue Teams Test Signal Device." June 8, 1987.
———. "State Rescue Teams Operate without Standards, Financing." February 8, 1999.
———. "Taxpayers Underwrite Search, Rescue Costs." November 5, 1976.
Arends, Lewis. "Linn County Sheriff Organizes Scout Search and Rescue Unit." *Statesman Journal* (Salem, OR), January 1, 1971.
Austin, David, and Mark Larabee. "On the Road, a Family Vanishes: Southern Oregon Is the Focus of a Search for a Couple and Their Children, Missing After a Portland Stop." *The Oregonian* (Portland, OR), December 6, 2006.
Barnard, Jeff. "Recent Searches Point Out Wide Divergence in Skills." *Statesman Journal* (Salem, OR), December 24, 2006.
———. "Rescue Attempts Draw Eye to Plan." *Spokesman-Review* (Spokane, WA), December 24, 2006.
———. "Review Cites 'Frequent Confusion' in Search for Kim." *Statesman Journal* (Salem, OR), January 19, 2007.
Bend (OR) Bulletin. "Activities for Year Planned by Scout Explorer Post 21." October 1, 1962.
———. "Bend Ski Patrol Plans for Winter." November 30, 1943.
———. "Bend Ski Patrol to Aid Airmen." December 7, 1944.
———. "CAP, State Air Board Meet." May 13, 1958.
———. "Dreams of Skyliners Are Not Coming True." January 1, 1936.
———. "Fliers Spot Bransetetters, Help Is Sent." March 21, 1960.
———. "Marooned Party Is Reported Safe: Plans of Skyliners Rescue Party Interrupted." January 18, 1833.
———. "Paul Hosmer Jr., New President of Skyliners." May 8, 1952.
———. "Plans Underway for Search and Rescue Program." September 2, 1961.

Bibliography

———. "Portland Youth Dies on Mount Jefferson." September 8, 1954.
———. "Priday Names New Chairman of Jefferson Rescue Group." August 10, 1963.
———. "Rescue Squad and Ski Patrol." October 12, 1939.
———. "Search Finds No Trace of Missing Roseburg Plane." August 16, 1947.
———. "Search, Rescue Group Forming." January 21, 1960.
———. "Search, Rescue Group Issues Report for 1960." January 18, 1961.
———. "Search, Rescue Mission Hearing Due on Friday." January 28, 1959.
———. "Search, Rescue Procedure Set." October 8, 1962.
———. "Ski Patrol Will Meet Next Week: Winter Safety Program to be Discussed." October 11, 1939.
———. "The Skyliners Birthday." December 10, 1937.
———. "Skyliners Plan Rescue Effort: Subscriptions to Fund Are Received." February 11, 1938.
———. "Tentative Form Taken by Group." January 9, 1960.
———. "Toboggan, Snow Tractor and Truck Used in Rescue." March 16, 1960.
———. "Training Taken in First Aid." December 19, 1956.
———. "Unfortunate Hassel." May 1, 1959.
———. "We Knew Jim Welch Was Euphorious, but We Didn't Know He Was Myopic." May 6, 1958.
Biggs, Joy. "Air Search Unit Flies to Redmond for Joint Meeting." *Herald and News* (Klamath Falls, OR), April 21, 1947.
Brauns, Katie. "Annual Great Nordeen Cross-Country Ski Race Links the Past to the Present." *Bend (OR) Bulletin*, December 16, 2007.
Brogan, Phil. "Injured Man Brought Out of Storm-Swept Cascades by Rescuers." *Bend (OR) Bulletin*, March 15, 1960.
Burns, Ann Reed. "Handicaps Faced in Oregon Searches for Lost Planes." *News Review* (Roseburg, OR), August 18, 1947.
Cain, Brad. "Climbers Plead Against Requiring Locators." *Corvallis (OR) Gazette-Times*, February 21, 2007.
———. "Should Mountaineers Use Tracking Devices?" *Corvallis (OR) Gazette-Times*, February 18, 2007.
Casper, Beth. "Tragic Homecoming." *Statesman Journal* (Salem, OR), May 16, 2004.
Capital Journal (Salem, OR). "AF Hearing Set on Snyder's Charges." April 30, 1958.
———. "Civil Air Patrol for State Planned." December 17, 1941.

Bibliography

———. "51 Alerts Sounded in Air Search." December 30, 1955.
———. "Funds for Rescue Proposed." September 23, 1976.
———. "One Reason for Lost Airplanes." August 16, 1947.
———. "Radio Beepers Would Aid Lost Climbers." January 15, 1976.
———. "Search Renewed for Missing Plane." November 11, 1946.
———. "Search, Rescue Groups Started." October 9, 1971.
———. "Snell, Farrell, Cornett, Pilot on Plane Missing in Lakeview Area." October 29, 1947.
———. "Three Plane Crashes Will Feature Rescue Drill." July 8, 1954.
Cooper, Rodney. "Rescued by Helicopter on Broken Top." *Bend (OR) Bulletin*, July 13, 1970.
Corvallis (OR) Gazette-Times. "Boy Dies After Rescue." December 5, 1984.
———. "Kulongoski Orders Search and Rescue Task Force." January 20, 2007.
———. "Legislature Asked for Funds for Search and Rescue Costs." January 24, 1977.
———. "Rescue-Device Bill OK'd." May 23, 1987.
———. "Rescue Group Being Formed." February 1, 1972.
———. "Rescue Report Suggest 'Fine Tuning.'" June 19, 1986.
———. "Search-and-Rescue Reform Bill Gets Unanimous Vote in House." June 6, 2007.
———. "Sheriff's Office to Sponsor Search, Rescue Explorers." October 18, 1996.
———. "Sheriffs Seeking Search-Rescue Funds." January 24, 1977.
———. "Snell, Farell, Cornett Sought in Klamath-Lakeview Area After Being Overdue in Airplane Flight." October 29, 1947.
Crombie, Noelle. "Mountain Locator Unit Can Help but Doesn't Guarantee a Safe Return." *The Oregonian* (Portland, OR), January 15, 2008. https://www.oregonlive.com.
Dillin, John. "Ski Boom Hits Patrol in the Pocket." *Capital Journal* (Salem, OR), February 6, 1980.
Dooris, Pat. "End of an Era: Mountain Locator Units Retired." KGW8 (Portland, OR), April 19, 2017. https://www.kgw.com.
Eden, Melinda. "Help Sought for Mountain Rescue Costs." *Statesman Journal* (Salem, OR), September 2, 1976.
———. "Who's to Pay for Rescues?" *Capital Journal* (Salem, OR). September 2, 1976.
Edmonston, George. "The Extraordinary Life of Oliver C. Yocum." *Newberg (OR) Graphic*, August 27, 2014.

Bibliography

Eugene (OR) City Guard. "Found." March 18, 1877.
———. "Lost in the Mountains." March 11, 1877.
Eugene (OR) Guard. "Four-State Air Search Plan Set at Meeting." May 4, 1952.
———. "Lane's Latest Addition: Disaster Unit to Aid Search and Rescue." March 24, 1958.
———. "Public Protected: Hundreds Perform Police Work, Fire Fighting." February 23, 1958.
Eugene (OR) Register-Guard. "Airline Crash Takes 4 Lives." March 10, 1967.
Evening Herald (Klamath Falls, OR). "Ski Patrolmen Display Equipment." February 23, 1939.
Fought, Tim. "After Climber Deaths, Oregon Faces Beacon Question" Associated Press, December 19, 2009.
Frear, Sam. "Scouts Find 'Lost' Hikers." *Eugene (OR) Guard*, February 25, 1963.
Gustafson, Alan. "Post 18 Professional Rescue Unit." *Statesman Journal* (Salem, OR), June 8, 1984.
Hale, Jamie, "Now 100 Years Old, Eagle Creek Helped Revolutionize Camping in the 20th Century." *The*
Hanson, Tor. "The History of the Skyliners." *Bend (OR) Bulletin*, January 19, 2019.
Hendrick, R.J. "Bits for Breakfast." *Statesman Journal* (Salem, OR), May 2, 1934.
Heppner Gazette-Times (Morrow County, OR). "Rescue Group." May 1, 1958.
Herald and News (Klamath Falls, OR). "KASRU Unit to Expand." March 6, 1953.
———. "La Grande Forms Air Search Group." December 17, 1946.
———. "Ski Patrol May Be Organized in the Park." February 21, 1947.
Hood River (OR) Glacier. "Blanchar Baldwin Lost Sunday Night." August 16, 1923.
———. "Serious Injury to Mr. Aschoff." July 6, 1905.
Howard, Randall. "Life on Top of Mount Hood is Full of Sublime Terror." *The Oregonian* (Portland, OR), September 24, 1916.
Jackson, Max. "Honor to Work with Explorers." *The World* (Coos Bay, OR), March 16, 1973.
Kasindorf, Martin. "Recent Searches Revive Debate: Who Pays?" *Statesman Journal* (Salem, OR), December 15, 2006.
Kim, Spencer. "The Lessons of My Son's Death." *Washington (DC) Post*, January 6, 2007.

Bibliography

King, Tim. "B-17 Plane Crash Sole Survivor's Story." *Salem-News* (Salem, OR), August 21, 2010. http://www.salem-news.com.

Kost, Ryan. "Oregon Is Falling into a 'Pit' of Deficits, Unemployment, Cuts." Associated Press (Salem, OR). February 19, 2009. https://kpic.com.

Larabee, Mark. "Hank Lewis: Sage of Mount Hood Started Ski Patrol in 1937, Trained Troops in WWII." *The Oregonian* (Portland, OR), May 22, 2004.

Liao, Ruth. "When You're Missing, His Group Will Help Find You." *Statesman Journal* (Salem, OR), December 3, 2007.

Madera (CA) Tribune. "Girl Kept Diary for 54 Days Before She, Two Others Died." October 3, 1967.

McAfee, Don. "Roy Barbour's Death Points Up Need for Rescue Program." *Corvallis (OR) Gazette-Times*, December 28, 1965.

Medford (OR) Mail Tribune. "Perished at Crater Lake." March 2, 1911.

———. "Planes, Boats, Blimps Team Up in Saving Fliers at Sea." July 16, 1944.

———. "Rescuers Ascend Jefferson to Reach Injured Climbers." September 7, 1954.

———. "Roseburg Family Airplane Found." August 22, 1947.

———. "Task Force Formed to Improve Search Efforts." February 11, 2007.

Melton, Kimberly. "Three Men Missing on Mt. Hood." *The Oregonian* (Portland, OR), December 11, 2006. https://www.oregonlive.com.

Miller, James B. "Story in Back of Air Search Much Work, Very Little Glamour." *The Statesman* (Salem, OR), October 4, 1952.

Monroe, Bill. "Sheriff's Adopt Plan on Search, Rescue." *Corvallis (OR) Gazette-Times*, December 19, 1973.

Morello, Ted. "Air Rescue Service Suggests Plan to Reduce Disasters." *Bend (OR) Bulletin*, September 24, 1947.

Myers, Wallace. "Lassen Park Peak Scene of Disaster." *Herald and News* (Klamath Falls, OR), June 2, 1952.

Nadrich, Lindsay. "Search-and-Rescue Teams Worry Clackamas Sheriff's Plan Puts Them Out of Business." *KGW8* (Portland, OR), February 17, 2020. https://www.kgw.com.

New York Times. "Doctors Remove Legs of Mt. Hood Climber." May 19, 1986.

Oregonian (Eugene), July 14, 2016.

———. "Rise of the Rookie Hikers: The Pandemic Pushed a New Wave of People Outside, for Better or Worse."

Oregonian (Portland). December 29, 2020.

———. "Search For Boy Futile." June 4, 1914.

Bibliography

Oregon Statesman (Salem). "5 Lost Students Found Safe on Mt. Hood; 4 Rescuers Missing." June 8, 1954.

———. "19 Climbers Slide into Mt. Hood Crevasse." July 30, 1956.

———. "Rescue Delayed by CAP; State Says, Probe Asked." April 29, 1958.

———. "Three Are Injured." September 6, 1933.

Oregon Sunday Journal (Portland). "Mountain Climbers Smash all Know Records of Coast." March 14, 1915.

O'Shea, Pat. "Risky Business: Mountain Rescues Dangerous and Costly." *Corvallis (OR) Gazette-Times*, May 21, 1992.

Pajutee, Maret. "Prince Glaze and the Lost Mountaineers." *Nugget Newspaper* (Sisters, OR), February 22, 2022.

Pannell, Wendy. "Many Volunteers in Search for Hunter." *The World* (Coos Bay, OR), December 8, 1965.

Petroccione, George. "Anatomy of a Search." *Corvallis (OR) Gazette-Times*, January 17, 1999.

Preusch, Matthew. "Search, Hope for Portland Boy All but Over." *The Oregonian* (Portland), October 21, 2006.

Register-Guard (Eugene, OR). "Crater Lake Skiers Organizing Patrol." January 17, 1939.

———. "Deep Snow Prevents Probe of Plane Crash." March 12, 1967.

Reyes, David. "Some Gather, Lobby for Funding: Who Really Needs Rescue Volunteers?" *Statesman Journal* (Salem, OR), February 27, 1977.

Roberts, Michelle. "Inside the Search for the Kim Family." *The Oregonian* (Portland), December 10, 2006.

Sass, Jerry. "Rescue Is More than a Hobby." *Statesman Journal* (Salem, OR), September 12, 1976.

Shipley, Sara. "Search, Rescue Criticized." *Statesman Journal* (Salem, OR), February 14, 1999.

Skidmore, Sarah. "OHSU Study Looks at When to Call off a Search." *Corvallis (OR) Gazette-Times*, July 18, 2007.

Sleeth, Peter, David Anderson and David Austin. "Clues Push Search for Missing Dad," *The Oregonian* (Portland, OR), December 6, 2006.

Sleeth, Peter, and Michelle Cole. "State to Sharpen Search Tools." *The Oregonian* (Portland, OR), December 23, 2006.

Sleeth, Peter, Steve Suo, Michelle Roberts and Elizabeth Suh. "Confusion Hampered Search for Kims." *The Oregonian* (Portland, OR), December 17, 2006.

Statesman Journal (Salem, OR). "Deer Season: When Hunters Become Lost." September 29, 1976.

Bibliography

———. "Governor Pledges His Support for Search-and-Rescue Input." April 5, 2007.
———. "House Will Vote on Liability Bill for Tracking Device Makers." June 16, 1987.
———. "Keep Hope Alive." Advertisement of the Mountain Signal Memorial Fund. June 8, 1987.
———. "Mountain Rescue Council Launches Fall Training at Santiam Pass." September 15, 1958.
———. "Park Service Will Charge for Rescue Missions." September 2, 1993.
———. "Plane Search Program Set for Operation." January 27, 1948.
———. "Rescue Teams May Bill You." August 11, 1993.
———. "Search-and-Rescue Crews Need State Help." February 22, 1999.
———. "Search-Rescue Bill Advances to the House." May 25, 1985.
———. "Search, Rescue Units Get Help of State Authority." October 9, 1971.
———. "State Board Releases Air Safety Manual." March 18, 1948.
Sullivan, William. "Hiking a Lost Wagon Trail." *Register-Guard* (Eugene, OR), July 18, 2020.
Suo, Steve, Peter Sleeth and Elizabeth Suh. "Conflicts, Confusion Undermine Search." *The Oregonian* (Portland, OR), January 19, 2006.
Thornton, Quinn J. "Letter." *Oregon Spectator* (Oregon City), December 10, 1846.
The Times-News (Hendersonville, NC). "Family Loses Fight for Life: Dramatic Story of a Diary." October 2, 1967.
Tomlinson, Stuart. "Generosity Springs from Grief." *The Oregonian* (Portland), February 19, 2008.
———. "Lost Hikers Keep Volunteers Busy." *Albany (OR) Democrat-Herald*, September 6, 1991.
Uhrhammer, Jerry. "Eugene Women Skis Ten Miles in Rescue Effort: Teacher Heroine of Cascades Rescue." *Eugene (OR) Guard*, March 16, 1960.
Urness, Zach. "Number of Outdoor Rescue in Oregon Skyrockets amid COVID, Hiking Boom." *Statesman Journal* (Salem, OR) January 29, 2022.
———. "Recreation Card Eyed to Fund Rescue Operations." *Statesman Journal* (Salem, OR), September 15, 2019.
Wilson, Kimberly, Eric Mortenson and Arthur Sulzberger. "Grim News on the Mountain." *The Oregonian* (Portland, OR), December 18, 2006.
Wisner, George. "Legislature Abolished Insurance on Rescuers." *Corvallis (OR) Gazette-Times*, August 29, 1980.
The World (Coos Bay, OR). "Coos Search, Rescue Group Seeks Equipment Donations." January 19, 1976.

———. "Critique Is Closed to the Public." June 3, 1986.
———. "Family of Missing Boy Threatens to Sue Klamath County." July 5, 1999.
———. "Fees to Fund Searches?" December 17, 1992.
———. "Mount Hood Rescue Efforts: Climbers Should Embrace Plan." March 5, 2007.
———. "Search-and-Rescue Task Force Advises Better Coordination." April 4, 2007.
Yates, Bill. "Co-ordination of Searches Improved: County Rescue Unit Capable of Serving Mid-State." *Bend (OR) Bulletin*, June 9, 1972.
Zeller, Tom. "A Different Outcome on Mt. Hood: Should Locator Beacons Be Required?" *New York Times*, February 20, 2007.

Documents and Reports

An Act to Establish a National Park Service, and for Other Purposes. August 25, 1916. [39 Stat. 535; 16 U.S.C. 1, 2, 3, and 4].
An Act to Facilitate and Simplify the Work of the National Park Service. July 3, 1926. 16 U.S.C. 12. HR 12264. Public No 513. Chap. 792.
Administrative History of Crater Lake National Park. Annual Report. Washington, DC: Department of the Interior, 1906.
"Air-Sea Rescue's Part in War History." *Air Sea Rescue Bulletin* 2, no. 3 (November 1945): 3–4.
Arant, William. "Report of the Superintendent of Crater Lake National Park, Oregon, to the Secretary of the Interior, 1906." In *Annual Reports of the Department of Interior*. Washington, DC: U.S. Government Printing Office, 1906.
Beckham, Stephen Dow. *The Oregon Central Military Wagon Road: A History and Reconnaissance.* Washington, DC: U.S. Department of Agriculture, 1981.
Cantwell, Gerald. *Citizen Airmen: A History of the Air Force Reserve, 1946–1994.* Washington, DC: U.S. Government Printing Office, 1994.
Civil Aeronautics Board. *Accident Investigation Report. Beechcraft Bonanza, Lakeview Oregon. File No. 4-3917* (May 19, 1948).
Clackamas County Sheriff's Office. "May 2002: Disaster on Mt. Hood." Press Release. https://www.clackamas.us/sheriff/2002SARIncidentRecap.html.
The Coast Guard at War: LORAN. Vol. 2. Washington, DC: U.S. Public Information Division, 1946.

Bibliography

Cooper, D.C., J.R. Frost and R. Quincy Robe. *Compatibility of Land SAR Procedures with Search Theory*. Washington, DC: Department of Homeland Security, 2003.

Department of the Interior, General Land Office. *Forest Reserve Manual for the Information and Use of Forest Officers*. Washington, DC: Government Printing Office, 1902.

Donahue, Ellen. *Oregon Search and Rescue. 85:149*. Oregon Legislative Assembly Research Monograph. Salem, OR. (April 2, 1985).

"The Evolution of SAR." *Air Sea Rescue Bulletin* 3, no. 7 (July 1946): 2–11.

Gillmouthe, Rupert. "Hood River County Rescue Groups." *FBI Law Enforcement Bulletin*, November 1973.

Governor's Search and Rescue Task Force Report. Salem, OR (March 31, 2007).

Grossnick, Roy A., ed. *Kite Balloons to Airships: The Navy's Lighter-Than-Air Experience*. Washington, DC: U.S. Government Printing Office, 2004.

Harris, Moses. *Native Sons Scrapbooks*, Roll 56. Kansas City Public Library. Kansas City, MO.

Kulongoski, Ted. *Executive Order No. 07-01 Search and Rescue Task Force*. January 19, 2007.

Lee, Myra. "Lifeboat Radio Test." *Air Sea Rescue Bulletin* 2, no. 6 (December 1944): 32.

———. Testimony before the Oregon House State and Federal Affairs Committee Minutes. House Bill 2977 Relating to Emergency Services. May 12, 1983.

Little, Donald D. *Aerospace Rescue and Recovery Service: 1946–1981: An Illustrated Chronology*. Scott AFB, IL: United States Air Force Military Airlift Command, 1983.

McGuire, Bruce. Search and Rescue Advisory Council (SARAC). Oregon State Sheriffs' Association (OSSA), Annual Report, 2020.

Mitchell, Ryan Franklin. "Ambivalent Landscapes: An Historical Geography of Recreation and Tourism on Mount Hood, Oregon." Master's thesis, Department of Geography, Portland State University, 2005.

Mountain Rescue Association. "Rescue Responsibility and Rescue Group Formation." Golden, CO: American Alpine Club, November 1961.

Mountain Rescue and Safety Council of Oregon. "Articles of Incorporation." September 16, 1955.

National Park Service. *Search and Rescue Reference Manual*. Washington, DC: Department of the Interior, 2011.

National Search and Rescue Committee. *National Search and Rescue Plan of the United States*. Washington, DC: Government Printing Office, 2016.

Bibliography

Naval Air Station Tillamook ZP-33 Squadron Diary, August 3, 1943.

Oregon Legislative Assembly, 2019 Regular Session. House Bill 2503.

Oregon Military Department, Office of Emergency Management. *Search and Rescue Accumulated Totals from 1997 to 2013*.

Oregon Mountain Rescue Council. Letter of Understanding with OSSA SARAC. September 27, 2017.

———. Letter Opposing HB 2509. March 23, 2007.

Oregon Revised Statute, 2009. Chapter 718, HB 3021, section 2.

Oregon Revised Statute 401.573. Established by 1985 c 470 s2.

Oregon Revised Statute 1975 c.401 §1.

Oregon State University Mountain Club Records, 1947–1975. Special Collections and Archives Research Center, Oregon State University, Corvallis, OR.

Page, Arthur W. "The Statesmanship of Forestry." In Donald R. Theoe's *The World's Work*, vol. 15, 9,734–57. New York: Doubleday Page & Company, 1908.

Phillips, Ken. *National Park Service Technical Rescue Handbook*. 11th ed. Washington, DC: U.S. Department of the Interior, 2014.

Pinyerd, David. "The Preservation of Pre-World War Two Coast Guard Architecture in Oregon." Master's thesis, Interdisciplinary Studies Program: Historic Preservation, University of Oregon, June 2000.

Portland Mountain Rescue. "Three Dead, Many Injured on Mt. Hood After 9 Climbers Fall, and an Air Force Helicopter Crashes—PMR Coordinates Massive Rescue Effort." Special Statement. May 30, 2002. https://pmru.org/headlinenews/three-dead-many-injured-on-mt-hood.

Rakestraw, Lawrence, and Mary Rakestraw. *History of the Willamette National Forest*. U.S. Forest Service, Pacific Northwest Region, 1991.

Review of Search Theory: Advances and Applications to Search and Rescue Decision Support. Washington, DC: U.S. Coast Guard Research and Development Center, 2001.

Shimanski, Charley. "Chopper's Going Down!" In *Accidents in Mountain Rescue Operations*. Mountain Rescue Association, 2016.

Stringfield, Tom. "A Founding Father." Portland Mountain Rescue Newsletter. Undated.

Tweed, William. *A History of Outdoor Recreation Development in National Forests: 1891–1942*. Washington, DC: United States Department of Agriculture, 1989.

United States Air Coordinating Committee. *Annual Report to the President*. Washington, DC: Department of Commerce, 1956.

BIBLIOGRAPHY

United States Coast Guard. *National Search and Rescue Manual.* Washington DC: Government Printing Office, 1959.
United States Life-Saving Service. "Wreck of the Steamer Czarina." Annual Report of the United States Life-Saving Service. Washington, DC: Government Printing Office, 1911.
Unrau, Harlan D. *Administrative History of Crater Lake National Park, Oregon.* Vols 1–2. Washington, DC: Department of the Interior, 1987.
Walker, Hellenmerie. *History of the Oregon Wing, Civil Air Patrol-USAF*, Vol 1. Portland Air National Guard Base, Oregon, 1989.
Waston, John. "Cliff Blann: Far West Service Award Citation." Far West Ski Association newsletter, 2014.
Williamson, John E. et al. "Improper Decision—Failure to Turn Back, Fatigue, Exposure, Hypothermia, Inadequate Equipment, Weather, Failure to Follow Route, Oregon, Mount Hood." American Alpine Club, 1987. http://publications.americanalpineclub.org.

Digital Resources and Websites

American Alpine Club. "L.C. Jack Baldwin Obituary." 1987. http://publications.americanalpineclub.org/articles/12198735300/LC-Jack-Baldwin-1921-1986.
Anderson Tribute Center. "Virginia C. Baldwin Obituary." https://www.andersonstributecenter.com/memorials/Baldwin-Virginia/1891580/obituary.php.
Avitt, Andrew. "National Forest Visits Surged in 2020." U.S. Department of Agriculture, May 28, 2021. https://www.fs.usda.gov/features/national-forest-visits-surged-2020.
Bell, Peter. "A Short History of Stretchers." April 30, 2010. https://www.ambulanceservices.co.uk/NAPAS%20Training%20Files/Training%20Files/Short%20History%20of%20Stretchers.pdf.
Brock, Mathew, and Jack Grauer. "Mazamas." *Oregon Encyclopedia*, March 31, 2021. https://www.oregonencyclopedia.org/articles/mazamas/#:~:text=The%20Mazamas%20embraced%20scientific%20research,changed%20from%20year%20to%20year.
Cannon Beach History Center and Museum. "Shipwrecks of the Oregon Coast." https://cbhistory.org/blog/shipwrecks-of-the-oregon-coast/.
Cox, Steve. "Civil Air Patrol: A Story of Unique Service and Selfless Sacrifice." Maxwell Air Force Base, December 8, 2016. https://www.

maxwell.af.mil/News/Features/Display/Article/1024853/civil-air-patrol-a-story-of-unique-service-and-selfless-sacrifice/#:~:text=By%20 1944%2C%20one%20in%20four,to%20serve%20in%20the%20 organization.

Crater Lake Institute. "William C. Godfrey, Naturalist." http://www.craterlakeinstitute.com.

Fratus, Matt. "The Crag Rats: How a Band of Outdoor Hobbyists Transformed Mountain Rescue in the Pacific Northwest." *Coffee or Die*, April 14, 2022. https://coffeeordie.com/culture/history.

Freund, Bob. "Corvallis Mountain Rescue Unit History." Corvallis Mountain Rescue. https://corvallismountainrescue.org/history/history.html.

Gorge Community Foundation. "Alpinees/Hood River Civil Air Patrol Continue Legacy." November 2009. https://gorgecf.org/wp-content/uploads/2016/07/Alpinees_history.pdf.

Hadlow, Robert. "Columbia River Highway." *Oregon Encyclopedia*, September 19, 2022. https://www.oregonencyclopedia.org/articles/columbia_river_highway/.

Hardt, Ulrich. "Tillamook Air Museum." *Oregon Encyclopedia*, June 22, 2022. https://www.oregonencyclopedia.org/articles/naval_air_station_tillamook_tillamook_air_museum/.

Hood River County Museum. "The Crag Rats First Rescue." December 15, 2015. http://historichoodriver.com/index.php?showimage=1172.

Horton, Kami. "75 Years Ago, A Plane Crash Changed Oregon Politics." *Oregon Public Broadcasting*, October 28, 2022. https://www.opb.org/article/2022/10/28/75-years-ago-a-plane-crash-changed-oregon-politics/.

Kennedy, Michelle. "Mountaineers Take the Ridge." U.S. Army. https://www.army.mil/article/143088/bootprints_in_history_mountaineers_take_the_ridge.

King, Jerry. "History of Pacific Northwest Search and Rescue." Pacific Northwest Search and Rescue, https://pnwsar.org/history.

Kloster, Tom. *Wy'east Blog*. https://wyeastblog.org/tag/elijah-coalman.

La Follette, Cameron. "Czarina." *Oregon Encyclopedia*, January 10, 2020. https://www.oregonencyclopedia.org/articles/czarina/.

Mathieu, Deschaine. "Of Mountains and Metadata: The Photographs of Donald Burkhart." Oregon Historical Society, April 16, 2019. https://www.ohs.org/blog/of-mountains-and-metadata.cfm.

McClary, Daryl. "SS Rosecrans Wrecks on Peacock Spit at Cape Disappointment with a Loss of 33 Lives." *HistoryLink*, January 2015. https://historylink.org/File/11006.

Bibliography

Mosley, Joe. "Willamette Pass Ski Patrol History." Willamette Pass Ski Patrol, https://www.wpsp.org/history.

Mount Hood Ski Patrol. "History of the Mount Hood Ski Patrol." https://mthoodskipatrol.org/www/pmwiki.php?n=Main.OurHistory.

Muldoon, Katy. "Cloud Cap Inn." *Oregon Encyclopedia*, September 21, 2022. https://www.oregonencyclopedia.org/articles/cloud_cap_inn/.

Multnomah County Sheriff's Office Search and Rescue. "About Us." https://mcsosar.org/about-us/.

National Park Service. "U.S. Lifeboat Station and Capstan." https://www.nps.gov/places/000/1877-u-s-life-boat-station-and-capstan.htm.

Nemec, Bethany. "The Applegate Trail." *Oregon Trails Coordinating Council*, November 3, 2022. https://historicoregoncity.org/2019/04/02/the-applegate-trail/.

Nokes, Gregory. "Black Harris—Northwest Mountain Man of Mystery." *Histories of the Early West*, April 3, 2017. http://gregnokes.com/2017/04/03/black-harris-northwest-mountain-man-of-mystery.

Nye, Nancy C. "Recreation and the Forest Service." Forest History Society, https://foresthistory.org/research-explore/us-forest-service-history/policy-and-law/recreation-u-s-forest-service/.

Oregon Coast Beach Connection. "Coos Bay's Czarina Shipwreck a Heart-Wrenching Oregon Coast Tale." August 7, 2020. https://www.beachconnection.net/news/czarina_shipwreck_coosbay_oregoncoast.php.

Oregon State Archives. "Bombs Fall on Oregon: Japanese Attacks on the State." https://sos.oregon.gov/archives/Pages/exhibits.aspx.

———. "Life on the Home Front: Oregon Responds to World War II." https://sos.oregon.gov/archives/exhibits/ww2/Pages/default.aspx

———. "The National Guard is Off to War: Who Will Protect Us Now?" https://sos.oregon.gov/archives/exhibits/ww2/Pages/protect-guard.aspx#footnote7.

Pattison, Don. "History of the Crag Rats." https://www.donpattison-scribe.com/crag-rat-history.

PCN Flight West. "Alvin F. Oien Jr. Obituary." November 3, 2016. http://pcnflightwest.blogspot.com/2016/11/dl-capt-alvin-f-oien-jr.html.

Pinyerd, David. "U.S. Life-Saving Service in Oregon." *Oregon Encyclopedia*, April 5, 2022. https://www.oregonencyclopedia.org/articles/u_s_life_saving_service_in_oregon/.

Randall, Gary. "Adolf Aschoff and Marmot Oregon's History." *Mount Hood History*, February 10, 2021. http://www.mounthoodhistory.com/historic-photos/adolf-aschoff-and-marmot-oregon.

———. "The Mt. Hood Ski Patrol: A True Mount Hood Institution." *Mount Hood History*, April 2, 2009. https://www.mounthoodhistory.com/mount-hood/the-mt-hood-ski-patrol/.

———. "Snow Saga of Lige Coalman." *Mount Hood History*, February 17, 2021. https://www.mounthoodhistory.com/mount-hood/snow-saga-of-lige-coalman/.

Seattle Mountain Rescue History. https://www.seattlemountainrescue.org/about/history/.

United States Civil Air Patrol. "History of Civil Air Patrol." Homeland Security Digital Library. https://www.hsdl.org/?view&did=456489

United States Coast Guard Aviation Association. "Coming of Age: 1957–1975." https://cgaviationhistory.org/the-history-of-coast-guard-aviation/coming-of-age.

———. "The Development of Air-Sea Rescue." https://cgaviationhistory.org/1943-the-development-of-air-sea-rescue/.

———. "Post–World War II Coast Guard Search and Rescue." https://cgaviationhistory.org/1946-post-world-war-ii-coast-guard-search-and-rescue/.

U.S. Life-Saving Service Heritage Association. "Beach Apparatus Drill." https://uslife-savingservice.org/lifesavers-duties-equipment/beach-apparatus-drill/.

White, Conan. "The Sea Shall Not Have Them!" RAF Air-Sea Search and Rescue, War History Online. April 21, 2019. https://www.warhistoryonline.com/history/the-sea-shall-not-have-them.html?chrome=1

Williams, Gerald. "Willamette Pass." *Oregon Encyclopedia*, March 30, 2022. https://www.oregonencyclopedia.org/articles/willamette_pass.

Interviews, Discussions and Correspondence

Blanchard, Jim. Interviews and correspondence, November 2022.

Cash, Steve. Discussions and correspondence, September 2002–January 2023.

Foster, Jeremy. Interview and correspondence, October 2022.

Gubele, Russell. Discussions and correspondence, September 2022–February 2023.

Henderson, Rocky. Discussion and correspondence, September 2022.

Lucas, Scott. Discussions and correspondence, October 2022–March 2023.

Keller, Jake. Correspondence, March 2023.
Kleinbaum, Georges. Interview and correspondence, February 2023.
Koester, Robert. Interview and correspondence, February 2023.
Mark, Steve. Discussion and correspondence, October 2022.
O'Leary, Joe. Interview and correspondence, December 2022.
Rollins, Steve. Discussions and correspondence, September 2022–February 2023.
Stringfield, Tom. Interviews and correspondence, November 2022.

INDEX

A

Air Force Rescue Coordination
 Center 130, 134
air-sea rescue 10, 74, 77, 79
Air-Sea Rescue Service 74
Alpinees 87, 89, 90, 94, 122
Anderson, Andy 44, 45
Applegate, Jessie 15, 17
Arant, William 35, 36
Arens, John 95
Aschoff, Adolph 31, 32, 35
Atkeson, Ray 52, 56

B

Bakowski, B.B. 35, 36
Baldwin, Blanchar 44, 87, 89, 90
Battle Ax Inn 41, 45
Bauer, Wolf 88, 96
Billstrom, David 126

Blanchard, Jim 114, 115
Boice, Clarence 26, 27, 29
Brownlee, Leslie 41, 42, 45, 46
Burkhart, Don 43, 56, 57, 60, 70,
 90

C

Central Mountain Emergency
 Committee 68
Central Oregon Search and Rescue
 (CoSAR) 51, 99, 100, 101, 106
Central Rescue Committee 60
Civil Air Patrol 51, 79, 80, 81, 84,
 85, 89, 92, 102, 107, 120, 129,
 134, 142, 148
Civilian Conservation Corps 43, 57
Cloud Cap Inn 42, 45, 48, 93
Coalman, Elijah "Lige" 32, 33, 34,
 35, 42, 70
Coffey, Harry 79

Index

Conway, Ray 42, 48, 52, 60, 68, 69
Corbus, Carla 107, 108, 110
Corvallis Mountain Rescue Unit 102, 114
Crag Rats 9, 31, 42, 44, 45, 46, 48, 57, 60, 68, 70, 74, 86, 87, 90, 92, 93, 94, 95, 115, 123, 128, 138, 151
Craig, John Templeton 18
Cramer, Henry 48, 50, 51
Crater Lake 35, 36, 37, 39, 61, 113, 135, 139, 142, 156
Czarina 26, 27

D

Daiber, Ome 88, 95, 96
Darr, Everett 40, 52, 57, 62, 86
Devaney, Leo 79
Dobbins, lifeboat 22
Dole, Charles "Minnie" 72

E

Elliott, Elijah 17
Engles, Harold 64, 66, 68
Eugene Mountain Rescue (EMR) 52, 114, 128, 148
Explorer Search and Rescue (ESAR) 104, 106

F

Fay, Corey 129
Ferry, Guy 48, 50, 51
Feyerabend, Al 41

Forest Service 30, 31, 32, 33, 34, 35, 42, 44, 46, 48, 51, 53, 56, 61, 62, 64, 68, 70, 72, 81, 91, 92, 94, 100, 101, 103, 113, 126, 128, 142, 146
Fuhrer, Hans 33, 34

G

Gibson Girl 75
Glaze, Prince 48, 51
Godfrey, William 38
Goman, Thomas 121, 122, 123
Gubele, Russell 126
Gueffroy, Russell 64, 65, 66, 68, 70

H

Harris, Moses 13
Hermann, Spike 68, 70
Holt, Thomas 16
Hood River Guides 44
Hvam, Hjalmar 52

J

Jackson, Mel 101, 115, 130, 141, 142
Jefferson, Mount 43, 51, 56, 57, 60, 70, 90, 92, 102, 114, 115

K

Kim, James 136, 138, 139, 141, 142

Klamath Air Search and Rescue Unit (KASRU) 80
Kleinbaum, Georges 130
Koester, Robert 147
Koopman, Bernard 76
Kostol, Chris 48
Kulongoski, Ted 139, 141

L

Lesley, Ernie 126
Leuthold, Joe 40, 52, 64, 66, 68, 69, 74, 86
Lewis, Hank 52, 62, 64, 66, 74, 94, 116
Lewis, Ray 52, 53, 56
Lien, Ole 52, 69, 70, 86
Lorentz, Jay 68, 69, 70
Lyle, gun 24, 27, 29

M

Mazamas 9, 31, 32, 40, 41, 42, 43, 44, 50, 52, 53, 56, 60, 62, 64, 66, 68, 70, 72, 74, 86, 93, 94, 98, 117, 123, 144, 148, 151
McCall, Tom 110, 111, 117
McLaughlin, Mark 114, 115
Meek, Stephen 14, 15, 17
Momyer, Henry 35, 36
Monner, Al 52, 56
Morley, William 92, 114
Mountain Locator Unit 125, 126
Mountain Rescue Safety Council of Oregon (MORESCO) 60, 61, 64, 68, 87, 90, 93, 94, 95, 96, 106, 110, 114, 115, 116, 117, 128

Mountain Wave Search and Rescue 127
Mount Hood Ski Patrol 52, 60, 64, 68, 70, 86, 90, 92, 93, 94, 117, 123, 125, 132, 148
Mount, James 52, 57, 62
Mt. Hood SAR Council 128

N

National Search and Rescue Plan 85
Naval Air Station Tillamook 76
Nelson, Lorenz 41, 42, 60, 66
Nordeen, Emil 48, 61

O

Obsidians 10, 32, 48, 51, 52, 56, 57, 61, 70, 98, 102, 114, 115, 116, 148, 151
Oien, Alvin 106, 107
O'Leary, Joe 139
1042nd Air Ambulance Company 132, 138
Oregon Episcopal School 114, 121
Oregon Mountain Rescue Council 114, 125, 128, 144
Oregon State Sheriff's Association 10, 111, 113
Oregon Wing, CAP 79, 80, 84

P

Payton, Perlee 43, 56
Petrie, Keith 87, 117, 125, 126

Pooley, Dick 40, 87, 93, 94, 95, 96, 117
Portland Mountain Rescue (PMR) 116, 117, 122, 123, 133, 138

R

Reid, Henry Fielding 32, 125
Rich, Stuart 115, 116
Rosecrans 26, 29, 30
Russell, Scott 64, 65, 68, 70, 123, 125, 126

S

Scott, John 18, 40, 60, 66, 123, 125
Search and Rescue Agency 75
Skyliners 10, 32, 48, 50, 51, 52, 56, 57, 61, 70, 86, 98, 99, 100, 151
Snell, Earl 82
Snyder, Earl 84
South Sister 48, 50
Stringfield, Tom 123
Stryker, Stanton 42, 43

T

Tetherow, Solomon 15
304th Rescue Squadron 101, 107, 113, 120, 122, 132, 138
Trott, Otto 88, 95, 96

U

U.S. Coast Guard 30, 74, 75, 76, 77, 85, 94, 113
U.S. Life-Saving Service 9, 19, 30

V

Varney, Roy 64, 65, 66, 68

W

Weygandt, Mark 42, 53, 56, 91
White, Calvin 34, 41, 45, 68, 122, 123, 125
Wiese, Ralph 62, 64, 65, 74, 92
World War II 10, 30, 39, 51, 60, 62, 64, 72, 85, 93, 96, 101, 115
Wright, Dee 33
Wulfsberg, Nils 48
Wy'east Climbers 43, 52, 56, 57, 60, 62, 64, 68, 70, 86, 93, 94

Y

Yocum, Oliver 32, 44

ABOUT THE AUTHOR

Glenn Voelz served for twenty-five years in the U.S. Army as an intelligence officer and spent over a decade living and working across Asia, Europe, the Middle East and Africa. He held senior leadership positions at the Pentagon on the Joint Chiefs of Staff, in the White House Situation Room and at NATO headquarters in Brussels, Belgium.

He is a graduate of the United States Military Academy at West Point and served on the faculty as an assistant professor in the Department of History. Glenn is the author of over a dozen books and journal articles, including three novels. When not writing, he works as a professional ski patroller at the Mt. Bachelor Nordic Center and is a volunteer member of the Deschutes County Sheriff's Office Search and Rescue team.

Visit us at
www.historypress.com